Thank You

Ray Edwards

Natural Light

Natural Light

VISIONS OF BRITISH COLUMBIA

PHOTOGRAPHS BY

DAVID NUNUK

HARBOUR PUBLISHING

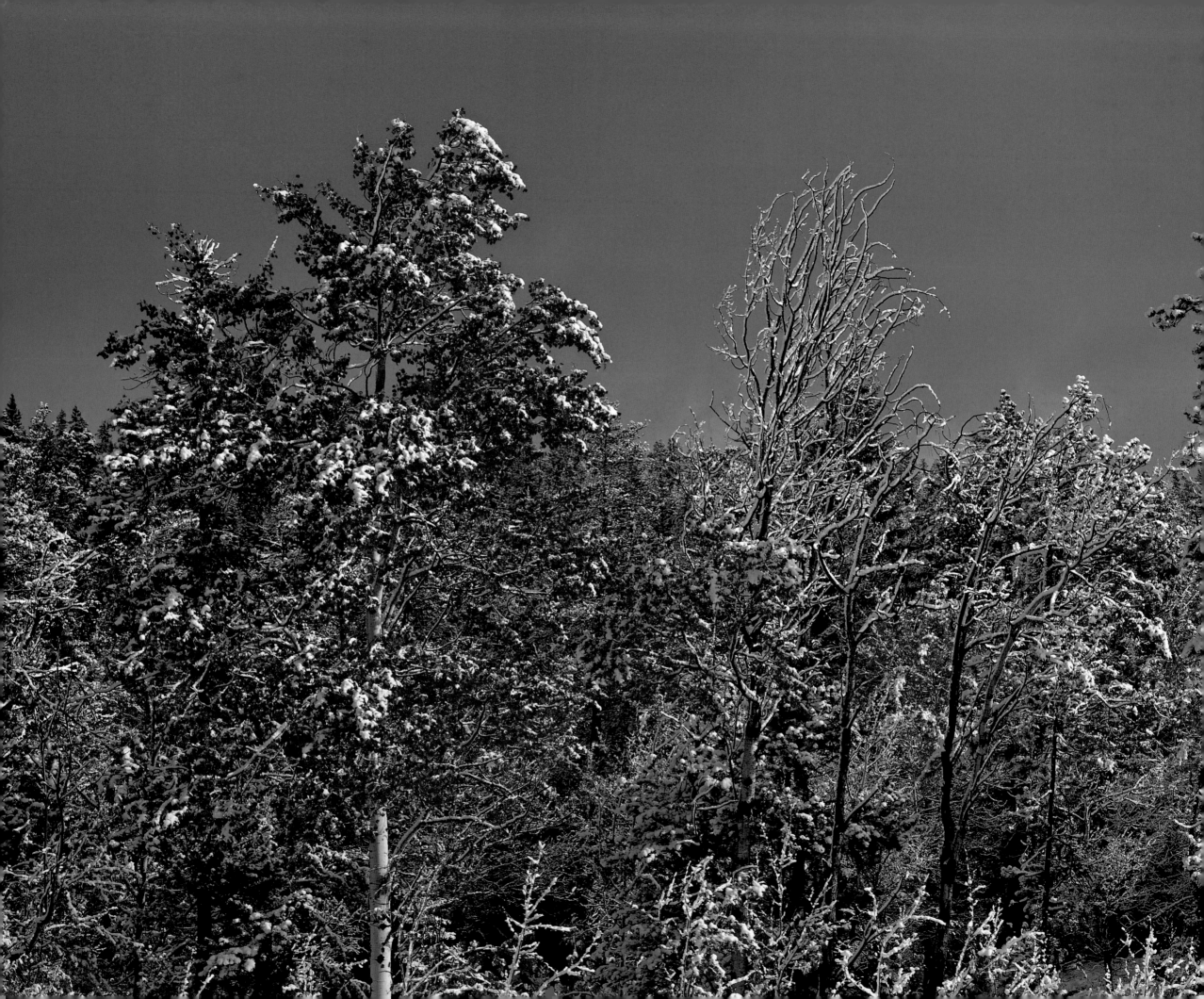

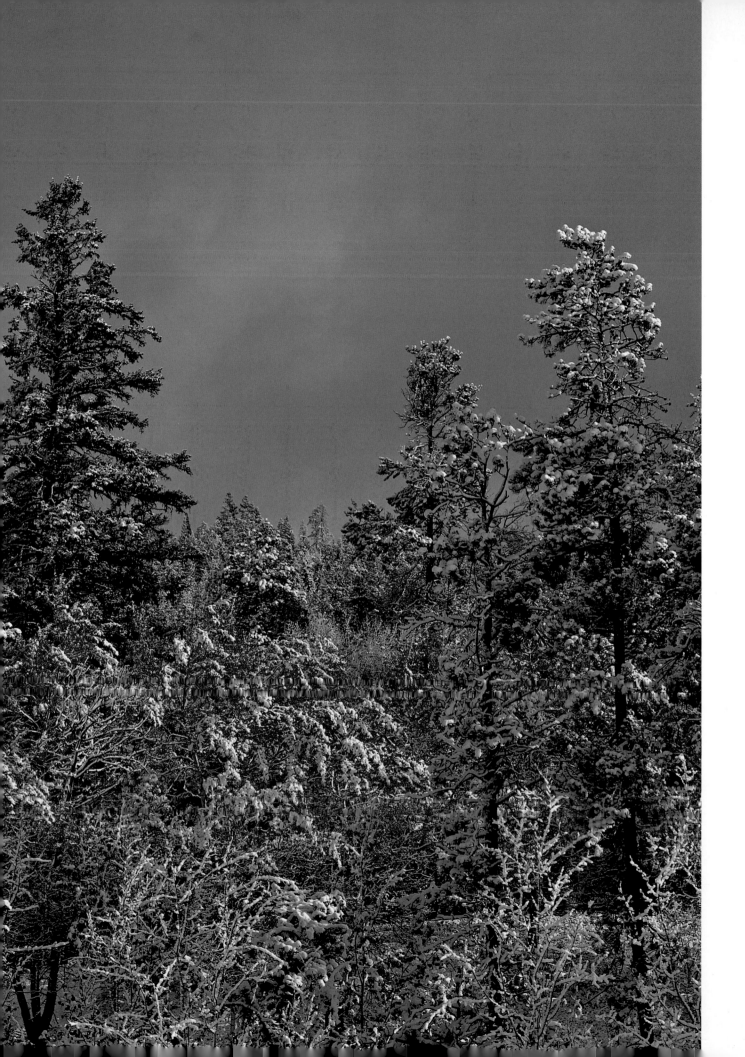

Contents

FOREWORD 6

INTRODUCTION 8

SOUTH COAST 22

SOUTHERN INTERIOR 48

CENTRAL & NORTHERN
INTERIOR 68

NORTH COAST 98

ACKNOWLEDGEMENTS 120

Foreword

One of the first books of colour photography on British Columbia was called *Challenge in Abundance*, and the title was apt. Photographing a scenic realm as diverse as BC presents an enormous challenge that photographers tend to resolve in one of two ways. First is the forced march, whereby the expedition of image collecting sets out by plane, train and four-by-four at the 49th parallel and keeps on trucking to the Yukon border, clicking vigorously all the way. This is by far the most common approach, and it has the advantage of achieving a certain temporal unity and consistency of treatment. It also has a tendency to follow well-marked paths through the labyrinth of BC's multiple personalities, revisiting marker-posts much peed-upon by previous clickers and seizing recognizable icons we have come to accept as the quick solution to expressing BC's elusive identity. These thumb-worn images have been the staples of every book of souvenir photos since *Challenge in Abundance* made its smudgy appearance in 1966.

A second and much less travelled path to exposing the scenic genius of British Columbia is the one followed by David Nunuk in this book. It eschews the forced march for the leisurely, reflective meander and seeks to reveal BC's innate character not by making the circuit of Kodak photo spots, but by sleuthing out fresh images that at once startle by their originality and typify the qualities of the region. Thus Nunuk's signature image of the Queen Charlotte Islands is not the familiar profiles of Tow Hill or All Alone Stone, but an anonymous roadside swamp nobody ever thought to stop by, but which, in Nunuk's talented lens, sensuously evokes the delicate, mossy, fairy-like spirit of that enchanted archipelago.

Building up a book-length collection of such rare gems is slow work, more the project of decades than of a quick march across the map to the drumbeat of a publisher's schedule. It is made up of lonely days spent waiting for the exact concurrence of clear sky, full moon, and eagle's arrival—then when light and weather and bird fail to perfectly coincide, returning the next year to wait again—and this is just how Nunuk has approached his task over many patient years.

The photographs in this book are the work of a consummate artist taking infinite pain. But the greater his pain, the greater the viewer's pleasure.

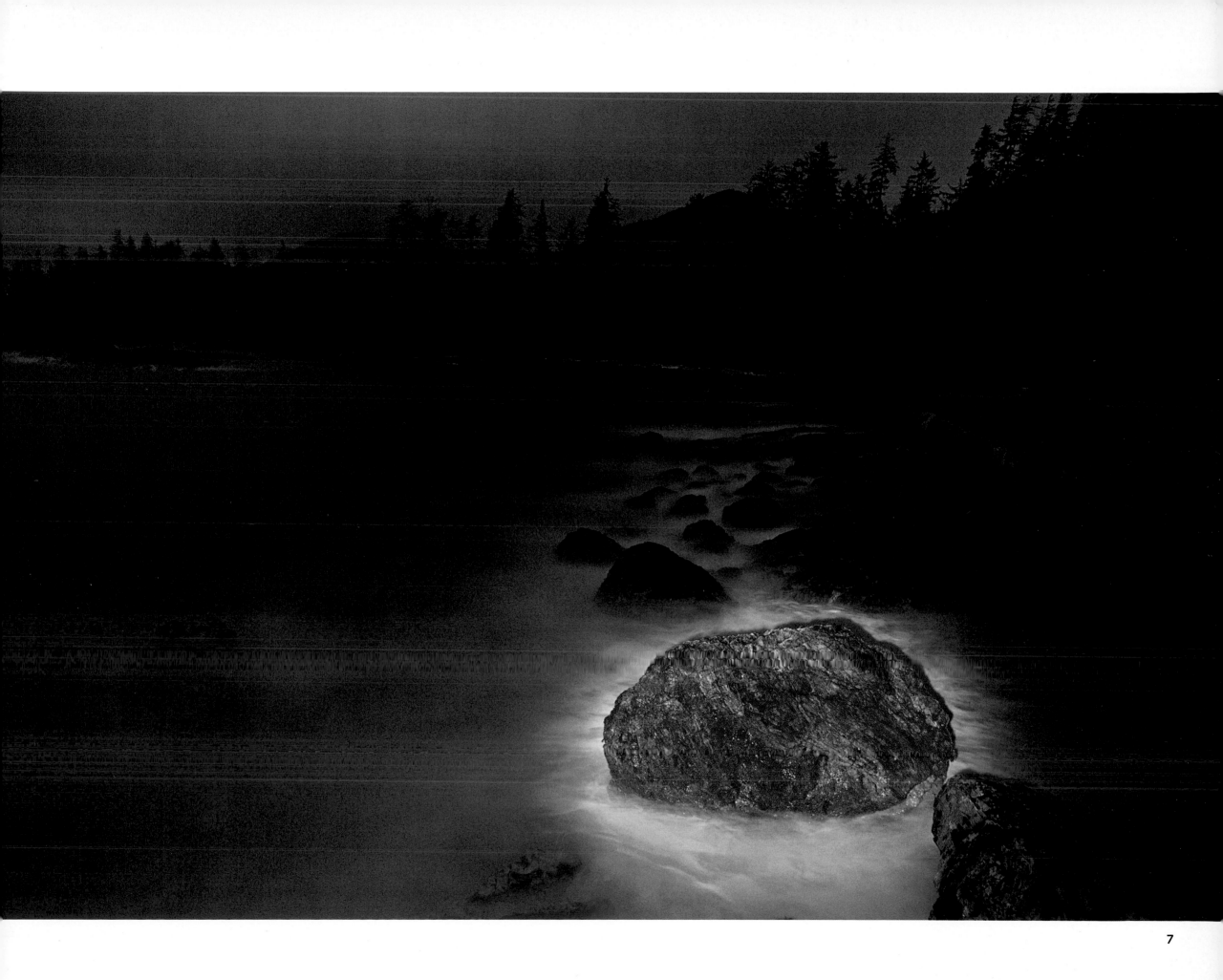

Confessions of a Scenery Hunter

It was one of those happy accidents that make it hard to be a full-time cynic. I was on my way to Europe to photograph a solar eclipse and had just boarded my flight. As I walked down the aisle, searching for my seat number, I was surprised to find a stunning Nordic blonde in the place next to mine. This couldn't be right: where was the gushing insurance salesman, love handles spilling over our shared armrest, normally assigned to sit next to me? I checked my pass again. No mistake. I breathed a prayer of thanks to the seat-selection gods and sat down.

Her name was Kristen and she was a curator on her way home to Berlin. In typical German fashion she was eager to know all about the wilds of Canada. In typical single-male fashion I was eager to impress her, and for once I had the right stuff. I waxed poetic about my beautiful home province. I described untouched rainforests full of majestic trees that have never known the pain of a chainsaw's teeth, beautifully rugged windswept shorelines, and stunning snow-capped mountain vistas stretching to the horizon and beyond, studded with glacier-fed lakes and flower-laden alpine meadows that would have moved the fabled Heidi to spontaneous yodelling.

I couldn't tell if my hormonally motivated sermon moved her or not. Smitten and emboldened by a couple of glasses of airline wine, I took the plunge and offered to show it to her.

"The whole province," I offered magnanimously. "I have a book to shoot and I'll be hitting all the high points. It would be no trouble at all to take another person along. I would welcome the company.

"It would be a rare chance to see the best BC has to offer, all in one non-stop, thrill-filled rush," I continued, like a low-budget, used-car salesman. I was expecting her to laugh out loud, but she surprised me.

"I'll think about it," she said.

We parted company at the luggage carousel in Berlin with an exchange of phone numbers.

Two months later when the phone call came, it was better than I dared hope. Kristen was taking a year off work and wanted to come to Canada to spend part of her time visiting the scenes I had so energetically described.

So there's the secret out: my true motivation for doing this book. Actually, I had been working up to it for 15 years, but I took this unexpected appearance of an attractive and willing assistant (so I imagined) as a sign the photography gods wanted me to get on with the job. I temporarily forgot the gods' favourite sport is tormenting humans with heavenly pranks.

II

I was sincere enough about appreciating company on the looming final pan-BC blitz needed to finish off this book. BC is a photographer's—and wilderness-lover's—dream. It has so many world-class spectacles that are seldom seen by human eyes. The world is full of beautiful places, but they tend to be famous and filled with people, cars lining up to get into campsites and people standing shoulder to shoulder to photograph a view you always imagined you'd be the first one to see since Dr. Livingstone. In British Columbia, I've been alone for days in places that have taken my breath away: I've kayaked to my own private island on countless afternoons; I've been on beaches where every morning the tide left me a meal of giant scallops; and I've sat with a glass of Pinot Noir in an alpine meadow and listened to the marmots whistle while asking myself, "Why isn't the rest of the world here with me?" This makes BC a great place to hunt down fresh images, but it makes the nature photographer's life solitary, and sometimes rather arduous.

I still remember the first time I hiked the West Coast Trail. It's not a very good example of unknown BC, since you have to place your name on a list months ahead of time to get into it nowadays, but in the primordial times I'm speaking of, you were lucky to see another hiker. And even choked with Gore-Tex and serviced by a hamburger stand as it is today, it is still not to be taken as lightly as I took it then. I set out on the 78-kilometre trek with a backpack full of canned beans, a six-pack of beer, lots of camera gear and little else. The weather was perfect so who needed a tent? I would save the weight and sleep out under the stars.

I spent two glorious days and nights camped at Owen Point near the trail's southern end before heading north for some serious hiking. I enjoyed one more day and night of perfect weather. Night four would be different. The day had been flawless. I'd photographed the sunset and watched the sky fill with stars before making my bed in the sand. Big thoughts filled my head, inspired by my surroundings: How many stars are there in the sky? How many grains of sand are there on the beach? I drifted off to sleep serenaded by the West Coast surf.

At midnight a raindrop between my eyes shattered this perfect world. By quarter past, I was in a West Coast downpour and my surroundings now inspired just one thought: how many raindrops are there in a rainstorm? Two large plastic garbage bags suddenly became my most precious possessions. I used one to protect my camera gear, the other to protect myself. By morning I was soaked anyway.

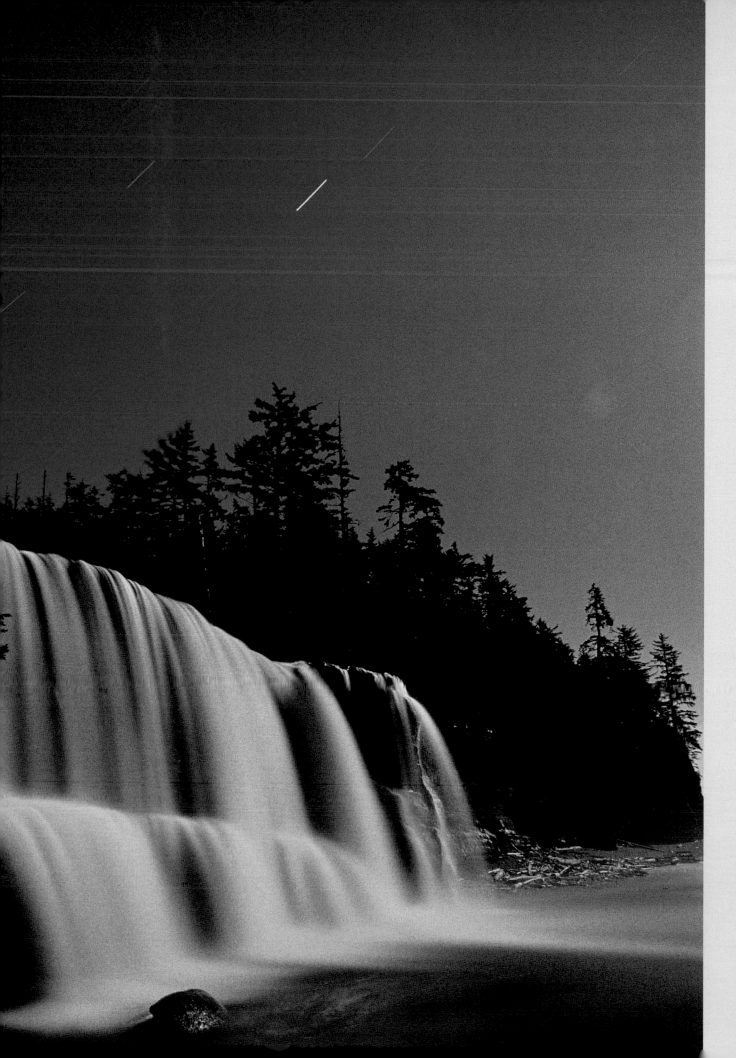

Tsusiat Falls by full moonlight, West Coast Trail

I love moonlight and finding scenes that are complemented by its cool glow. It takes 650,000 times longer to expose a frame by moonlight than by sunlight, but if you do it properly, the picture will look almost as if it was shot in the daytime. Only the star trails give it away.

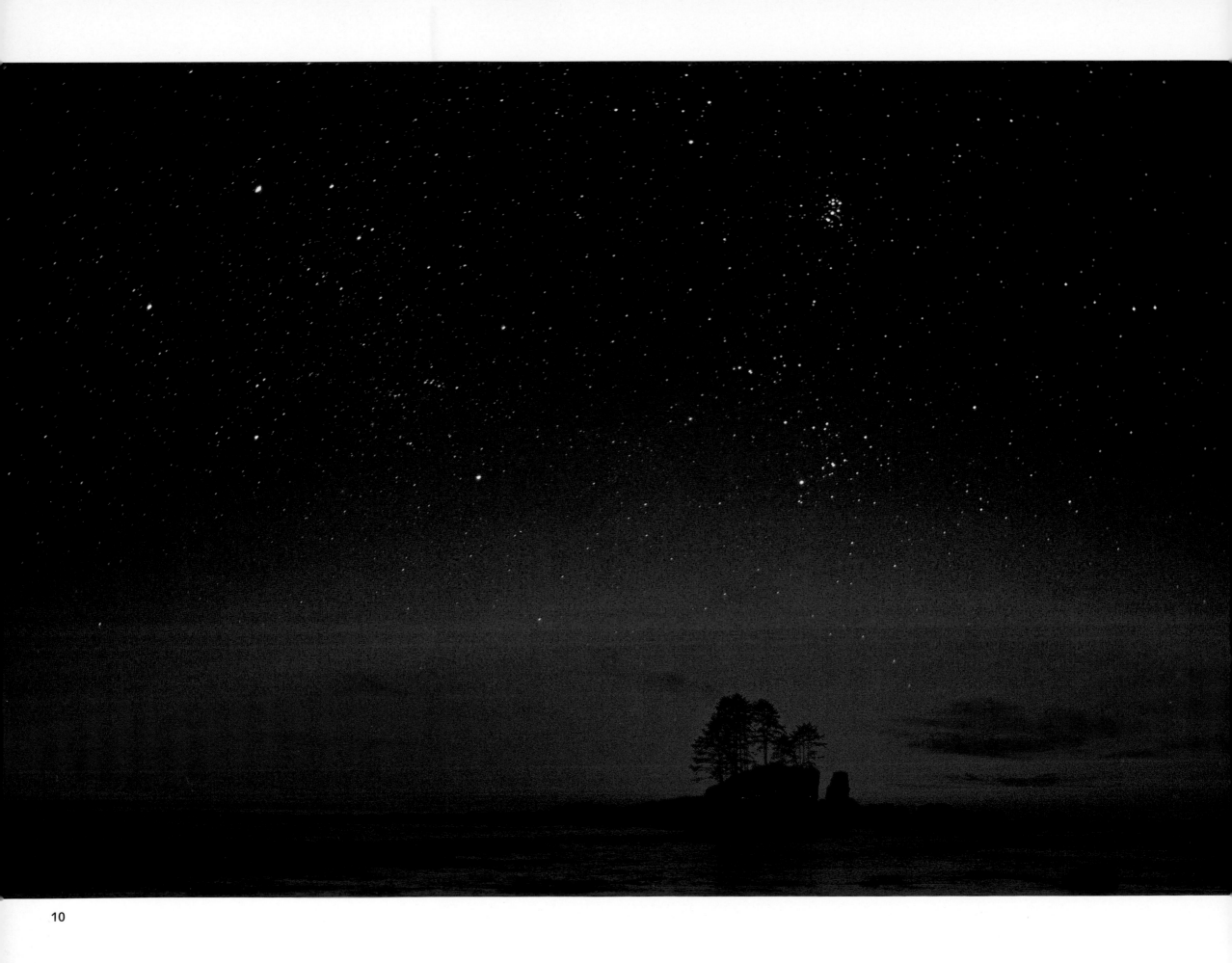

I was saved from myself, and three more days of relentless rain, by a motley crew of First Nations people calling themselves the "independent state of Qwa-Ba-Diwa." The Qwa-Ba-Diwaians fed, dried, resupplied and bombarded me with information about their claim to independent aboriginal statehood. Native independence started making sense. Just about the time I was ready to dedicate my life to the Qwa-Ba-Diwa cause, the weather cleared and the lure of unphotographed vistas overcame the pull of political rhetoric.

Fortunately, many years of experience as a scenery hunter have helped me develop better camping techniques that keep such embarrassments to a minimum. These days my photo expeditions commonly find me with lawn chairs, portable wine cellar, camp stove, thick foamie to sleep on, pillows and lots of good food. Still, most previous attempts to drag friends along with me had flopped. My way of experiencing nature was a little too natural for them, despite my modern conveniences. As a result, most of my wilderness forays continued to be solo, and it was the one thing about the work that continued to bug me. It is fundamental to want to share thrilling discoveries with other people and I was getting tired of my own company—again.

III

I had talked myself into believing Kristen would prove to be the backpacking partner I had longed for. After all she was German, and Germans were born with racial affinity for the wilderness, were they not? Black Forest, Red Indians, brown bears and all that? The trouble with my Canadian friends was that they were spoiled by seeing big trees and snowy mountains all the time—they didn't want to work for it. She would be prepared to pay the price, wouldn't she? Whatever tiny misgiving I felt, I was more than willing to take the chance. She was just so damned gorgeous ... I cleaned six months worth of garbage out of my pickup, took a bath, put on a clean shirt and met her at Sandspit Airport in the Queen Charlotte Islands. This was risky in March and there was a good chance of encountering three straight weeks of rain, but Haida Gwaii is where Mother Nature hides some of her most beautiful secrets.

I took her first to one of my favourite places. It wasn't one of the landmarks that makes it into tourist brochures. It was a roadside swamp most people would never bother to stop at, the result of a beaver's handiwork in plugging up a drainage culvert under the road to Naikoon Provincial Park. But to my eye it had

the kind of beauty that I've come to expect in the most unexpected places—an uncelebrated patch of roadside waste and a scenic treasure.

I'd photographed this scene years before but was longing to re-do it with the new panoramic camera in which I had just invested my life savings. I worried that something might have happened to this accidental landscape, but I found it exactly as I'd left it more than three years earlier. I couldn't tell for sure, but I thought Kristen seemed to see what I saw in it, and the connection felt good.

Some photographs happen fast, others take hours or days. This one was taking hours, and Kristen was getting put to the test a little earlier than I'd intended. Oh well she'll understand, I told myself, and kept working the changing light and wind, trying for the perfect reflection ... and that's when I discovered comely German curators and that kind of "understanding" do not necessarily go hand-in-hand. She was getting bored and hungry and making no secret of it. I tried to invoke the capricious demands of the muses we were both sworn to serve, but she would have none of it. In the next few minutes I was reminded of another fabled German trait I'd heard about—will of steel. I crumpled before it like a piece of origami. I found us a campsite, opened a bottle of wine and cooked dinner, rapidly revising my internal visualization of just how the upcoming season of tandem nature loving would play out, and worrying about getting back to finish the shoot before some stalwart from the Ministry of Highways unplugged the culvert. As it happened, the muses eased up on me that day and let me sneak back and get a shot that had everything I was looking for.

The hardest part about this new axis of control in my life was accepting it. As long as I followed a path of capitulation, things went fairly smoothly. Thinking of our swing through the Gulf Islands, I can't even say this was always bad for the photography.

It was our last day on Gabriola Island and I was looking forward to an afternoon of laziness. Kristen wanted to go kayaking. This seemed like a lot of hot, sweaty, physical activity to me. Of course I'd learned that arguing with Kristen could also be a hot, sweaty activity, so I did the sensible thing and went kayaking. The weather was warm and calm and the paddling easy as we glided through an archipelago of island paradises all within five minutes of each other.

We made landfall on a nameless islet sculpted from the same kind of bubbly, eroded sandstone of which the whole of Gabriola

Star field over Carmanah Point

I made this photo showing a night landscape with a sky full of stars overhead by using two separate exposures on the same piece of film. First I shot the scene using an eight-second exposure on a regular tripod just before dark. Then I blacked out the bottom of the lens and did a 20-minute exposure with an equatorial mount that synchronizes the camera with the earth's rotation.

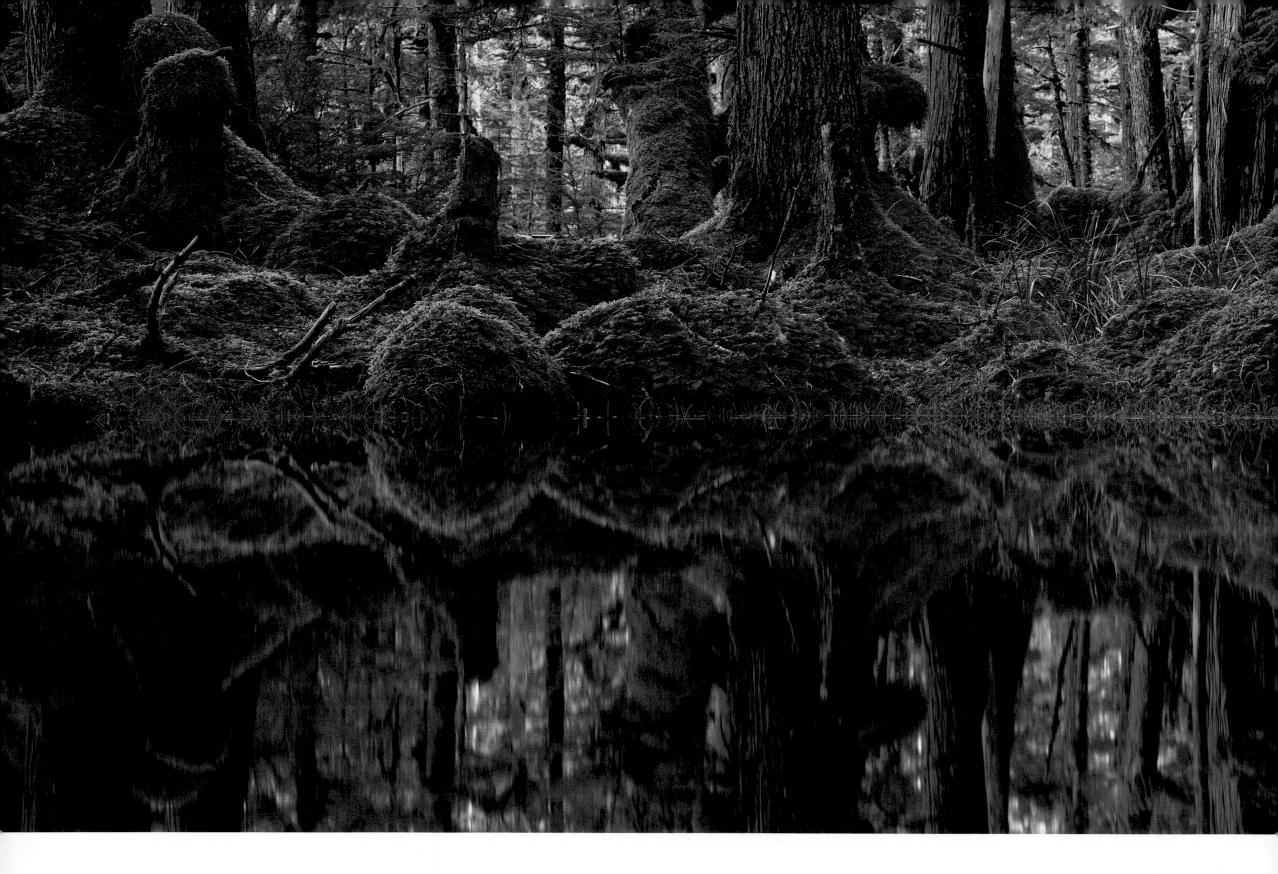

Queen Charlotte Islands

Usually moss is an opportunist, growing where nothing else will. Here on the Queen Charlotte Islands it doesn't just grow on rocks or the north side of trees. It grows everywhere and on everything, as if a giant green duvet has been pulled over the whole world.

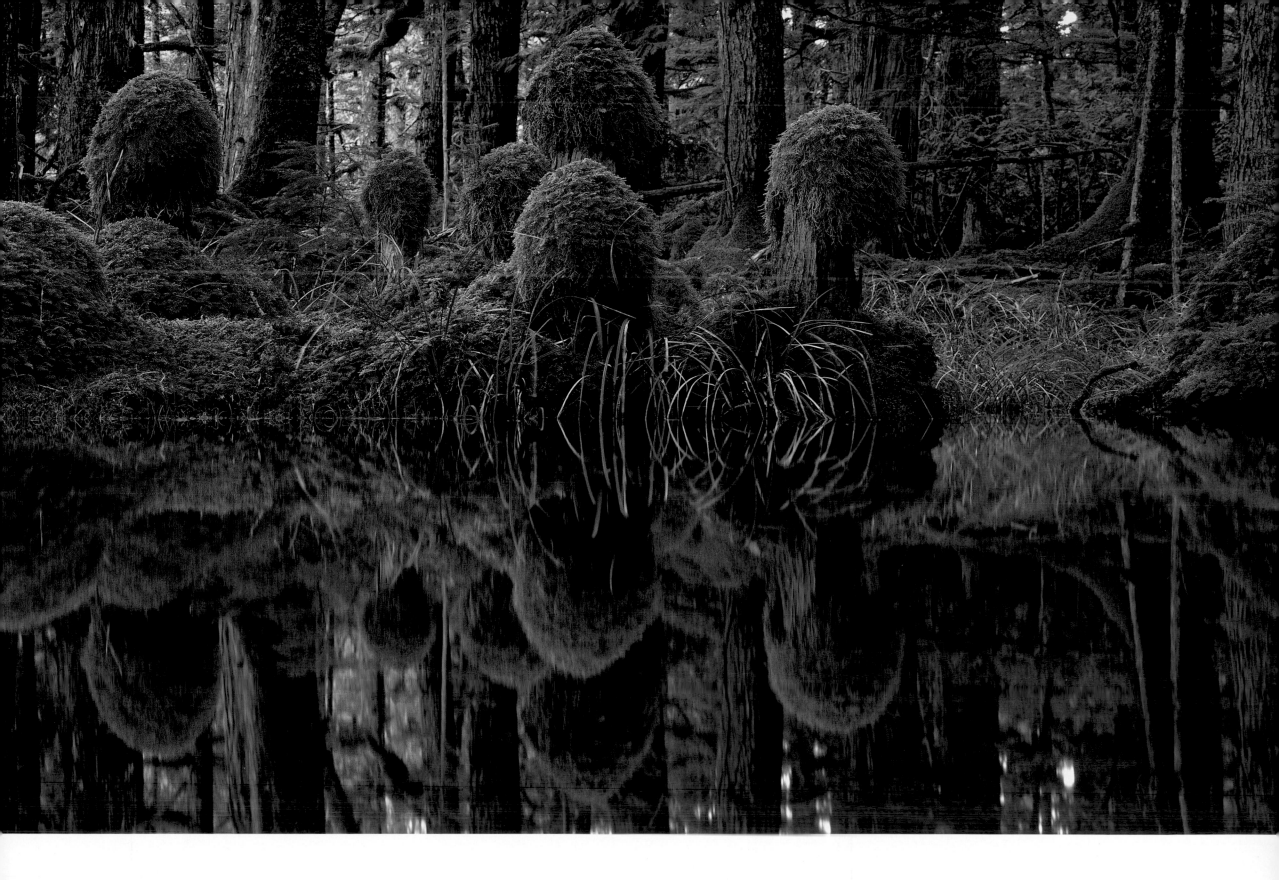

seems to be made. A cluster of pencil cedar trees adorned the high ground, each one looking like a runaway from the bonsai collection of the Royal Botanical Society. I was almost reluctant to take the photo on pages 30-31, knowing it was going to be the best one I shot during our visit to the Gulf Islands and realizing how much harder that was going to make it the next time I tried to convince Kristen to rein in her own wishes and do what I wanted.

I was already starting to worry about our foray into the alpine country of Mount Assiniboine Provincial Park. I wanted Kristen to see it because it is a tour de force of the classic mega-scenery that Germans must dream of when they hear about British Columbia, but it would be one of our longer, more strenuous expeditions and I wasn't sure how she would bear up. Or how I would, now that I was finding myself in the roles of bearer and butler as well as cook, bottlewasher and wagonmaster. I loaded up all the camping conveniences the chopper had space for and we flew from Canmore, Alberta across the Great Divide into Mount Assiniboine Lodge at Lake Magog, just a few kilometres inside the British Columbia boundary.

We were dismayed to learn the campsite was three kilometres away. With our excess of things like folding chairs, coolers and other items that don't backpack well, I estimated it would take three trips to move it all, totalling 18 kilometres. I wasn't happy about this unintended physical exertion and Kristen was downright indignant at the thought of how long she would have to wait for me to do it before I could make her a cup of tea. I was ready to go back on the next flight when we learned the lodge had cabins for rent only a few hundred metres from where we landed. The cabins were rustic but positively luxurious compared to my tent. The luxury that most excited Kristen was hot showers, available at the lodge for the price of $10 a wash. At those rates, I was reluctant to soap up at all, let alone every day, but found myself bound to a pledge of cleanliness for the duration of our stay.

Our cabin, built in 1925, was nestled in a grove of spruce and larch trees surrounded by a field of lupines and Indian paintbrush. Through this ran Magog Creek, so full of spawning brook trout you could reach in and touch them. The whole scene was backdropped by the peaks of Naiset Point and Mount Assiniboine.

Everything seemed to be laid out for maximum visual effect as if a flamboyant exterior decorator had been fussing endlessly about the placement of mountains, lakes and streams. Tiny lakes, which turned glassy calm every morning and evening, dou-

bled the beauty of the scenery by reflecting it in perfect mirror images. Snow-capped peaks rose into the sky to be kissed by the first and last light of day, and every tantalizing foreground had a stunning background to complement it. I won't go so far as to say it's hard to take a bad picture in such a place, but it certainly is easy to take a good one.

One of the things that made my summer with Kristen so interesting was that I never quite knew what to expect. This was the case with the ice cave that I found inside a pocket-sized glacier in the Pemberton Ice Field in the southern Chilcotin. It looked like the surface of a choppy, clear-blue lake that had been flash-frozen and turned inside out. Peering deep into its ancient walls, I was fascinated to be looking at ice that had fallen as snow 90,000 years ago and had been saving itself ever since.

Ice caves are dangerous, and I wasn't counting on being able to coax Kristen inside, but it was no problem at all. She was so charmed, I decided to go for broke and proposed we set up our tent inside and spend the night. Great idea.

You notice things spending the night in such a place that you don't in a quick visit. I noticed every creak, snap and pop as the glacier shifted under its own weight. More disturbingly, somewhere deeper in the cave, heavy-sounding crashes periodically occurred, indicating sections of the ceiling were falling down. I was wide awake the whole night, convinced we'd meet our maker at any moment. I prayed there was a difference between the ice roof over our tent and where it was caving in. If I'd been alone I would have been out of there in a flash. But I couldn't leave Kristen, and even less could I face breaking in on her beauty sleep to explain I had recklessly placed her in terrible danger—which she would probably want to argue about anyway. I kept hoping one of the thunderous crashes would do the convincing for me, but she slept like a rock through the entire ruckus.

Morning came and our maker hadn't unmade us. I walked the 50 or so yards to the cave's interior to find a pile of broken ice the size of a Sherman tank on the floor and a corresponding chasm in the ceiling. Our salvation appeared to lie in the arched architecture above our tent, whereas farther on the ceiling was too flat to support itself. I was quite convincing in explaining how expertly I had gone about selecting a perfectly safe location for our tent, I think.

For the most part, shooting this book had gone unusually well. Until now, many of the kinds of things that could go wrong, and usually do, hadn't. A temporary suspension of Murphy's Law, it seemed. Alone on a ridge in the Bugaboos, I would learn

Mount Assiniboine wrapped in clouds at sunset

I sometimes imagine places like this were consciously designed by an exterior decorator endlessly fussing about the precise placement of reflecting ponds, streams, mountains and lakes.

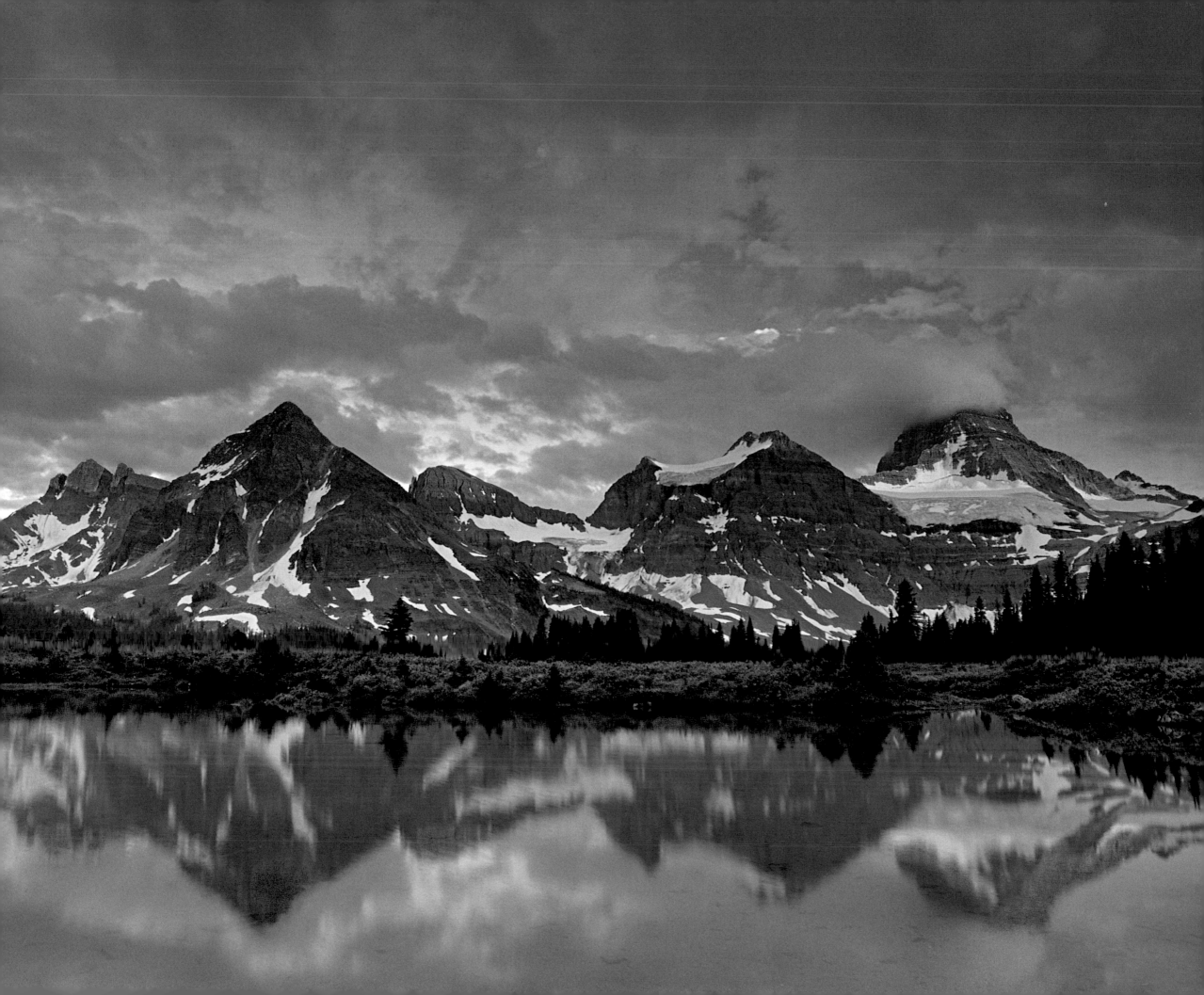

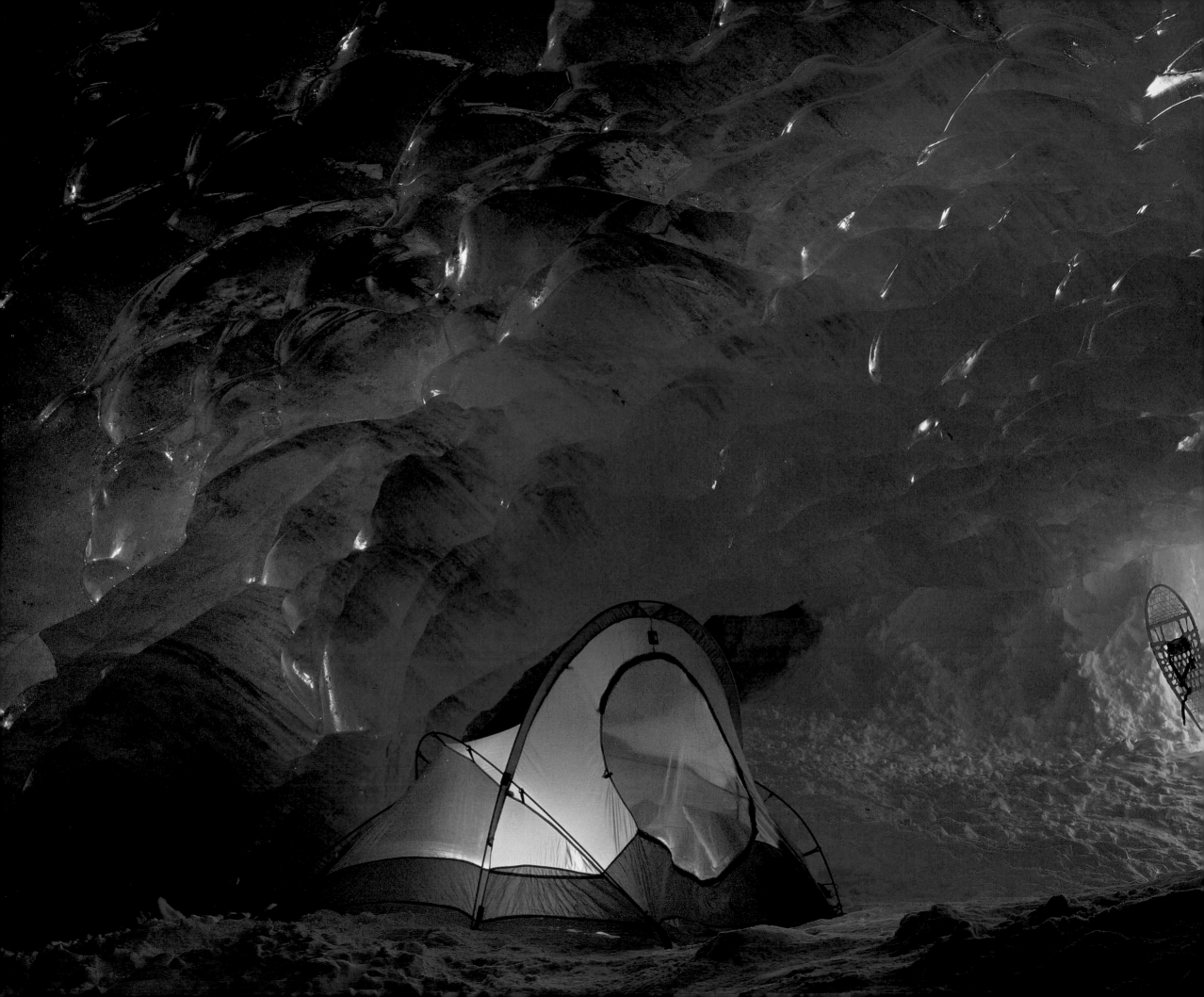

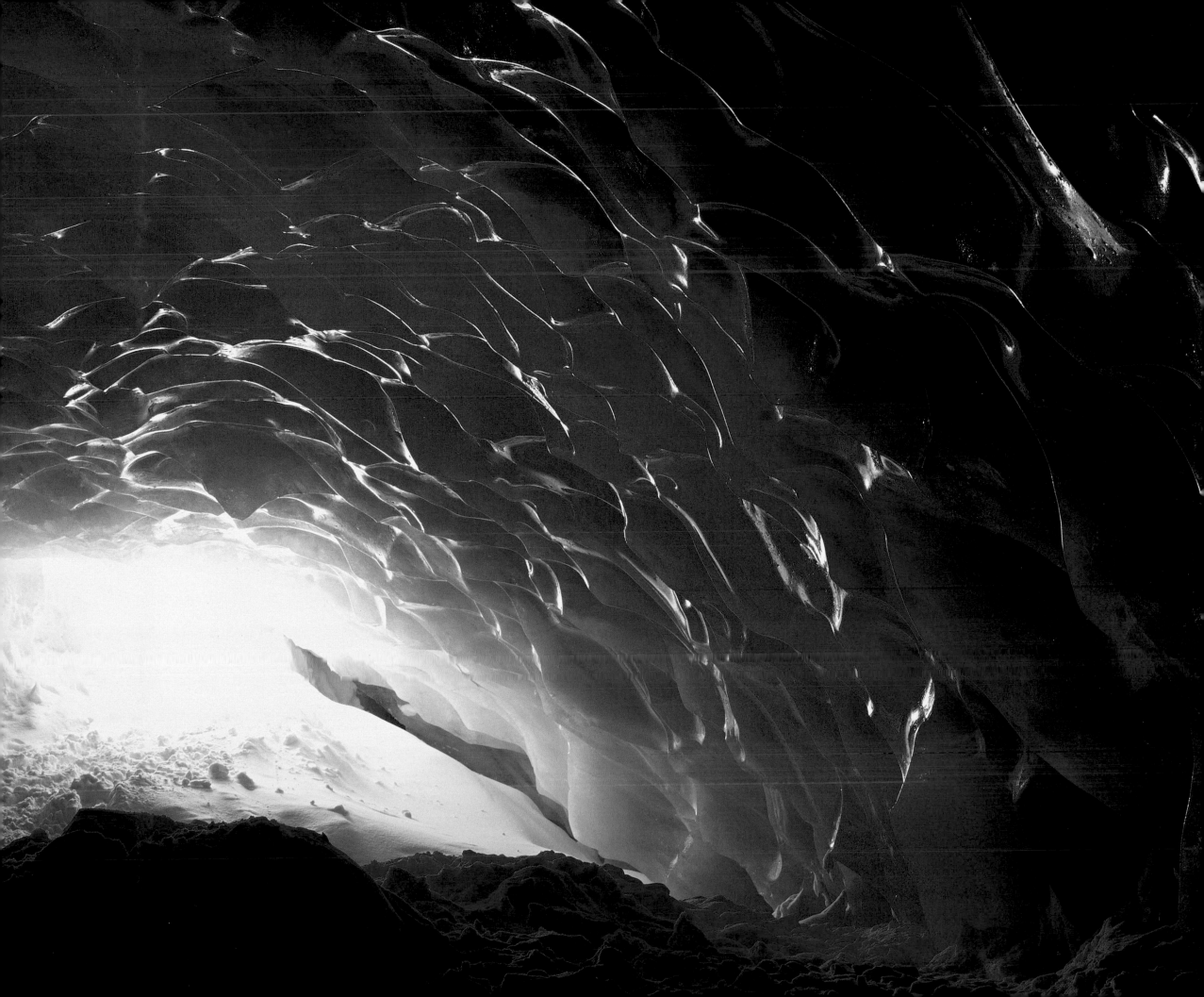

that this was simply because they had been saving themselves. Saving themselves to all go wrong at once. I had been fortunate enough to hitch a ride with a group of heli-hikers to Tamarack Ridge, and I decided to squeeze it in while Kristen was off on her own. It was a good thing.

My diary tells it all:

Day 1: Rain and wind so bad could not set up tripod.

Day 2: Shattered upper cuspid on chip of gravel embedded in giant smoked turkey leg. Henceforth could only suck on oatmeal in agony. Forgot toilet paper. Tore strips off T-shirt as substitute. Shirt will be reduced to tube top by trip's end. Night winds so bad must set up tripod in tent to keep it from collapsing in face.

Day 3: Out of booze. Fear of what helicopter crew would think stopped me from bringing portable wine cellar. Confined to tent by punishing weather, drink modest supplies quickly to kill boredom and tooth pain. Fantasize about making millions with country and western hit single "Out of Booze in the Bugaboos" but can't get past title.

Day 4: Set jacket and scarf on fire cooking oatmeal in tent. Actually set scarf on fire cooking oatmeal and set jacket on fire putting out scarf fire. With increasing tooth pain and slight delirium from being inappropriately sober, squander only brief interlude of reasonable light by not focussing panoramic camera. Will have to use backup shot on smaller camera.

Day 5: Fly out as weather turns glorious.

Tooth pulled two days later in Vancouver.

Hope this satisfies Mr. Murphy for a long, long time.

It seemed to. Not long after, we made a sweep of the sun-soaked Okanagan Valley. It was getting near the end of Kristen's stay and I wanted to give her a taste of our driest region so she wouldn't go home thinking BC was entirely wet, cold or both.

Although the world has its share of dry Epsom salt lakebeds, none is quite like Spotted Lake, near Osoyoos. Dozens of lakes in the same area, some only a stone's throw away, are normal. How Spotted Lake came to be what it is and why, as it evaporates, it divides itself into hundreds of irregular ponds of varying salinity so that it comes to look like a cross-section of a giant lava lamp, is a limnological mystery. Luckily, on that clear September day, appreciating its beauty did not require scientific understanding. Kristen frolicked barefoot in the mineral mud, keeping that ideal distance where she was close enough to be admirable but far enough away to be harmless. And I allowed

myself to believe that the thousands of years of unique geological activity that produced this one-of-a-kind miracle did it all for me, my camera and this one perfect moment.

I could go on talking about the adventures I had shooting this book until there was no room for pictures, but I am sorely aware my writing skills fall short of my photographic ones, so I will shut up now. I guess I should just add that I tried to look at a complete spectrum of what British Columbia has to offer, from the remote and exotic to the common roadside attraction. I didn't try to document the province in the sense of making sure I got every important landmark. If I found myself in front of one of those, I ran in the opposite direction, or at least tried to show it in a way you'd hardly recognize it. At the same time, I tried to go to as many major regions as possible and find images that communicate the special genius of that locale. I know this is almost impossible in a province as endlessly faceted as British Columbia, but I gave it my best shot.

Kristen eventually returned to her curatorial duties in faraway Berlin and I returned to my solitary scenery hunting, feeling a strange combination of separation anxiety and relief. I had been fearing a return of the lonesome blues, but for the time being Kristen seemed to have cured me. I was back to thinking Mother Nature is a demanding enough mistress without having other complications to contend with. But no sooner did this lesson become clear than I recognized it from previous cycles of solitude and company, a pattern I've repeated so often I should probably chart it and label it "Dave's Dilemma."

I do sense something different this time around though. I've often tried to convince myself that I should be able to draw all the companionship I need on my travels from the people who end up seeing my pictures, but publishing mainly through agencies I seldom even know where my images appear, so it is as hard for me to develop a feeling for my audience as it is for them to develop one for me. Creating this book has been a very different experience. I have formed a very definite impression of who will be reading it, and for my part I feel very revealed to them. Now when the northern lights dazzle me, when the rising moon silhouettes two eagles in a tree, or when I come upon a cluster of wildflowers with a backdrop of mountain peaks, I feel as if I have you all with me, looking over my shoulder and through my viewfinder.

My warmest wish is that in reading this book, you will feel the same way.

Previous pages: Ice cave, Appa Glacier, Pemberton Icefield

This was surely the oddest place I've spent the night. Peering into the frozen walls of our ice hotel, I was intrigued by the thought that I was looking at ice which had fallen as snow eons ago and had been saving itself ever since—so that I could warm myself with Scotch on the 90,000-year-old rocks.

Bugaboos, southeastern BC

Dave Cochrane of Canadian Mountain Holidays was nice enough to allow me to hitch a ride with a group of heli-hikers to this ridge in the heart of the Bugaboo spires.

Following pages: Spotted Lake, southern Okanagan

Spotted Lake, or "Kliluk" as the local Natives call it, is a truly unique lakebed near Osoyoos. Why it divides itself into hundreds of irregular ponds of varying salinity as it evaporates is a geological mystery.

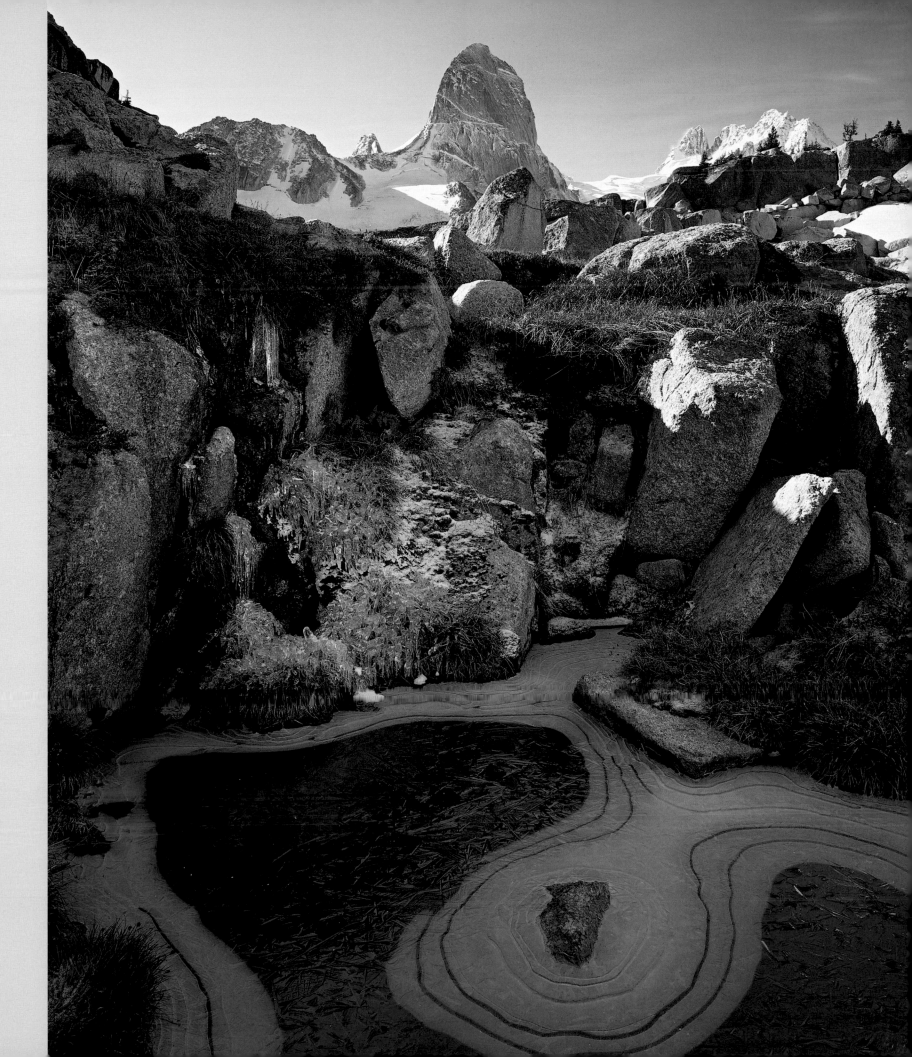

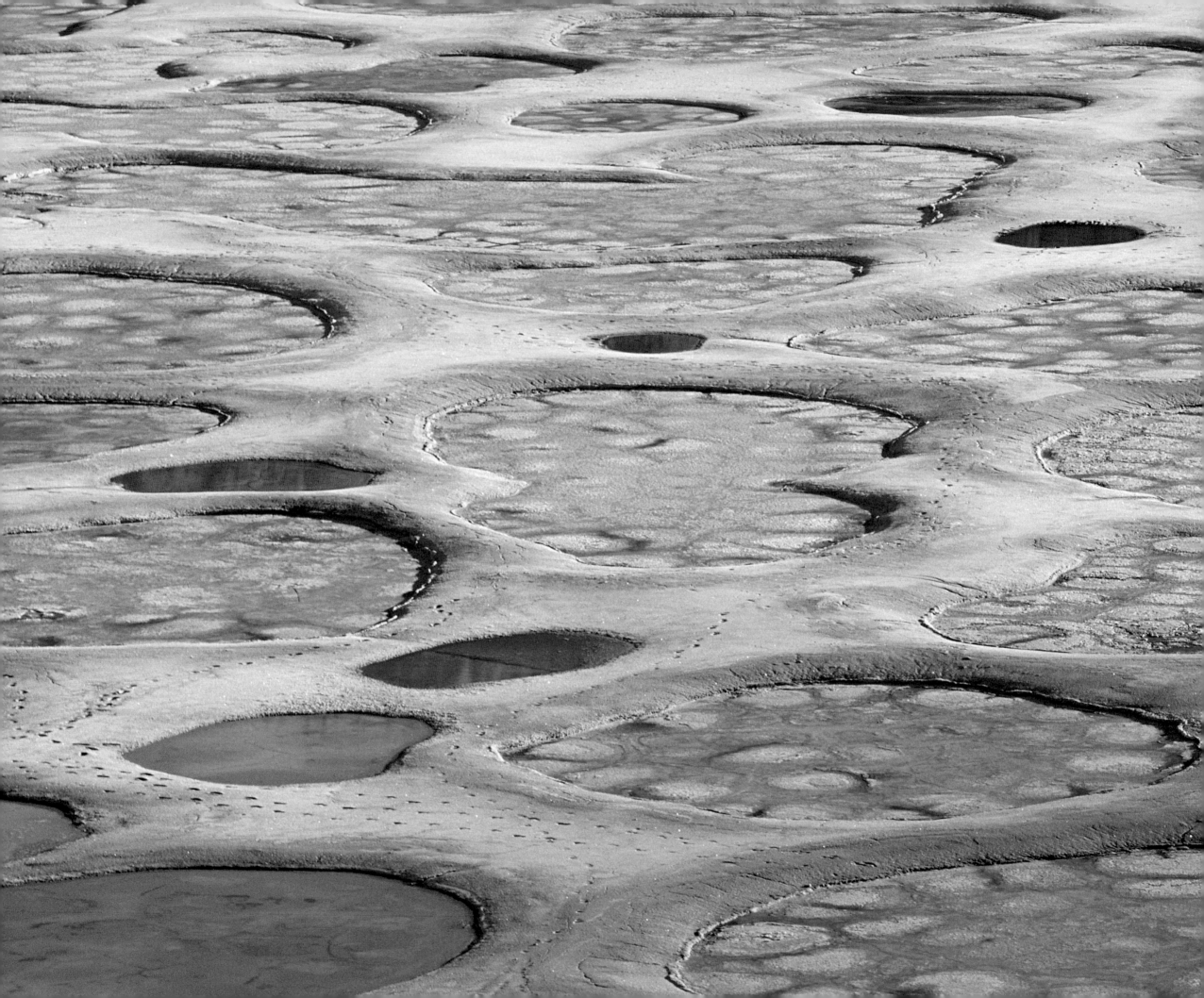

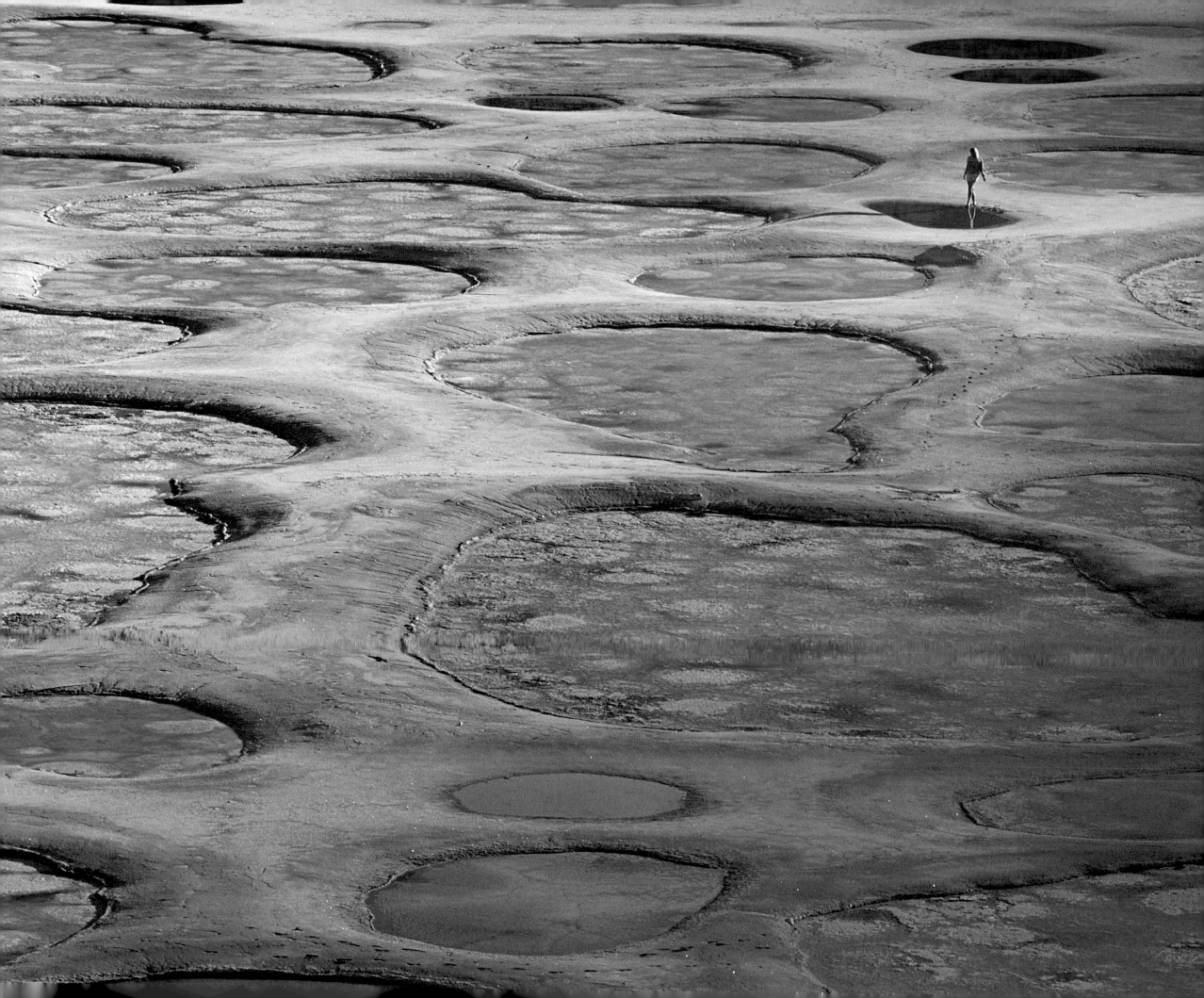

South Coast

Hot ice glows in the sunset over Siwash Rock,
Stanley Park seawall

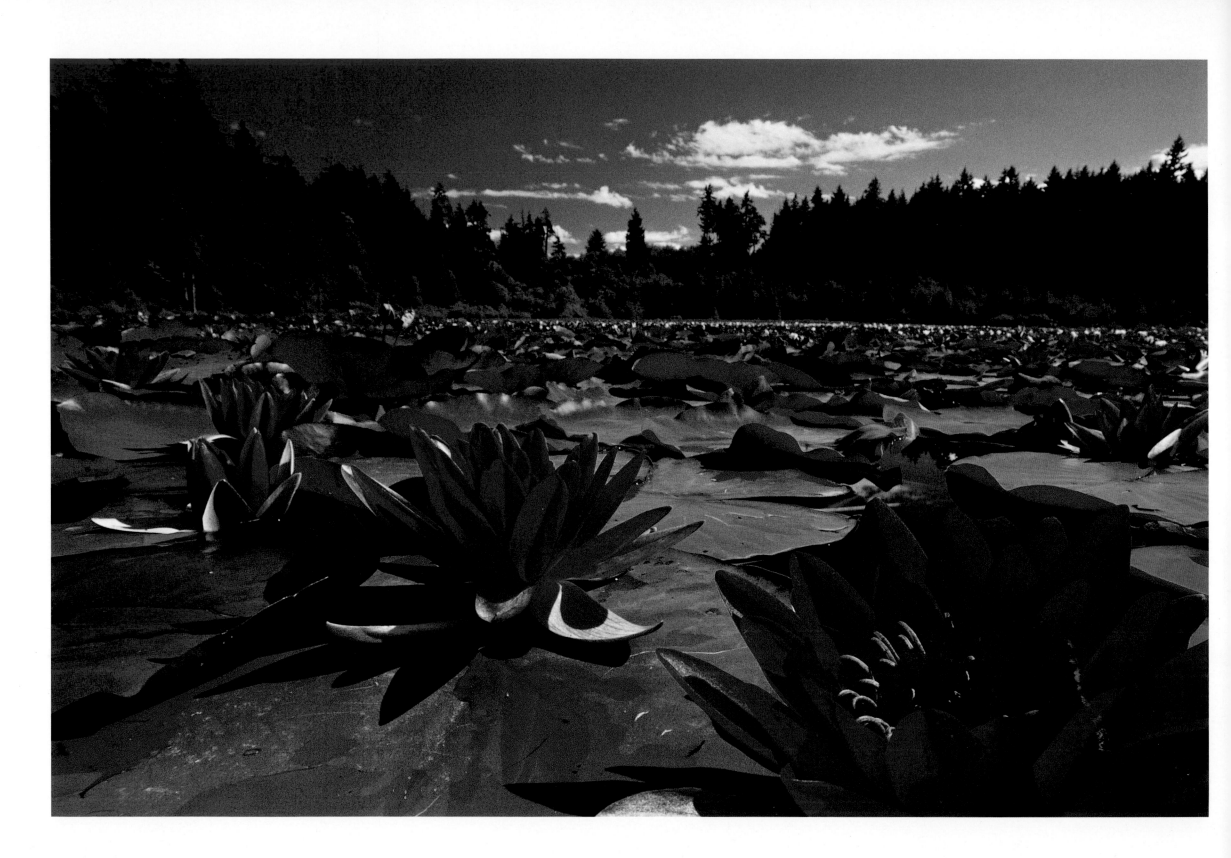

Beaver Lake, Stanley Park

I didn't have to drive into the wilderness to get this shot;

it's right in the heart of Vancouver.

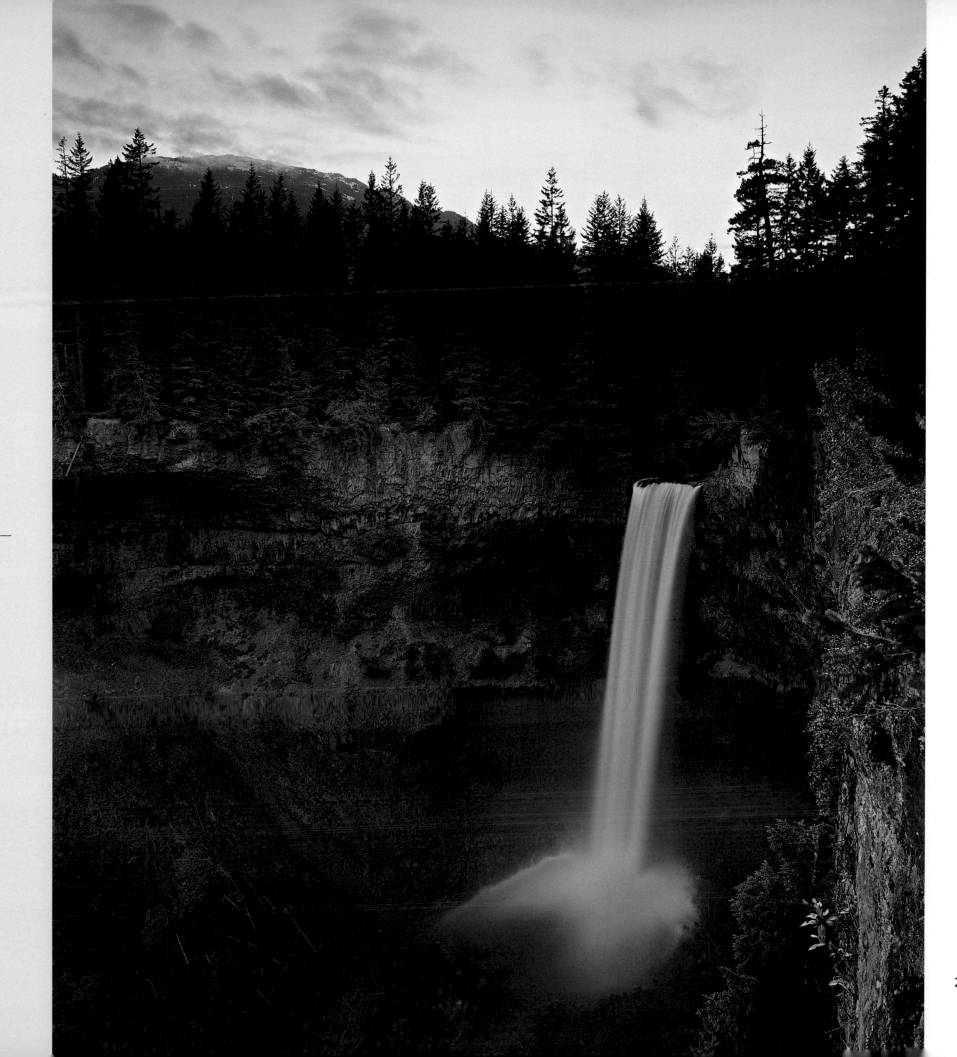

Brandywine Falls near Whistler

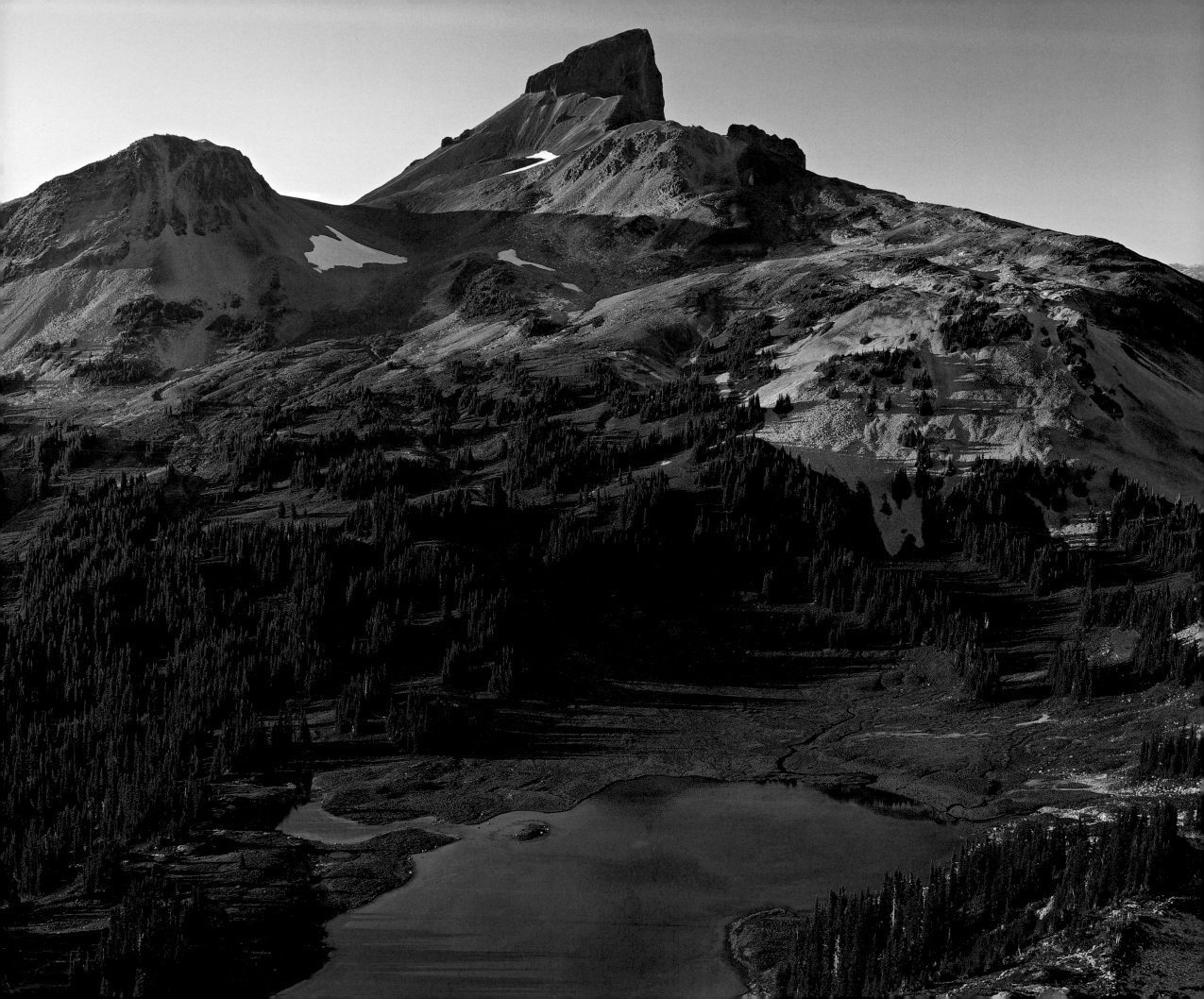

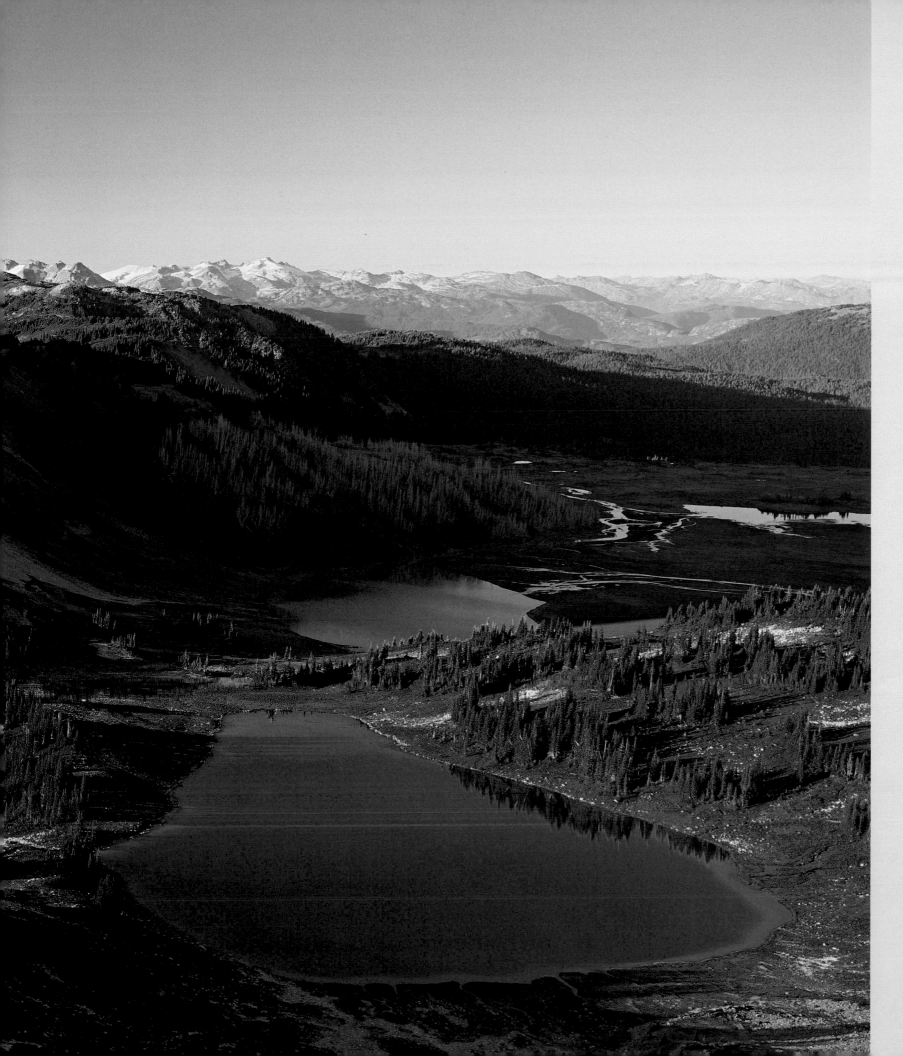

Black Tusk, Garibaldi Provincial Park

The scene facing north from Panorama Ridge.

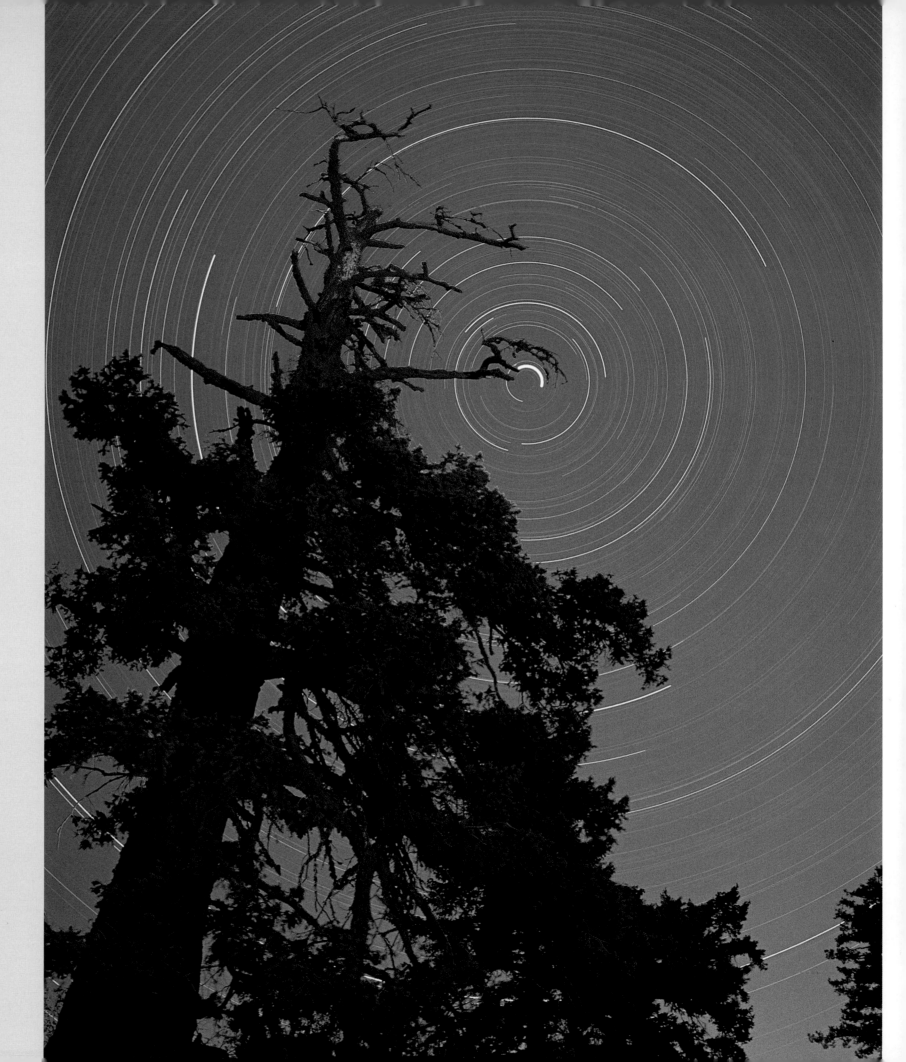

Old Douglas fir and North Star, southern Okanagan

Time exposures of the North Star are very enlightening. They help convince me that I am on a giant ball spinning through space and time.

Opposite: Sun over the White Rock Pier

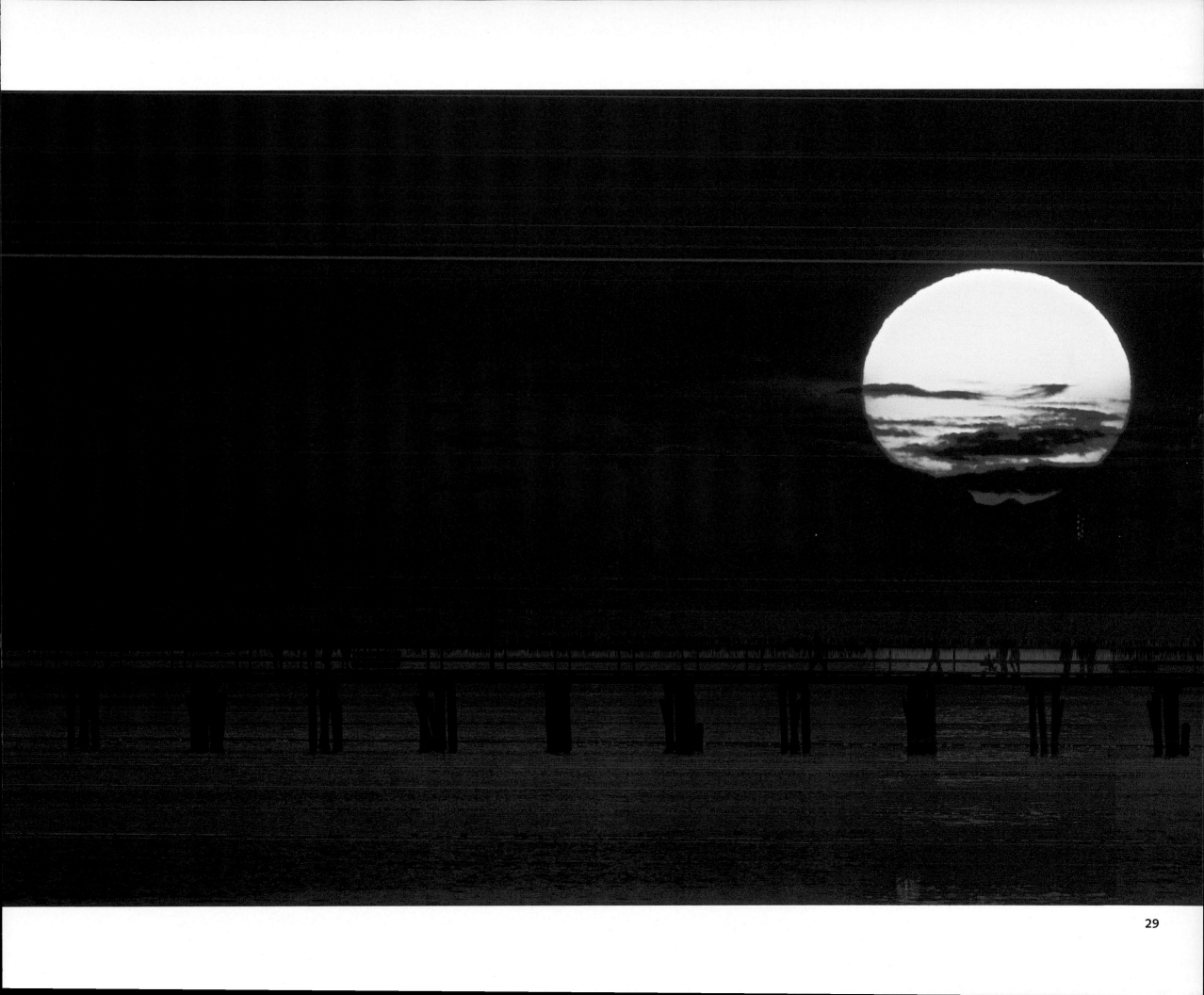

Islet near Gabriola Island

While kayaking around Gabriola Island, we made landfall on a tiny, nameless islet sculpted from the same kind of bubbly eroded sandstone of which the whole area seems to be made. A cluster of pencil cedar trees adorned the high ground, each one looking like a runaway from the bonsai collection of the Royal Botanical Society.

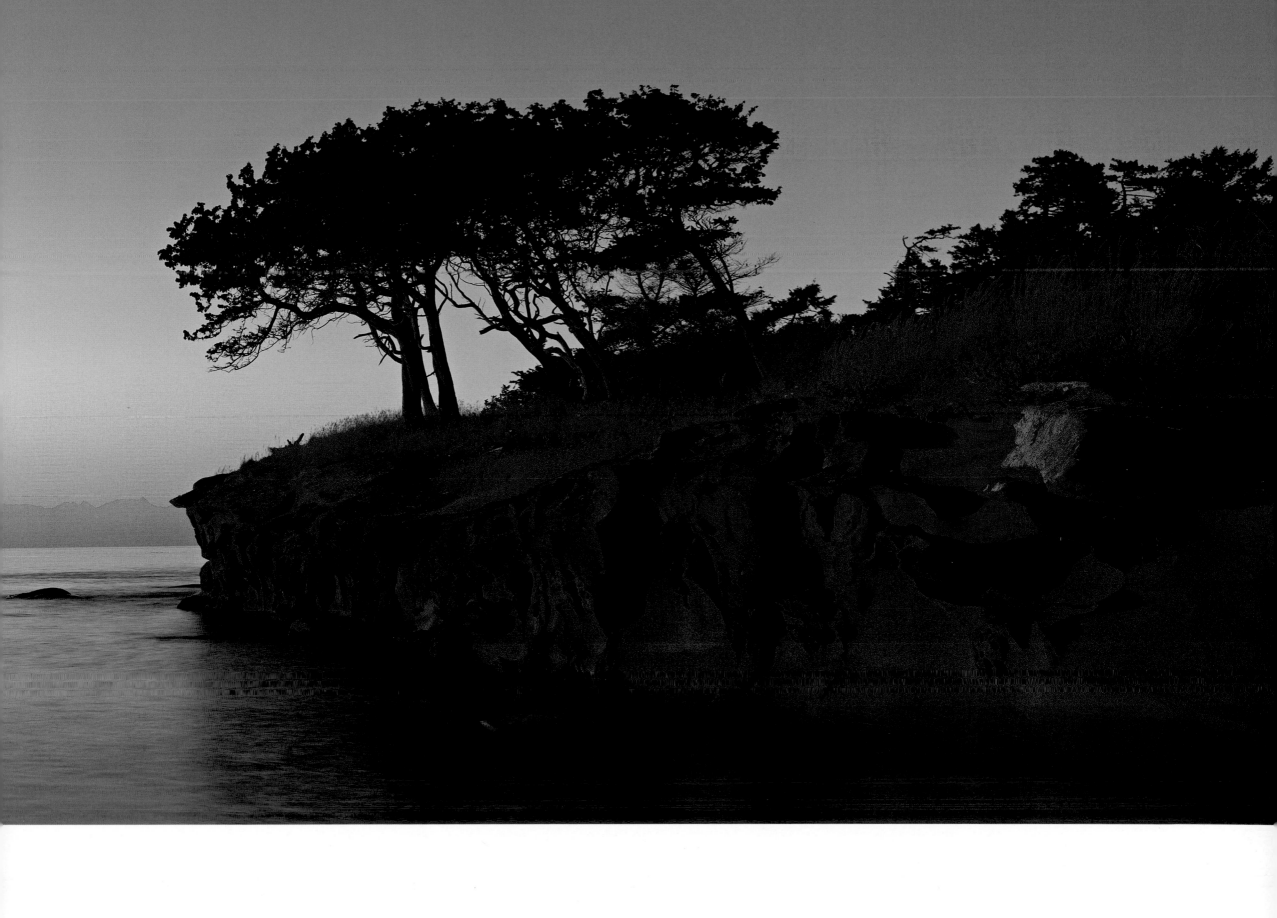

Arbutus tree

The bronze-skinned arbutus tree is emblematic of the South Coast landscape.

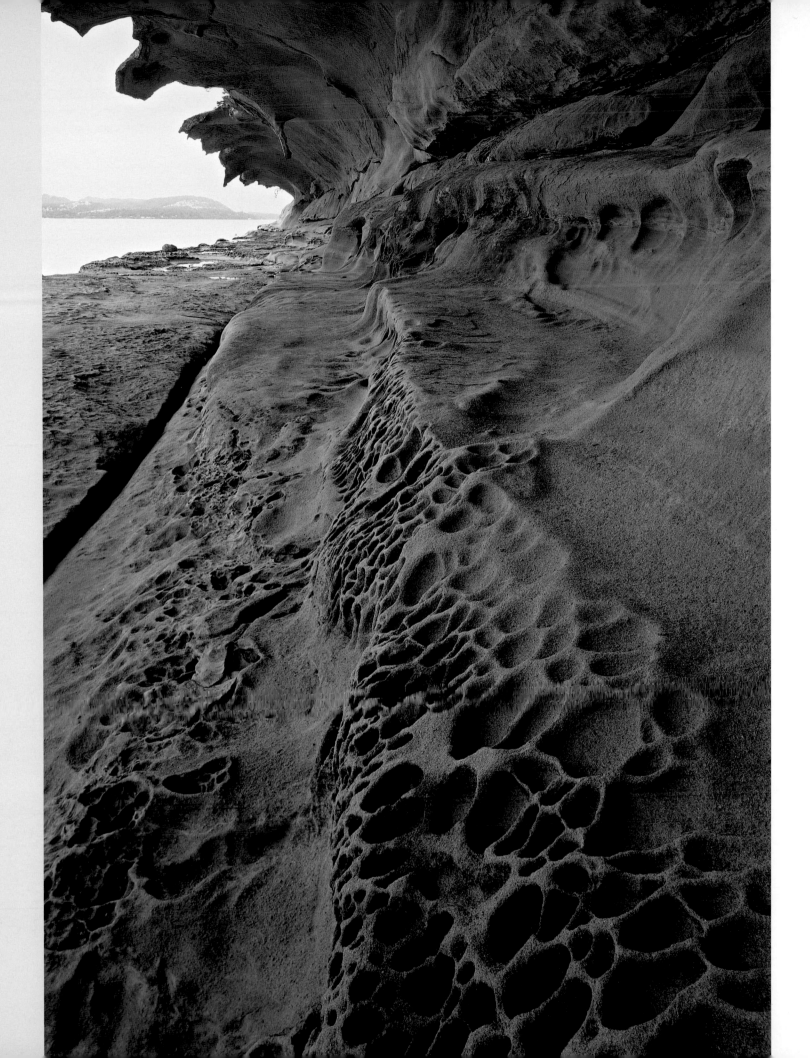

Malaspina Galleries, Gabriola Island

Like a surfer's dream solidified, this wave of sandstone has been cresting over amazed Gabriola sightseers since the Italian explorer Alejandro Malaspina first recorded it in 1791.

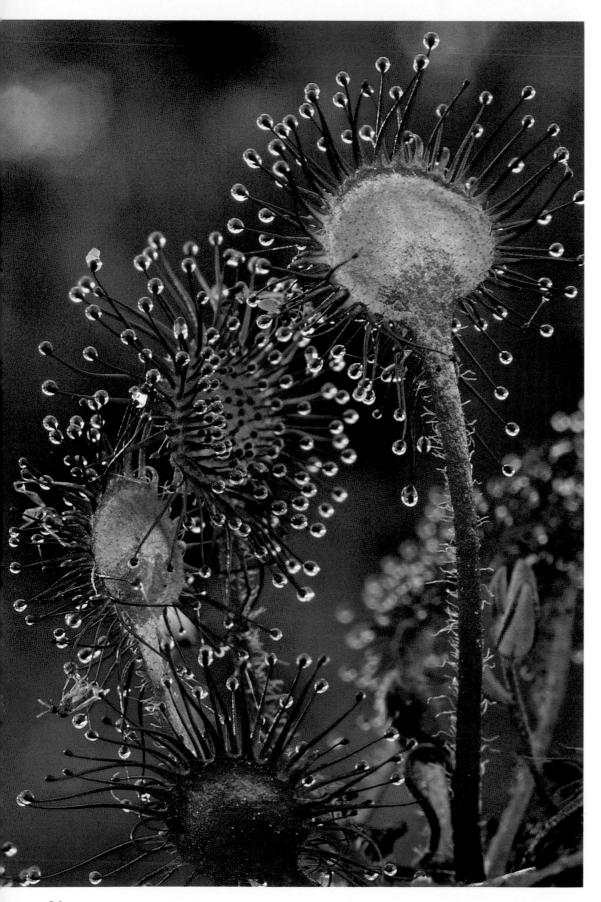

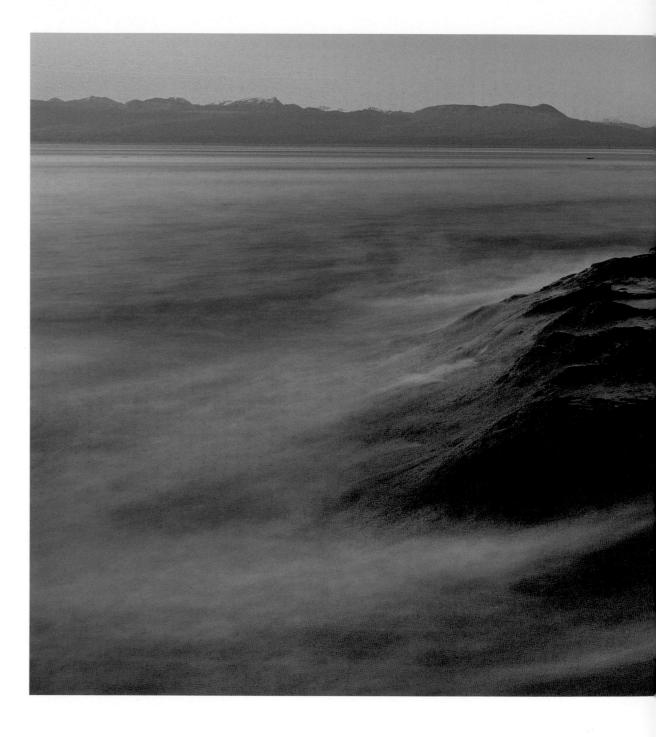

Left: Round-leaved sundew

Only an inch or two in height, these bog-dwelling carnivores supplement their diet by trapping insects in their sticky tentacles.

Above: Sandstone, Gabriola Island

Entrance Island Lighthouse appears in the distance.

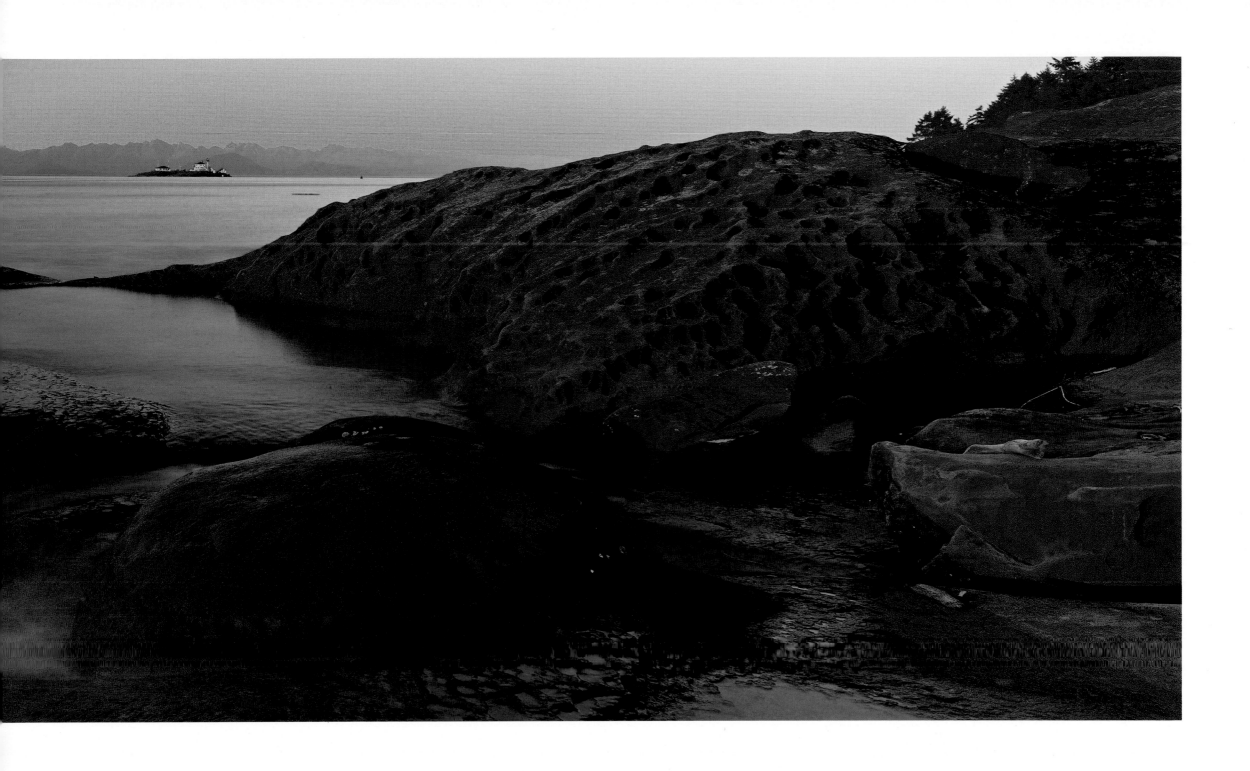

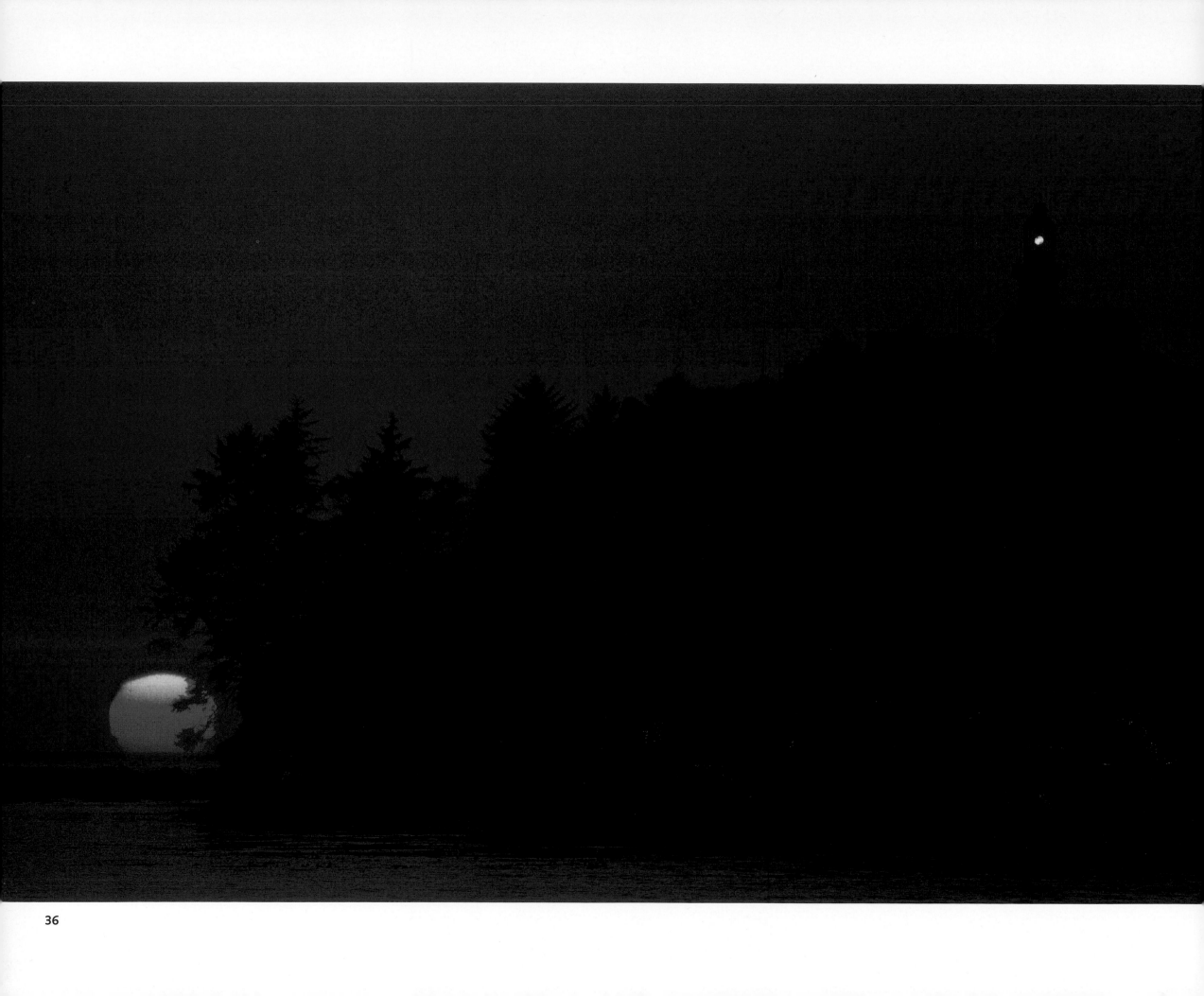

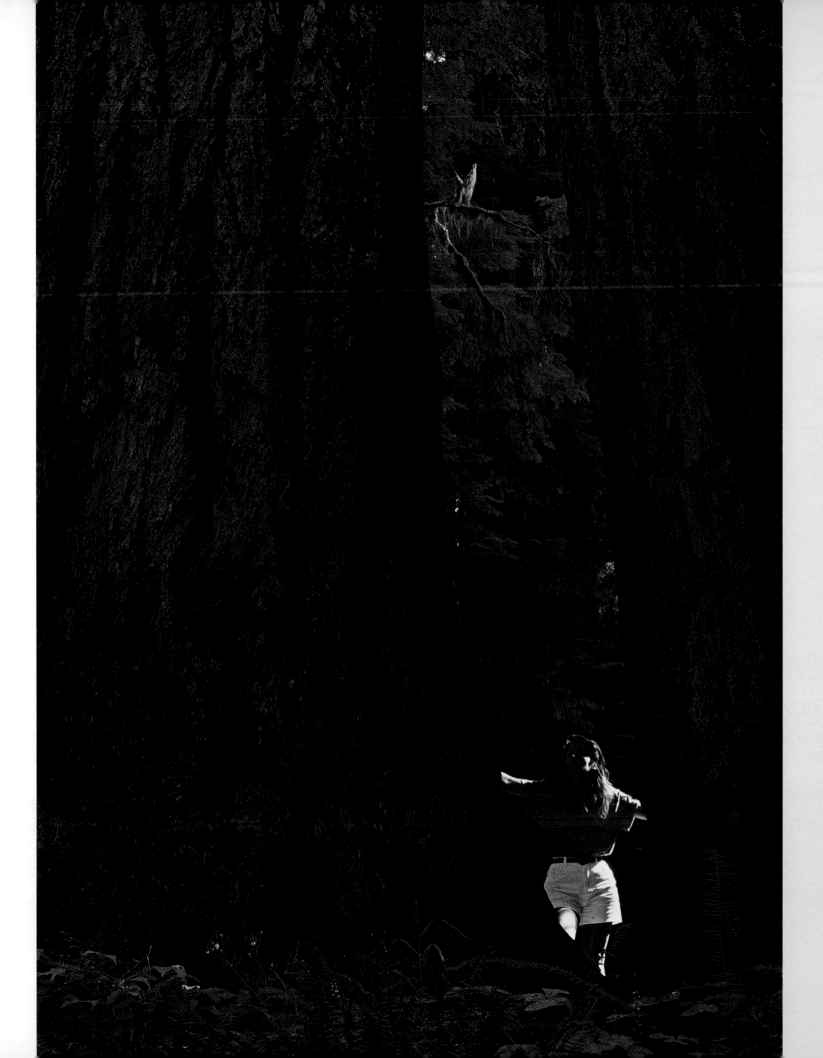

Opposite: Sunset over Carmanah Point
Lighthouse on Vancouver Island's west coast

Cathedral Grove, Vancouver Island

Following pages: Chesterman Beach, Pacific
Rim National Park

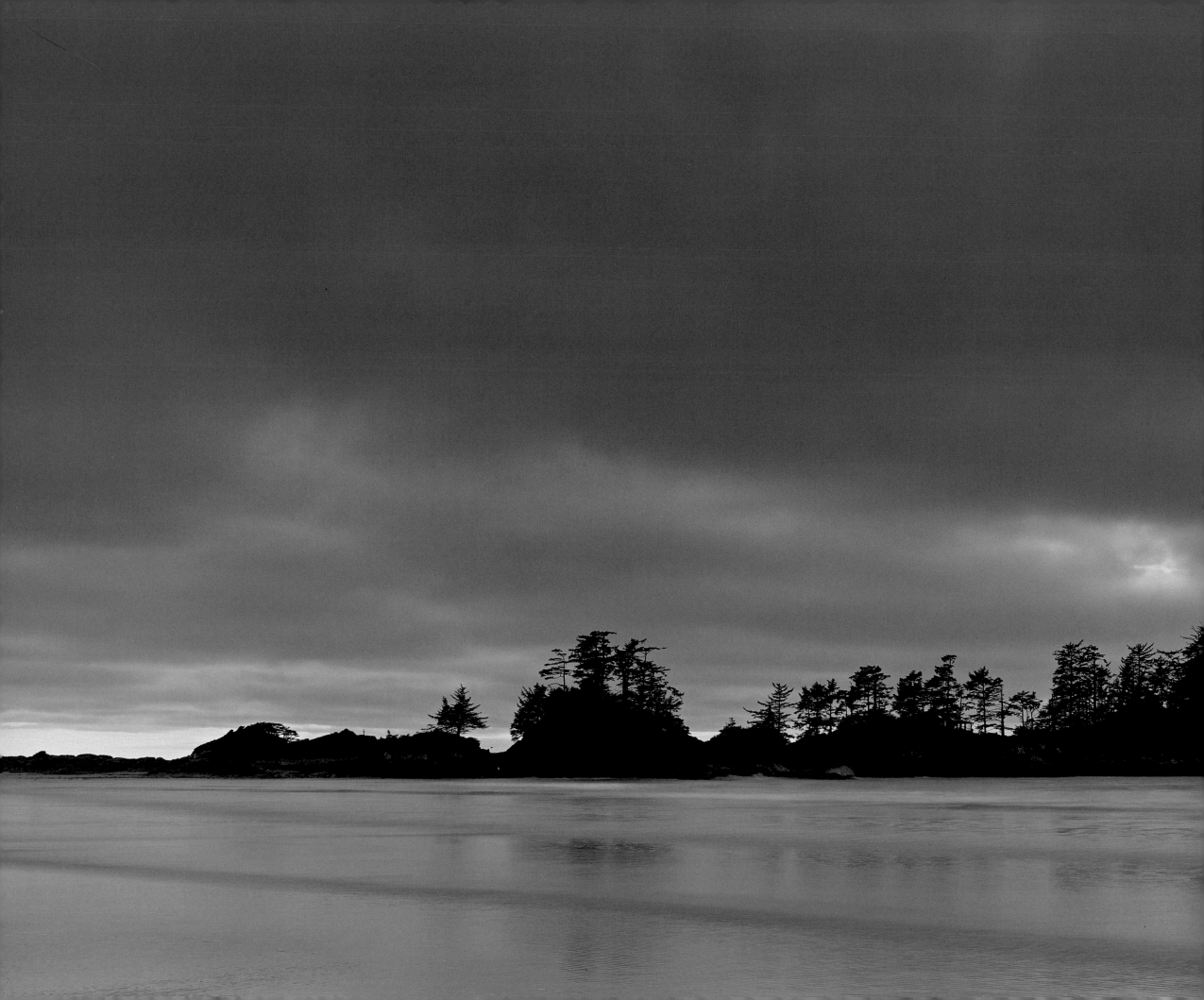

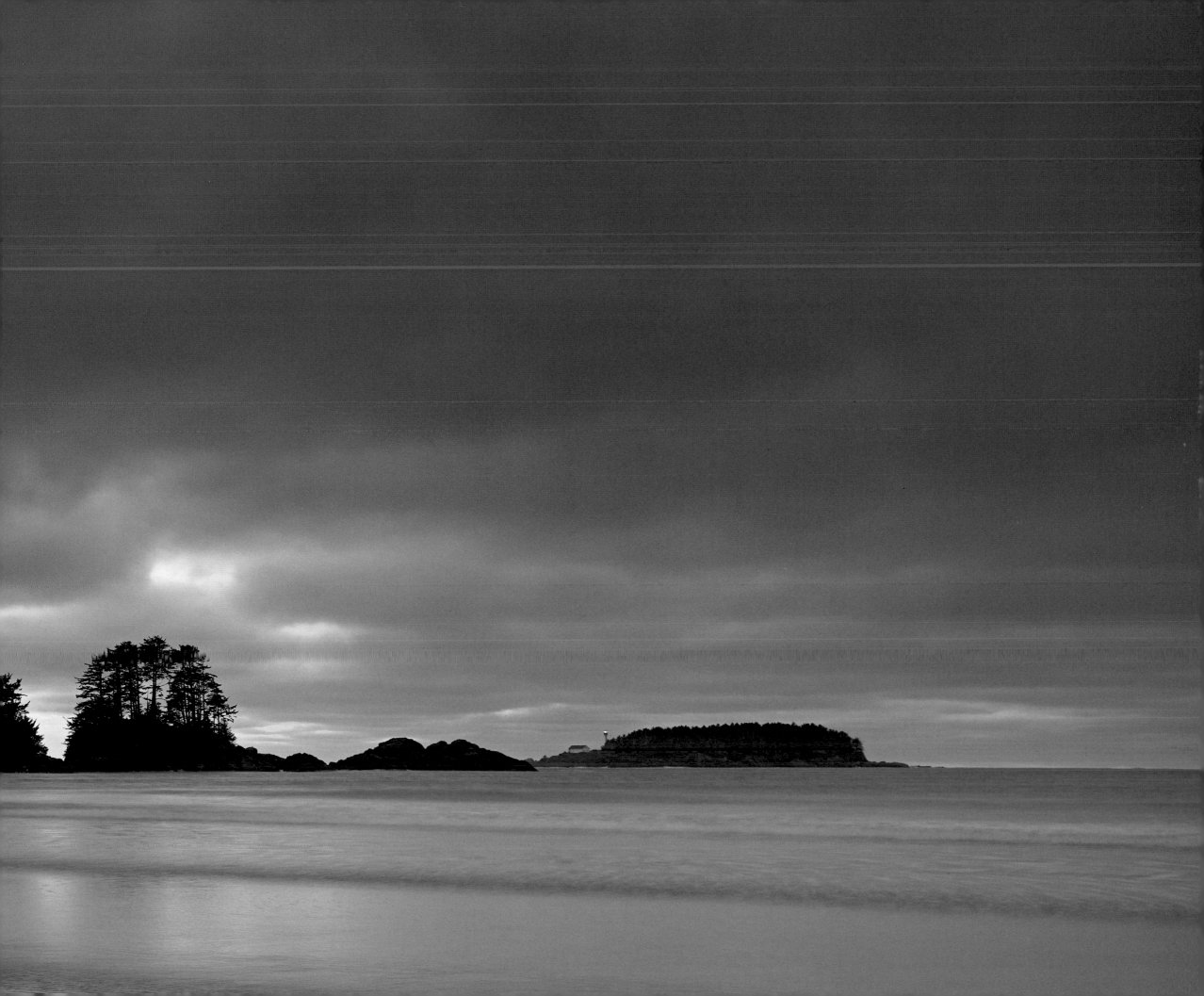

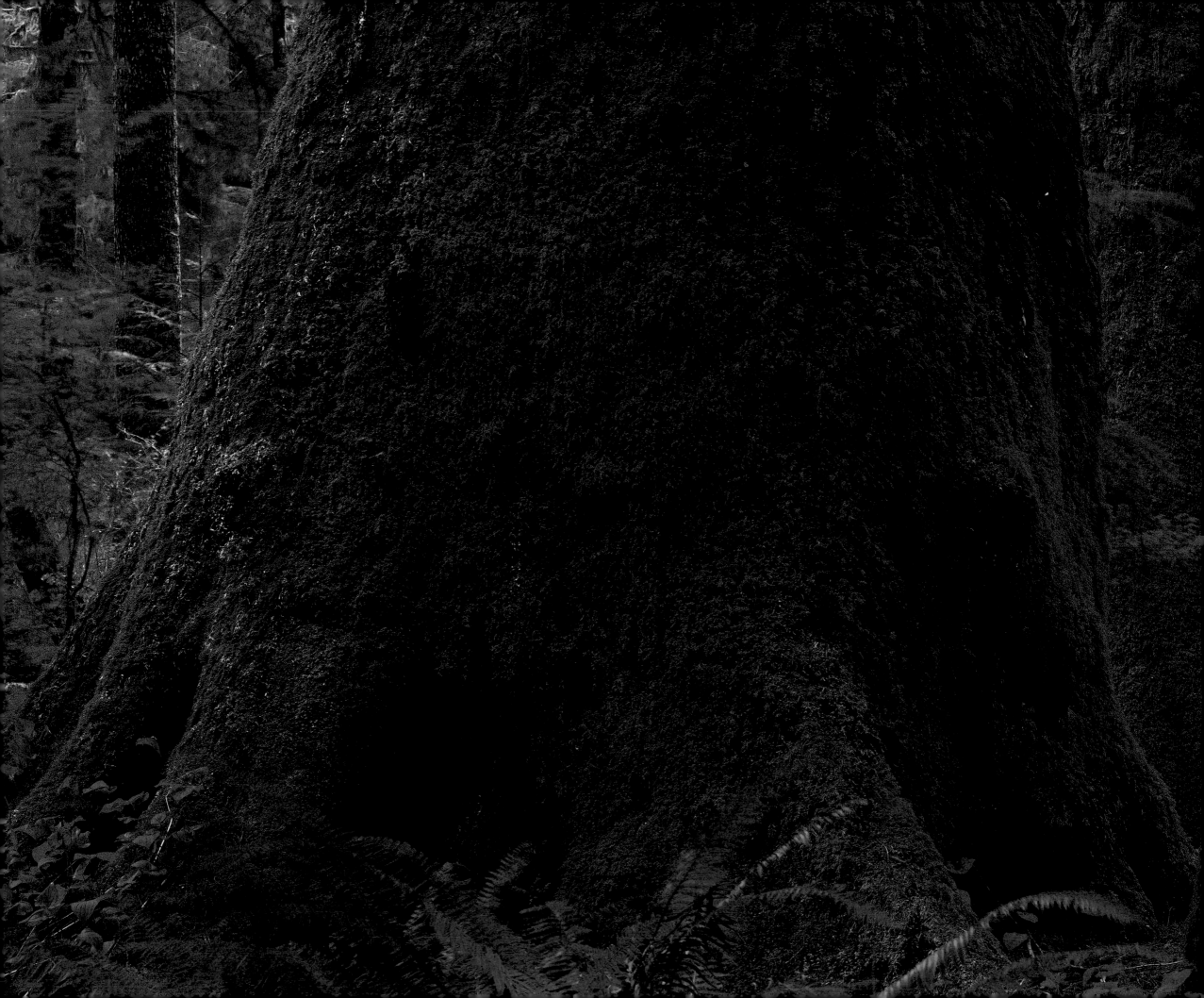

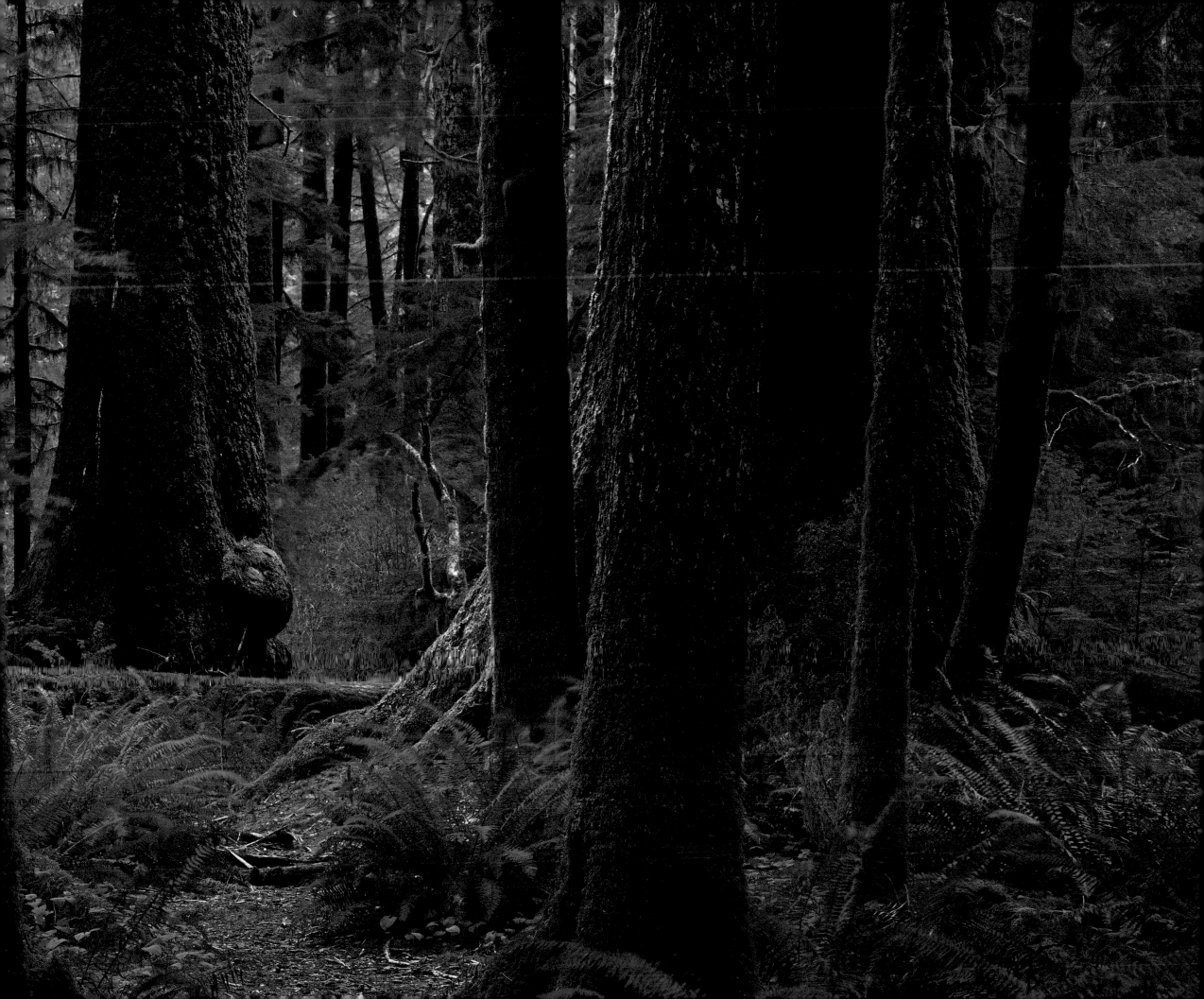

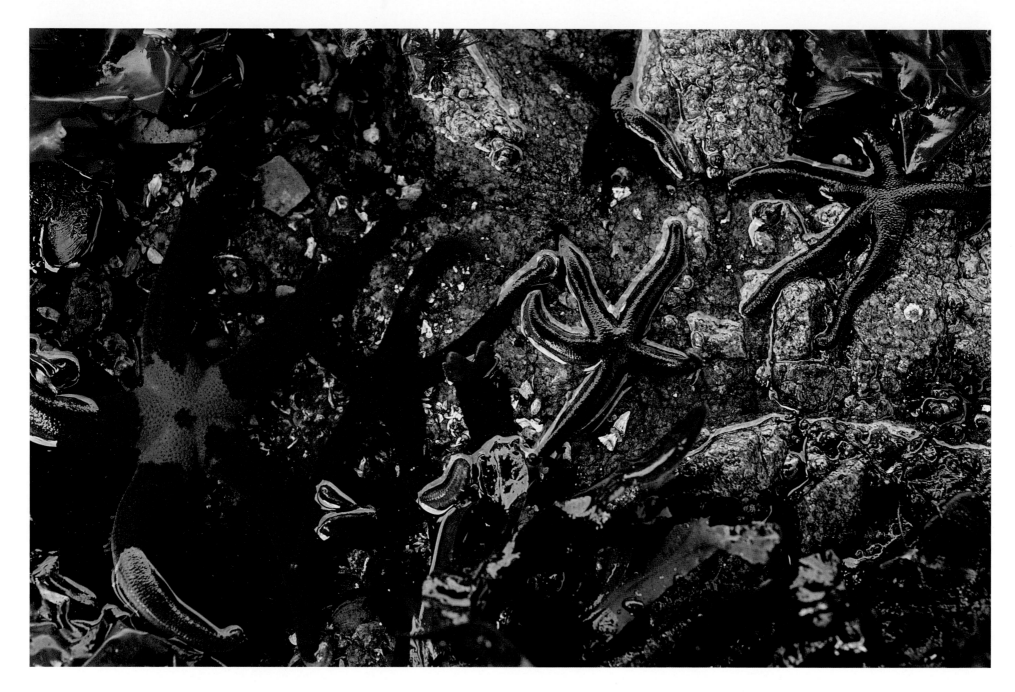

Preceding pages: Heaven Grove, Carmanah Walbran Provincial Park

Folklore tells us that where one tree grows greater than the rest, that is where a bear died. No sooner am I convinced I found "The Bear Tree" than I find another, and another. Perhaps Carmanah is the secret graveyard of the bears.

Above: Blood stars, Pacific Rim National Park

Opposite: Hikers, West Coast Trail

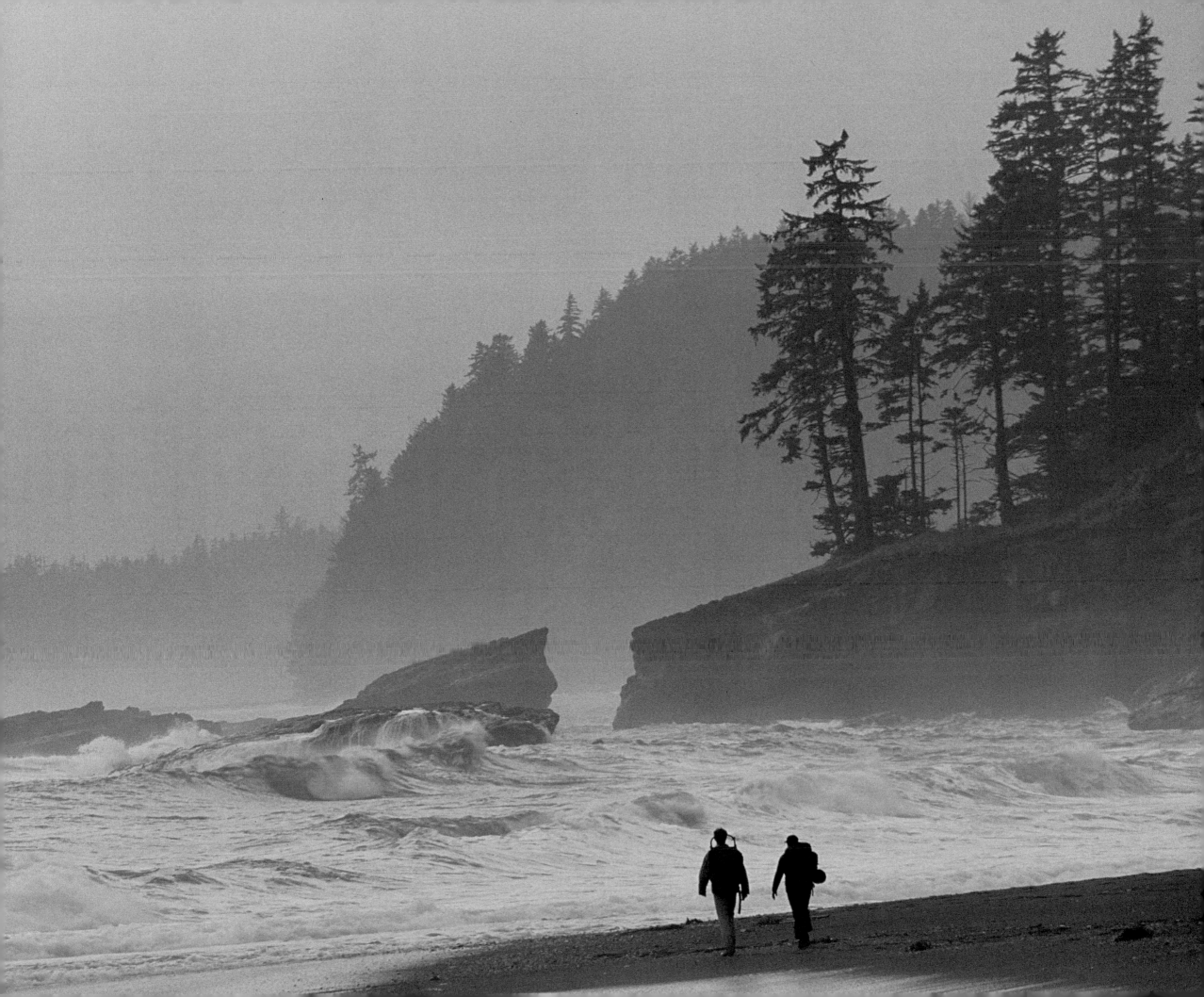

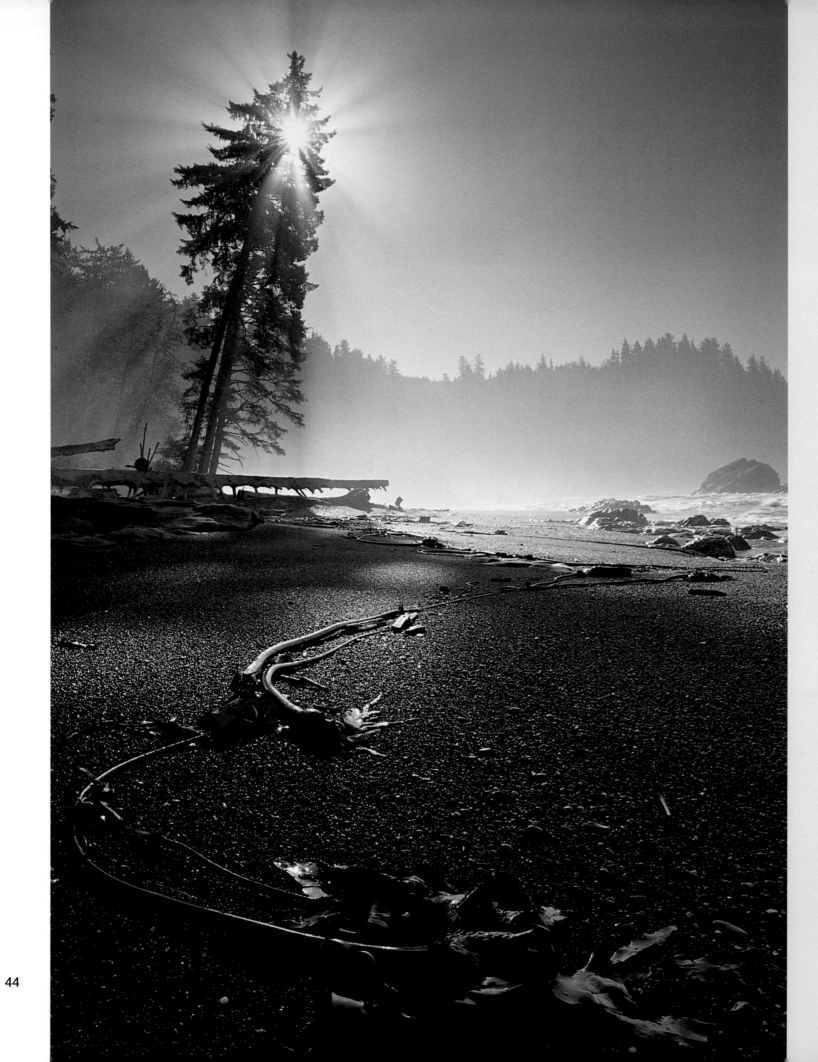

Dawn over the Juan de Fuca Marine Trail, Vancouver Island

The kind of light I'm always looking for.

Opposite: Tantalus Range Provincial Park

The star trail demonstrates the ability of the camera to collect light over time. I went to bed that night after leaving the lantern on for only 15 minutes and got up before dawn to close the shutter before the first hint of morning could overexpose the frame.

44

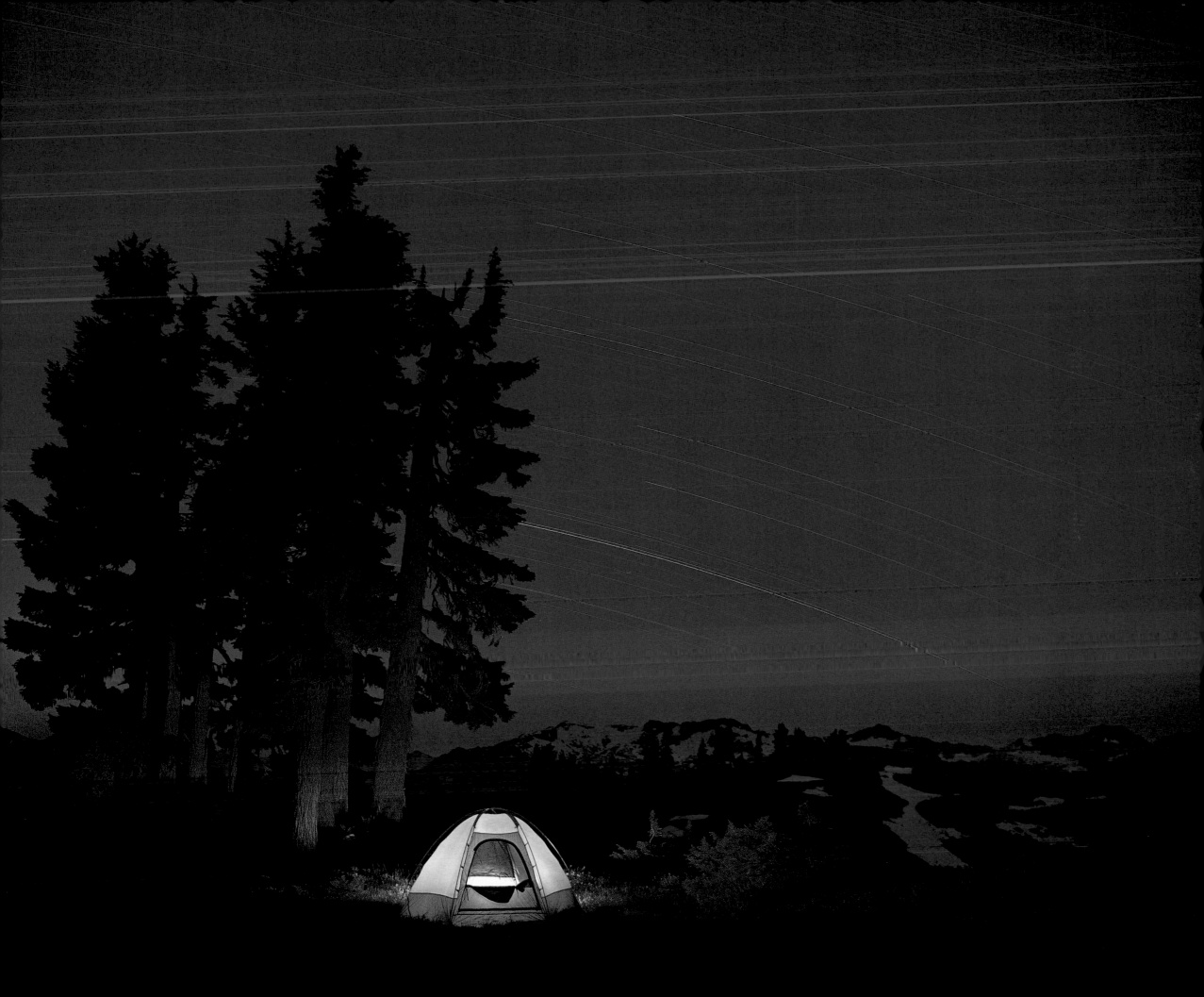

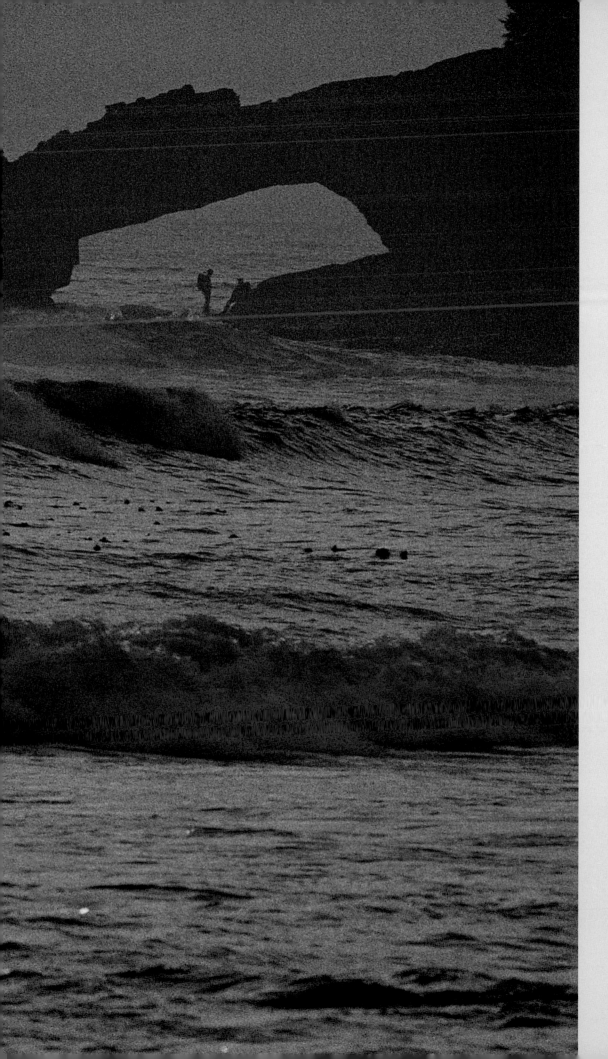

Stone arch, Tsusiat Point, West Coast Trail

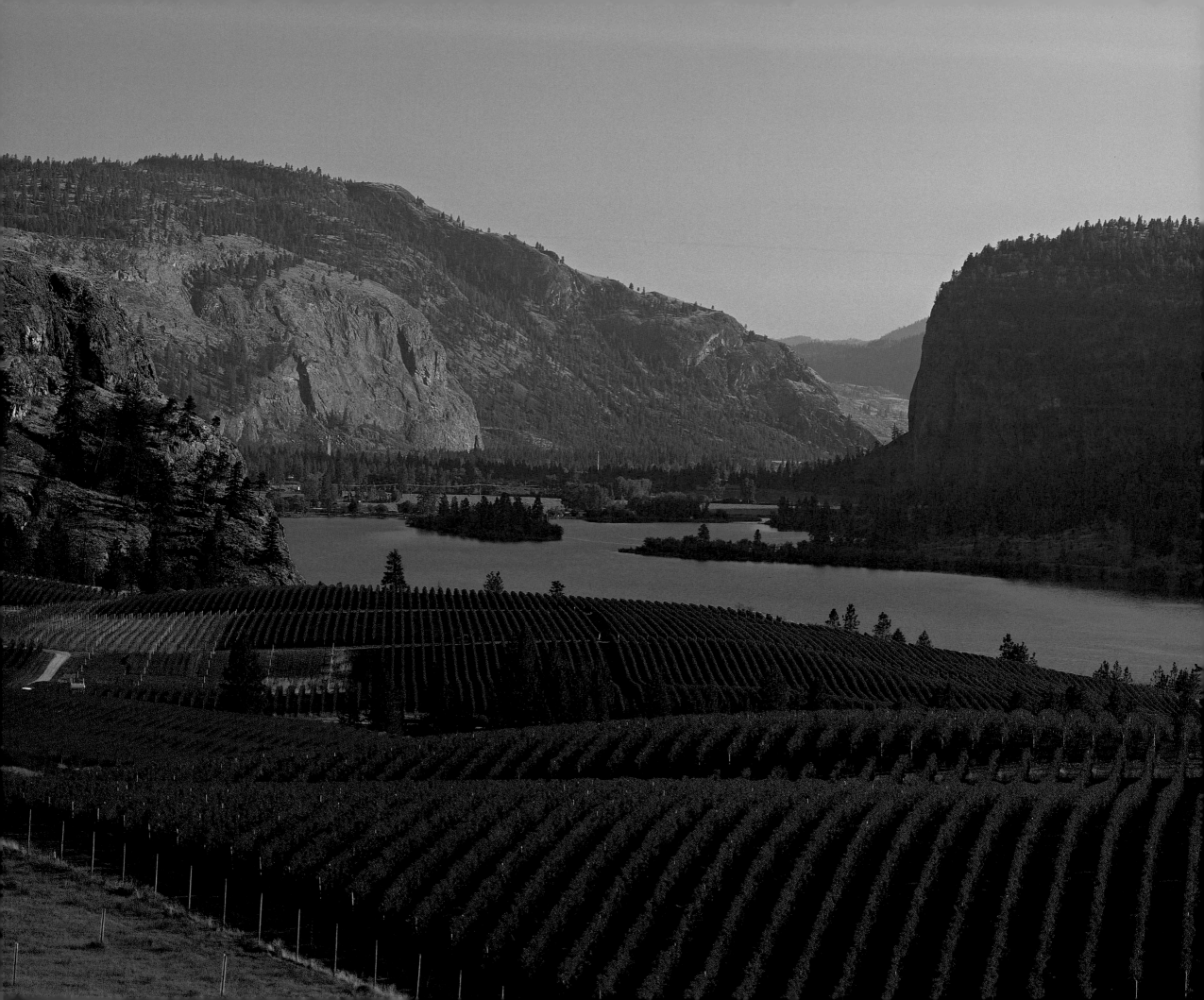

Southern Interior

Blue Mountain Vineyard

The southern Okanagan landscape has witnessed a welcome increase in the amount of acreage devoted to vineyards over the last 20 years. Blue Mountain, near the town of Okanagan Falls, makes an impressive Pinot Noir that tastes even better when you stroll the vineyard with a glass in one hand and a camera in the other.

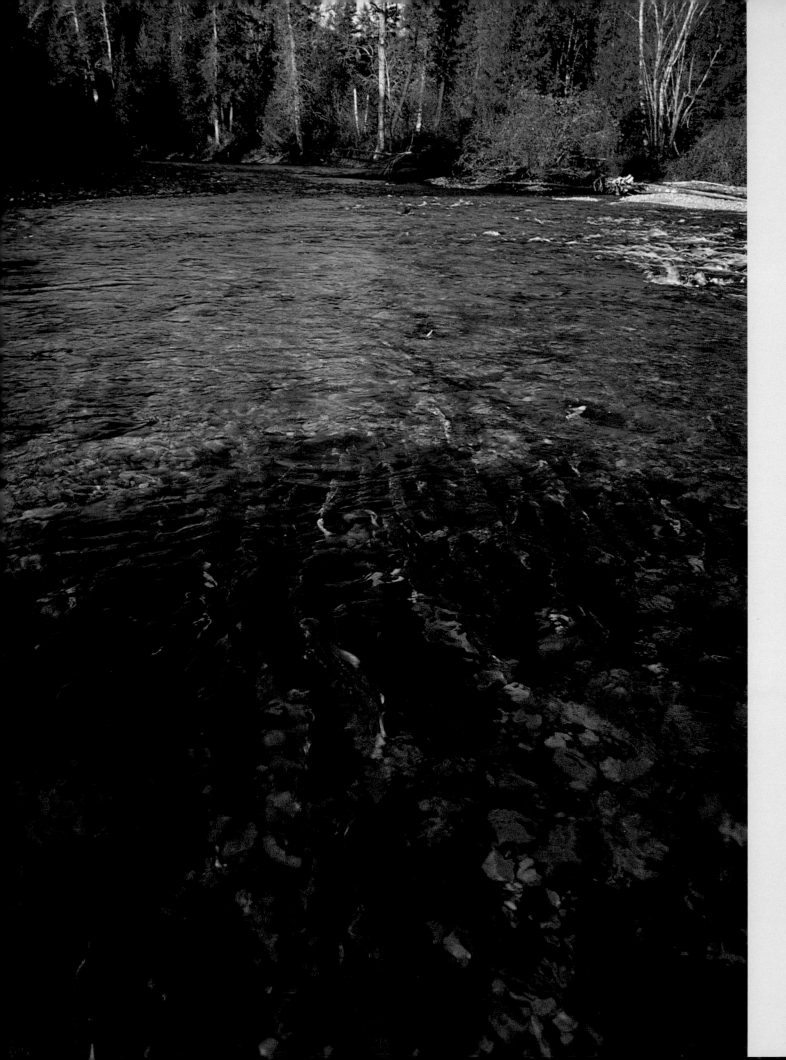

Adams River

Each fall, a natural reproductive marathon plays out in the rivers and lakes of the Adams system near Kamloops. In a good year, a million or so fish return. 2002 saw the return of over 3.5 million, making it the biggest run since record-keeping began.

Opposite: Falkland Hoodoo, Pillar Lake

The lone Falkland Hoodoo has a solitary look that makes you want to know its story. It goes like this: a Native girl became enamoured with a spirit that lived in Pillar Lake and joined him below the waterline. This brought grief to her parents, so the spirit built the hoodoo as a monument to his love and promised them that if ever he were to make their daughter unhappy, the pillar's stone cap would topple to the ground.

Following pages: Pumpkin stand

The produce from the abundant farmland of the Similkameen Valley near Keremeos is on roadside display during the summer and fall. There seems to be a kind of competitive one-upmanship among the displays, each owner trying to make his stand look like a more plentiful horn of plenty than his neighbour's.

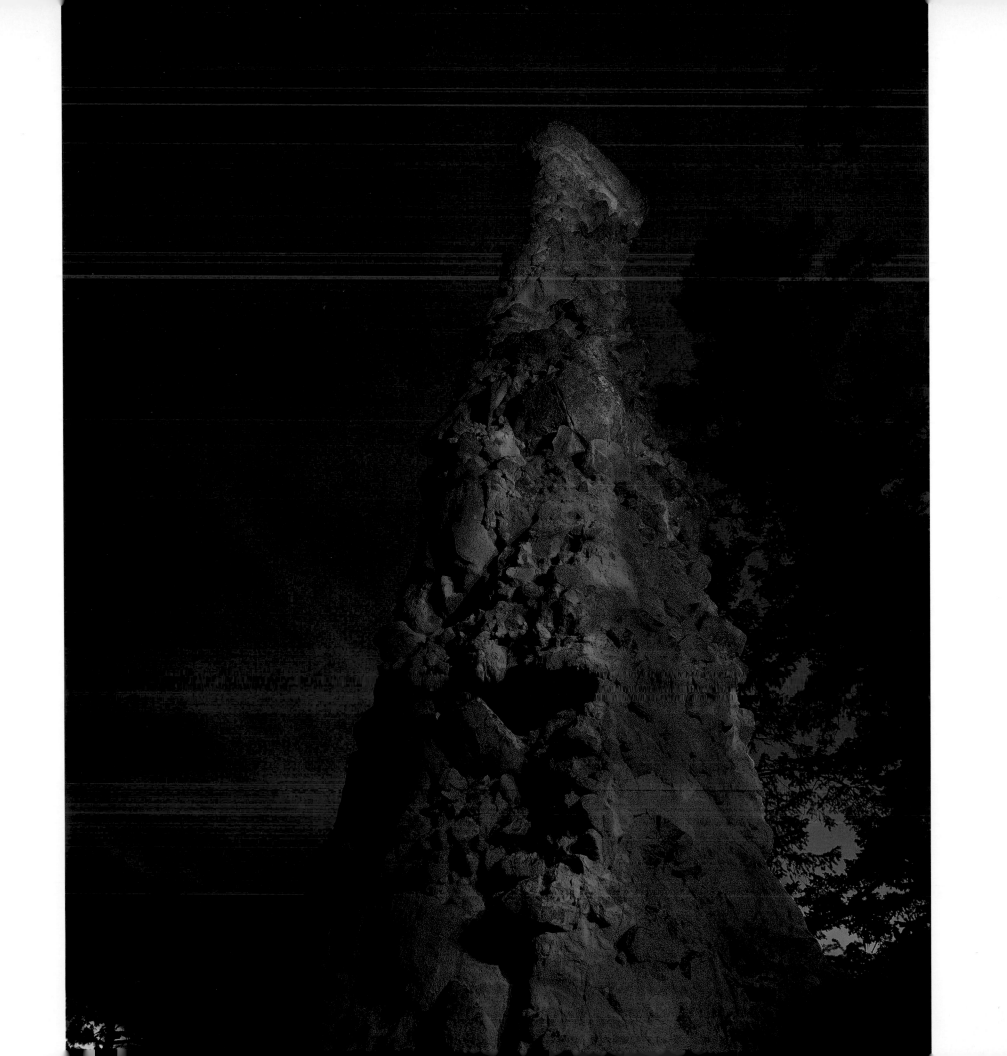

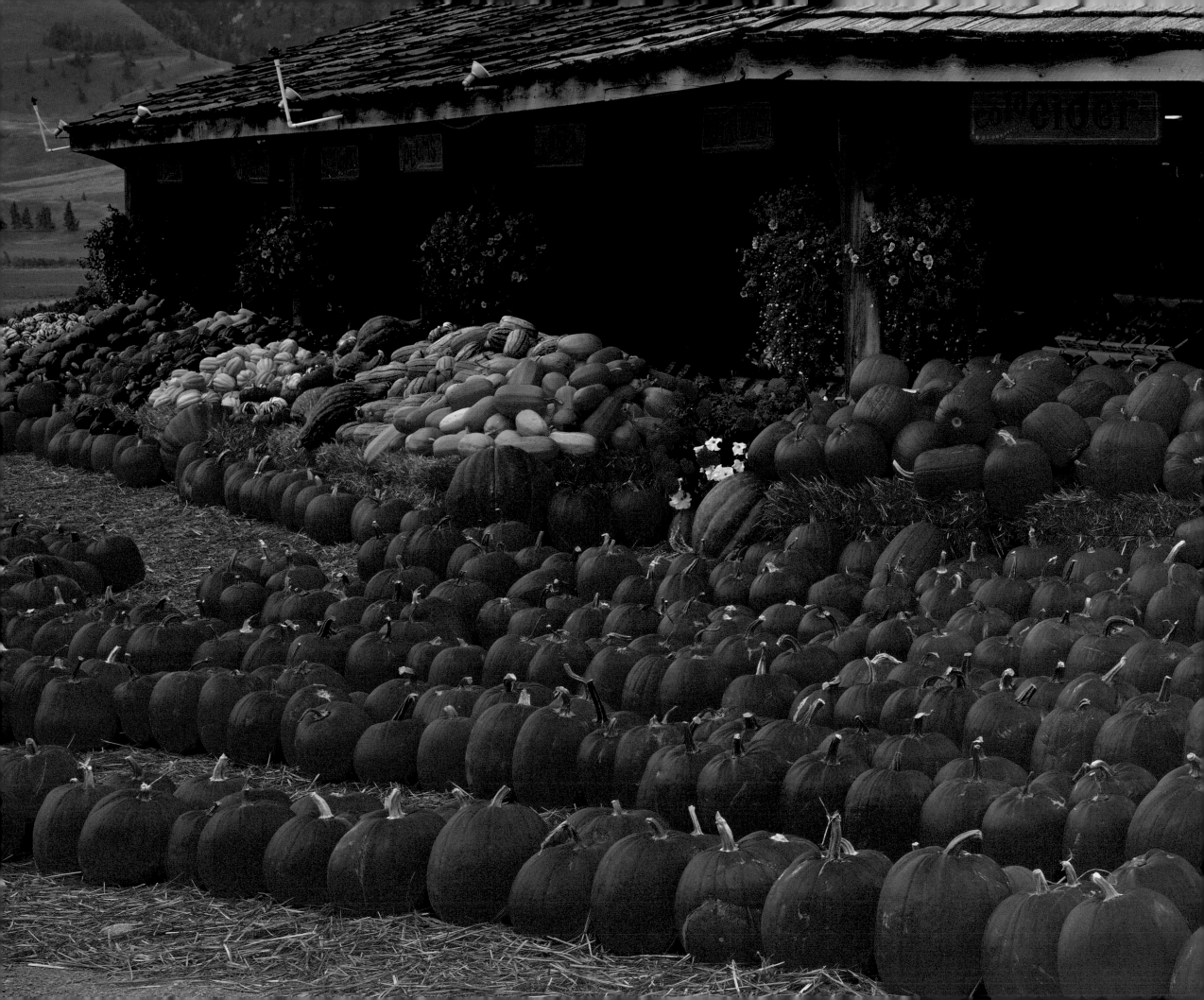

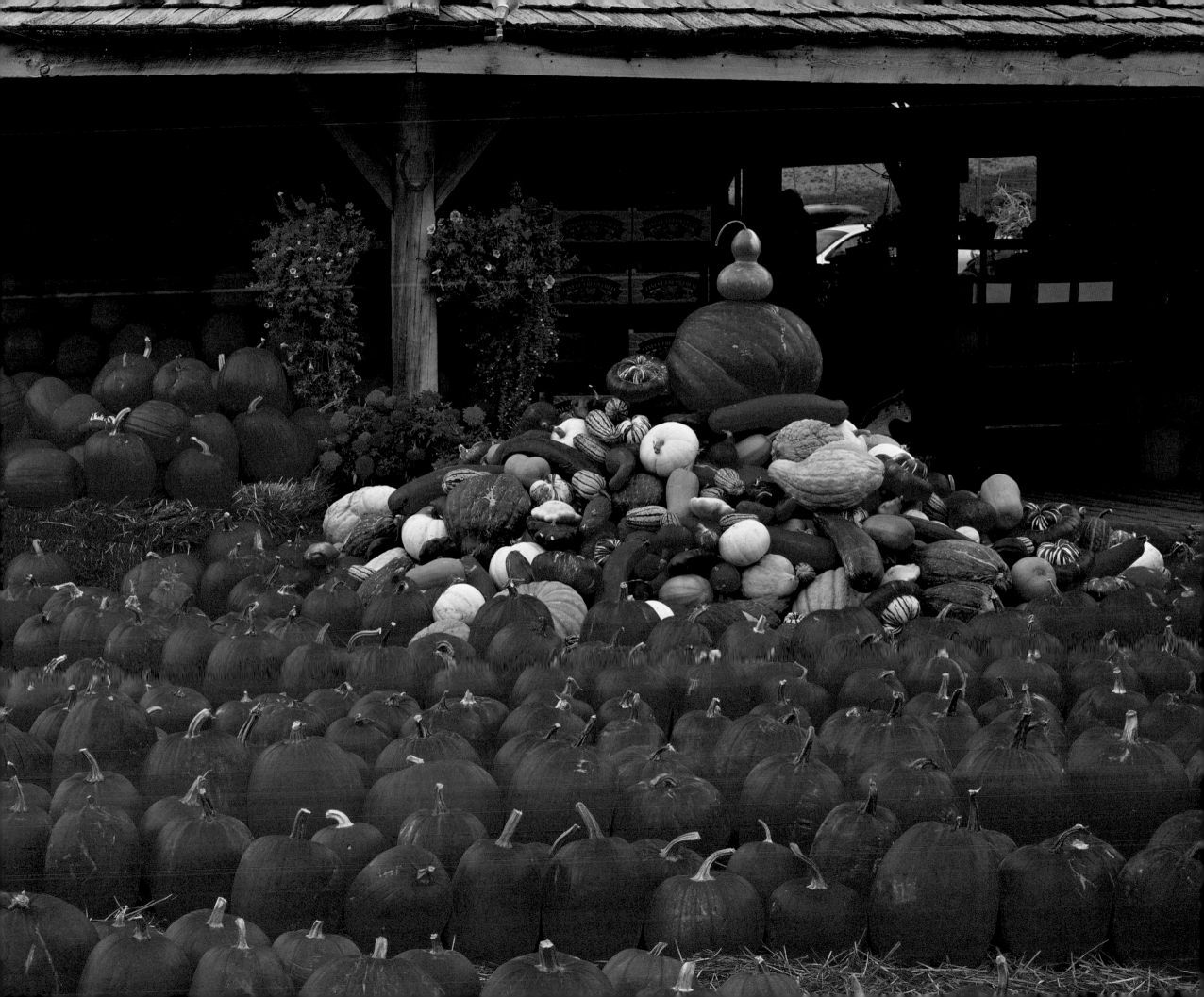

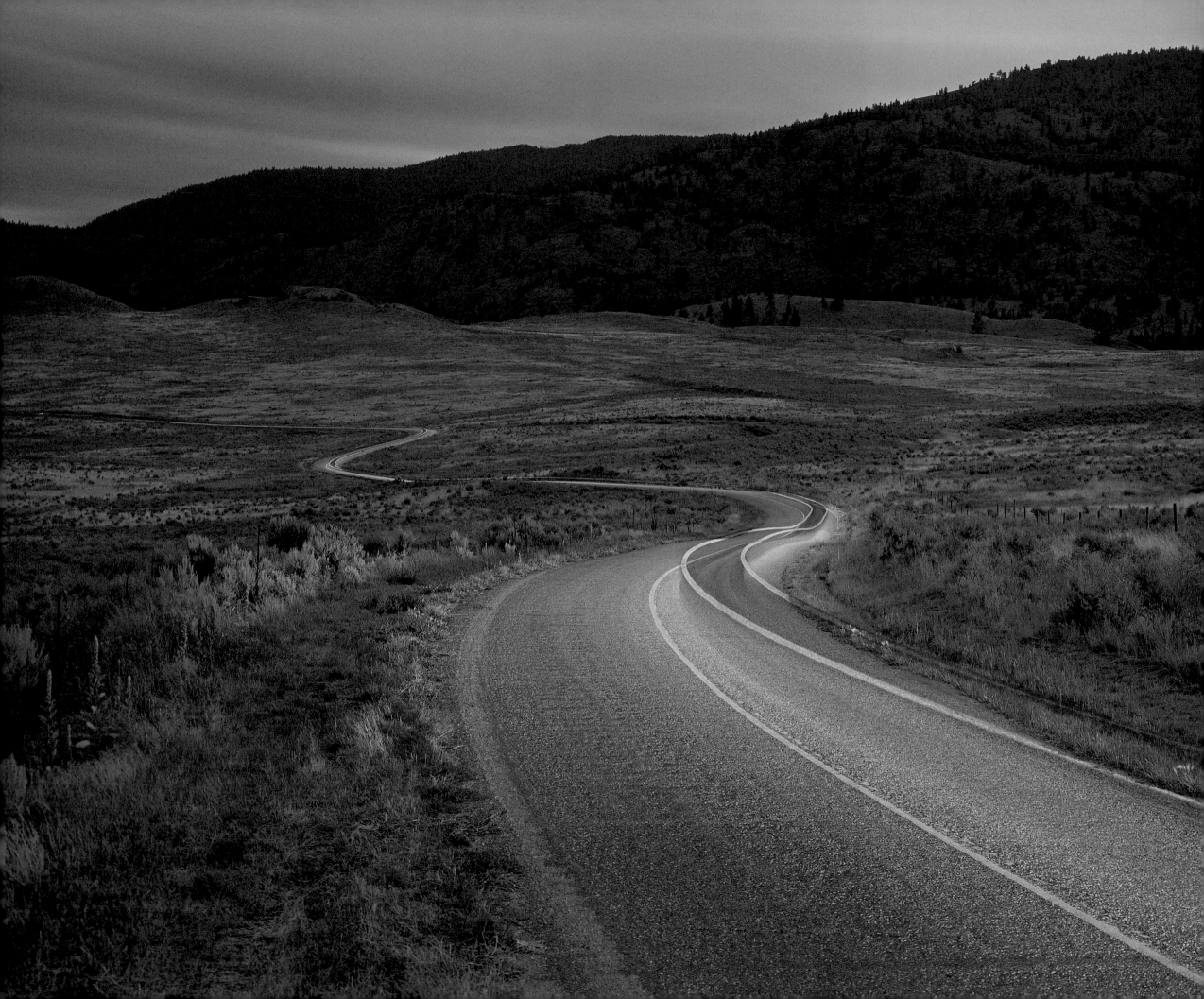

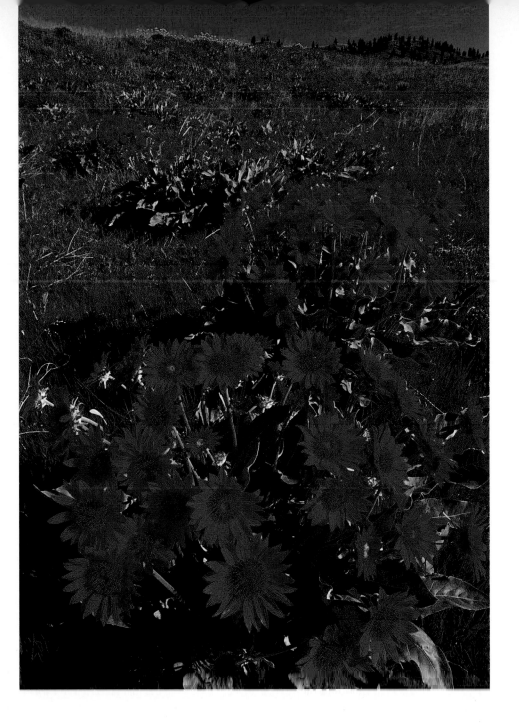

Above: Balsam-root

On the banks of the Okanagan Lake in spring, this flower blooms in profusion.

Opposite: Tail lights on a country road, Okanagan Valley

To highlight the serpentine swoop of this country road I set up my camera on a tripod and drove my own pickup through the scene. Then I had to drive back with all my lights off and close the shutter. Round trip, it took about 10 minutes.

Following pages: Forest fire sunset over Osoyoos Lake

I was setting up about an hour before sunset to make some star trail shots when the sky filled with a thick haze and I realized that a forest fire was burning somewhere in the distance. Although this ruined my plans for one kind of picture, it created ideal conditions for another.

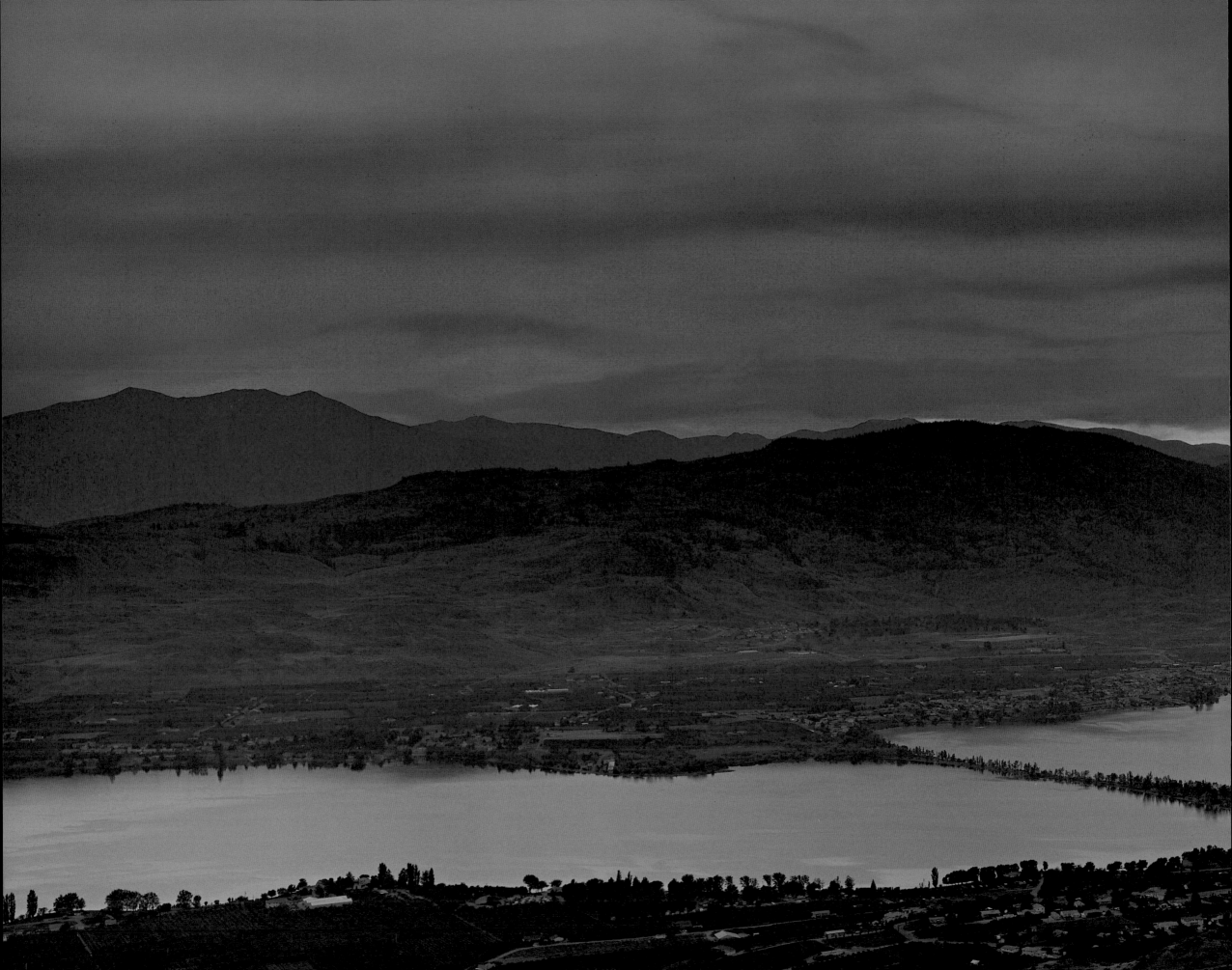

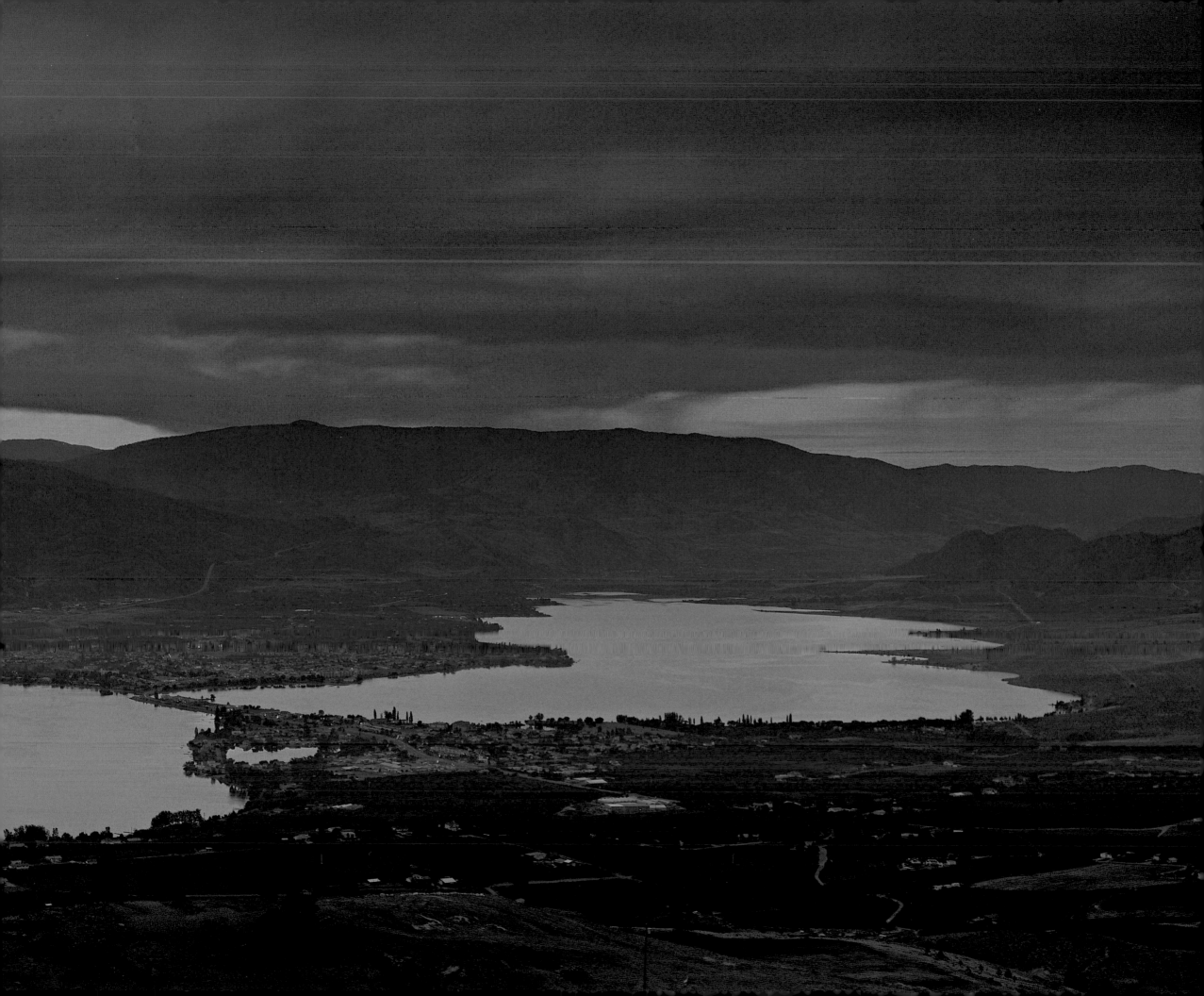

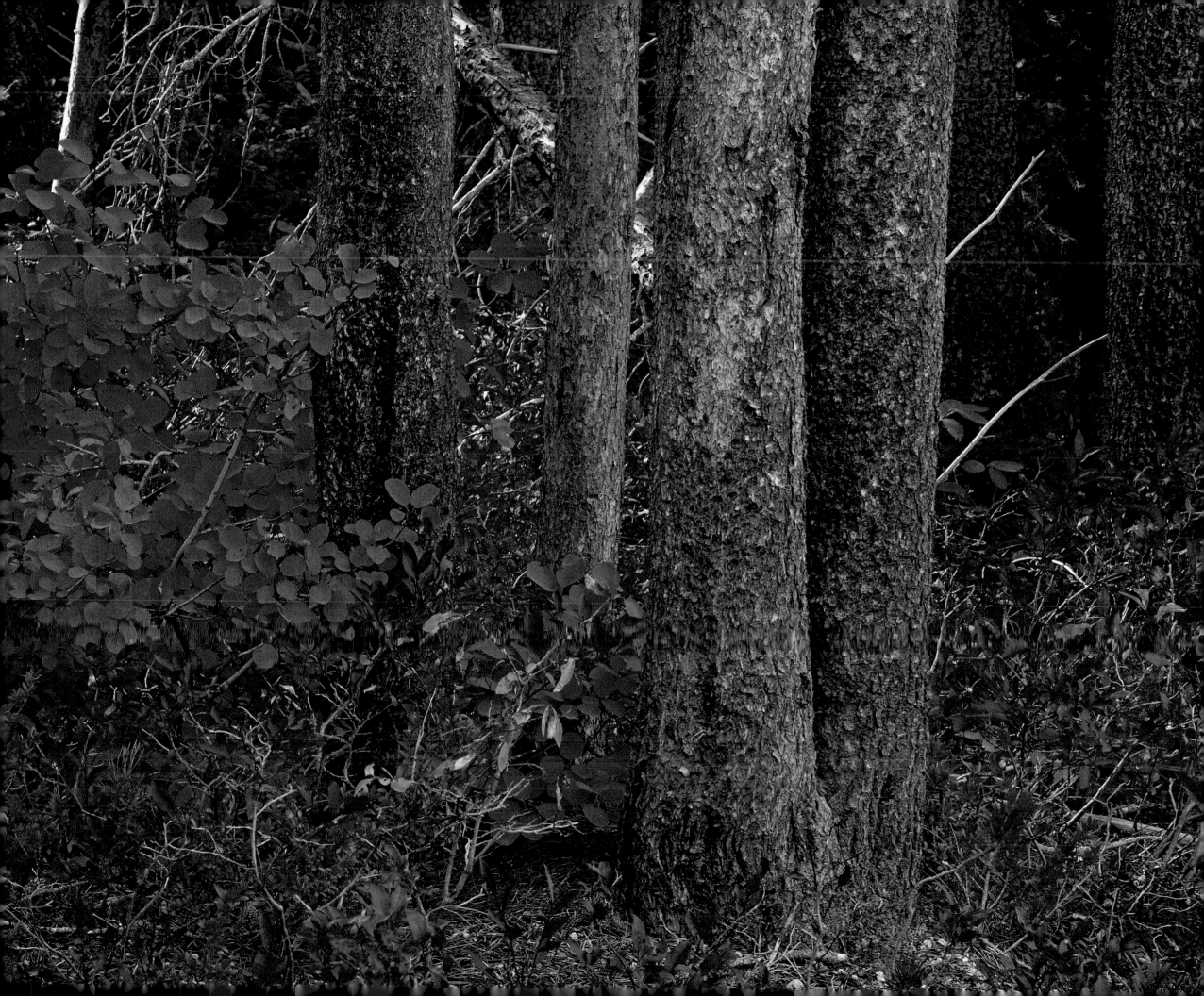

Preceding pages: Aspen, blue-berries and lodgepole pine
Driving into Cranbrook one September afternoon, I spotted this small green aspen emerging from a field of blueberries in a lodgepole-pine forest. I'm notorious for driving right by a scene like this before the sober second thought kicks in and I pull a U-turn to go back for the shot.

Wildflowers, Mount Revelstoke National Park

Opposite: Wapta Falls, Yoho National Park

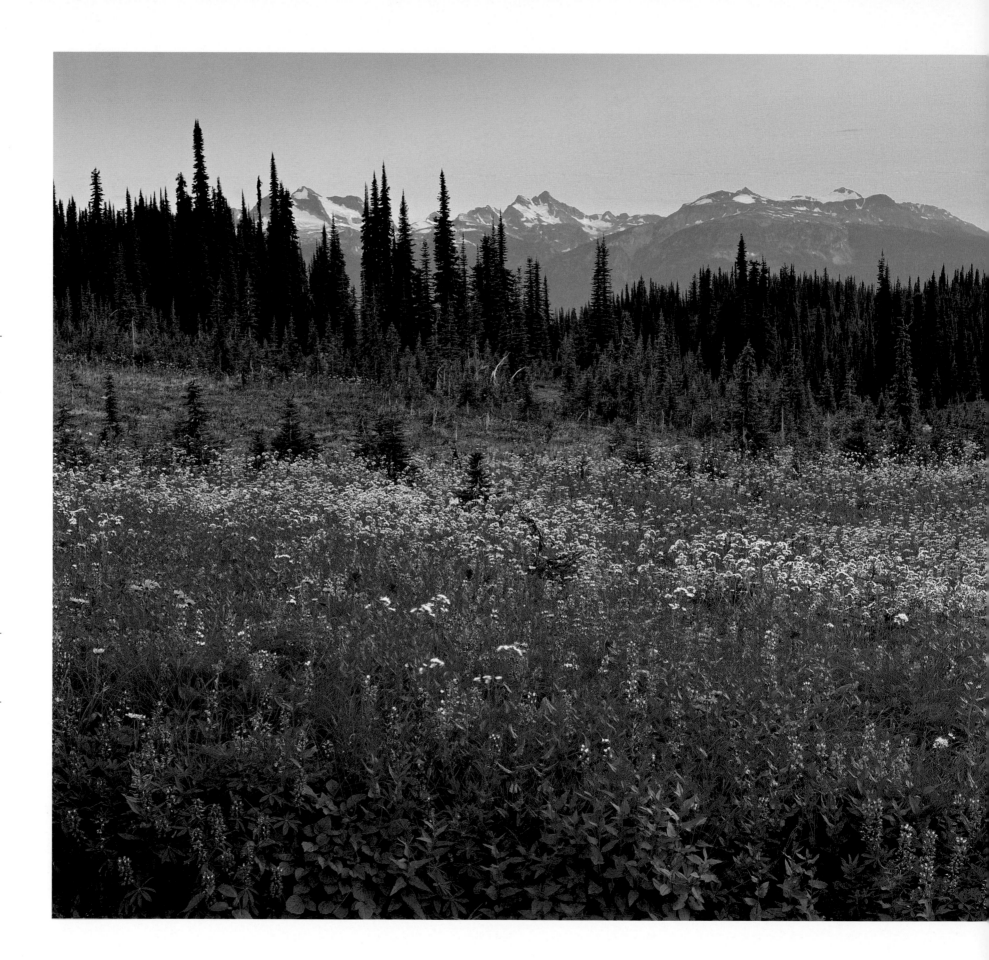

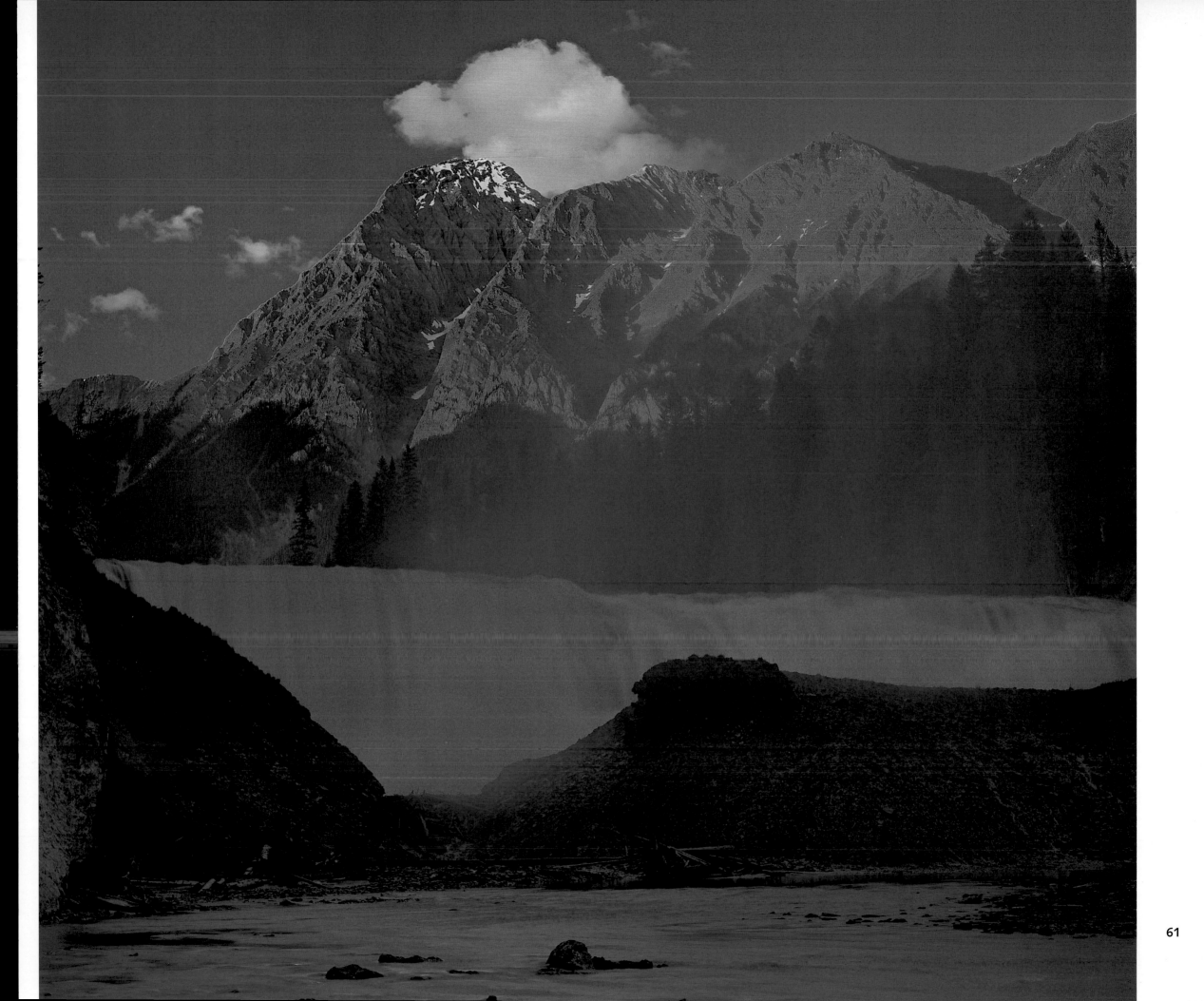

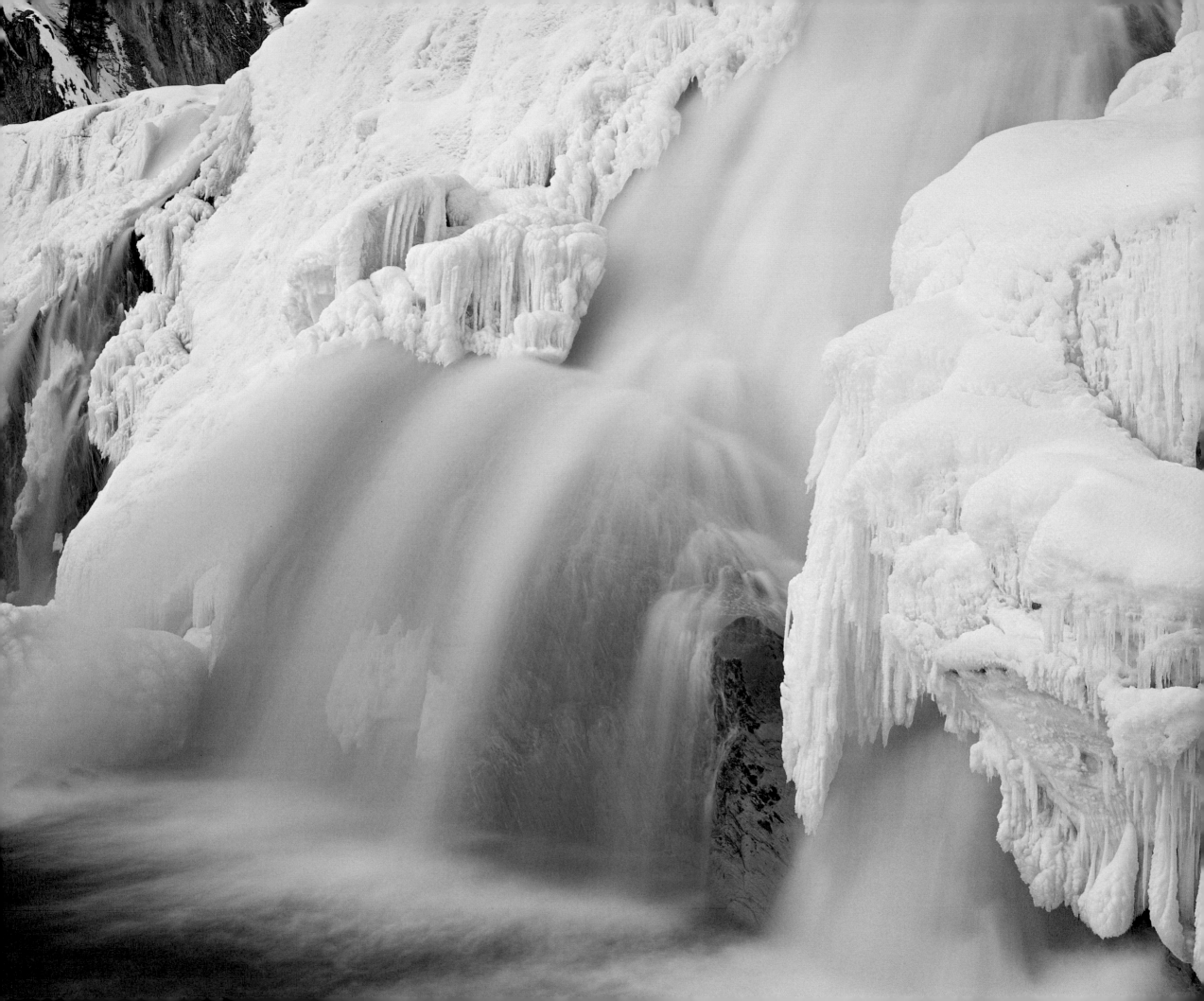

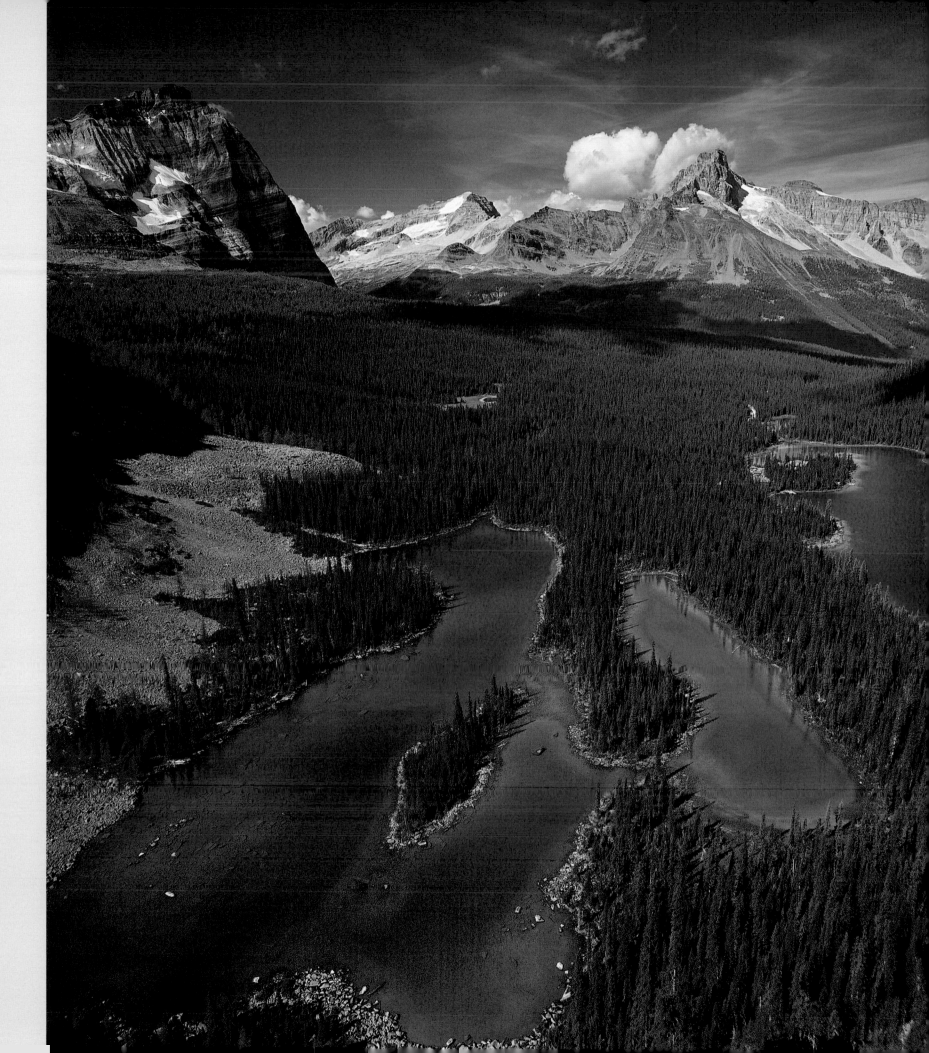

Opposite: Wapta Falls in winter, Yoho National Park

These are the same falls as on page 61 but a few months later and a whole lot of degrees lower.

Mary Lake from Opabin Plateau, Yoho National Park

Following pages: Opabin Plateau, Yoho National Park

Larches are one of the few conifers to change colour and lose their needles in the fall. The last few weeks of September through early October never fall to draw thousands of visitors to Yoho, named after a Cree word for wonder.

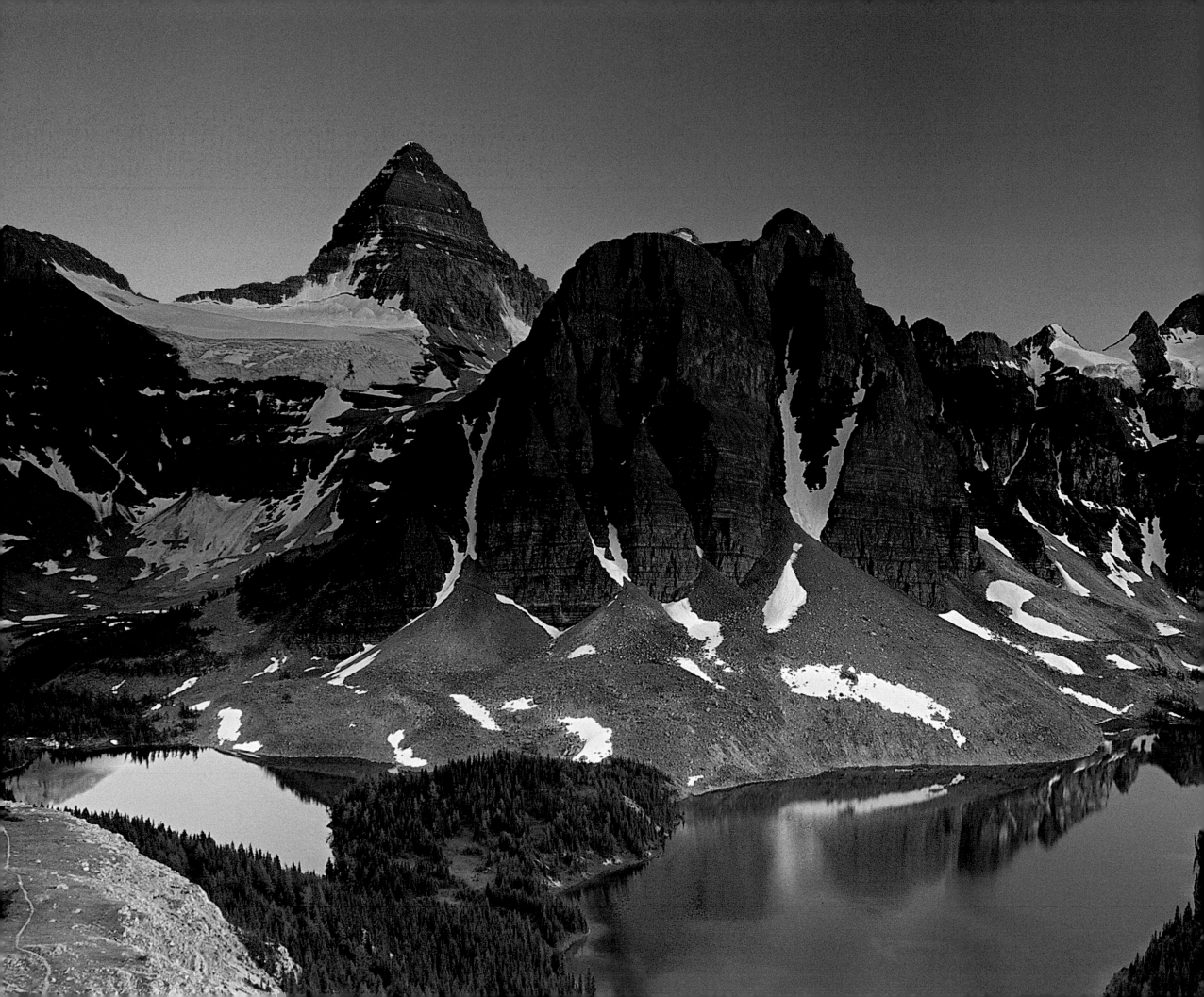

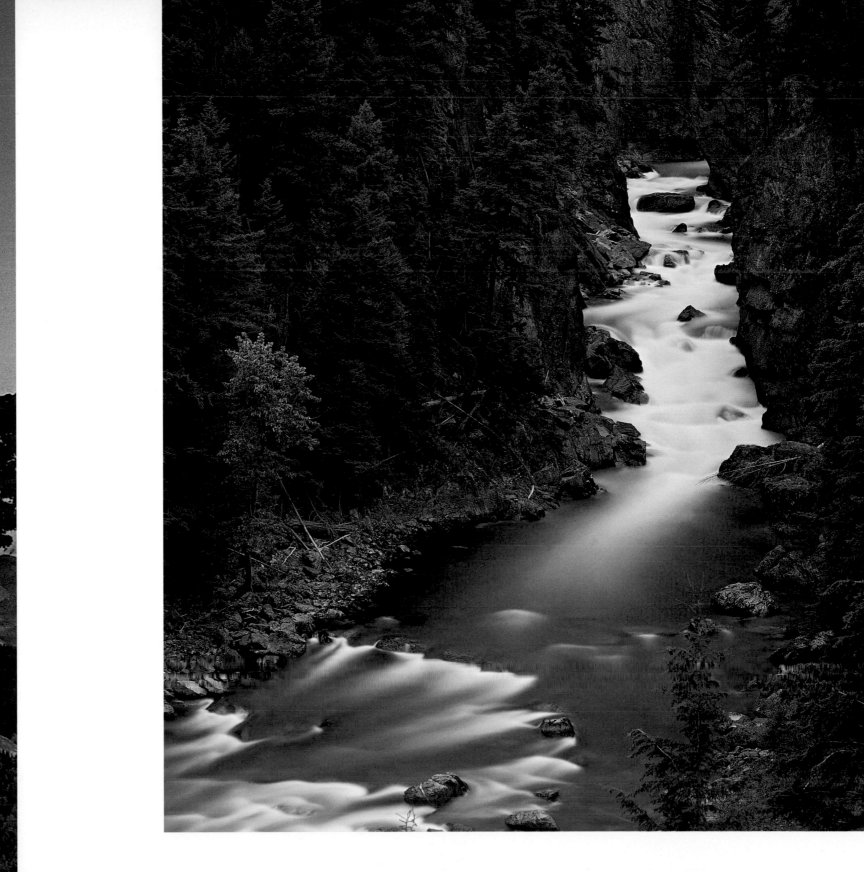

Opposite: Mount Assiniboine and Sunburst Peak, Sunburst and Cerulean Lakes in foreground

Mount Assiniboine Provincial Park has all the classic mega-scenery that I've come to expect from British Columbia's national and provincial parks.

Above: Near the headwaters of the Similkameen River

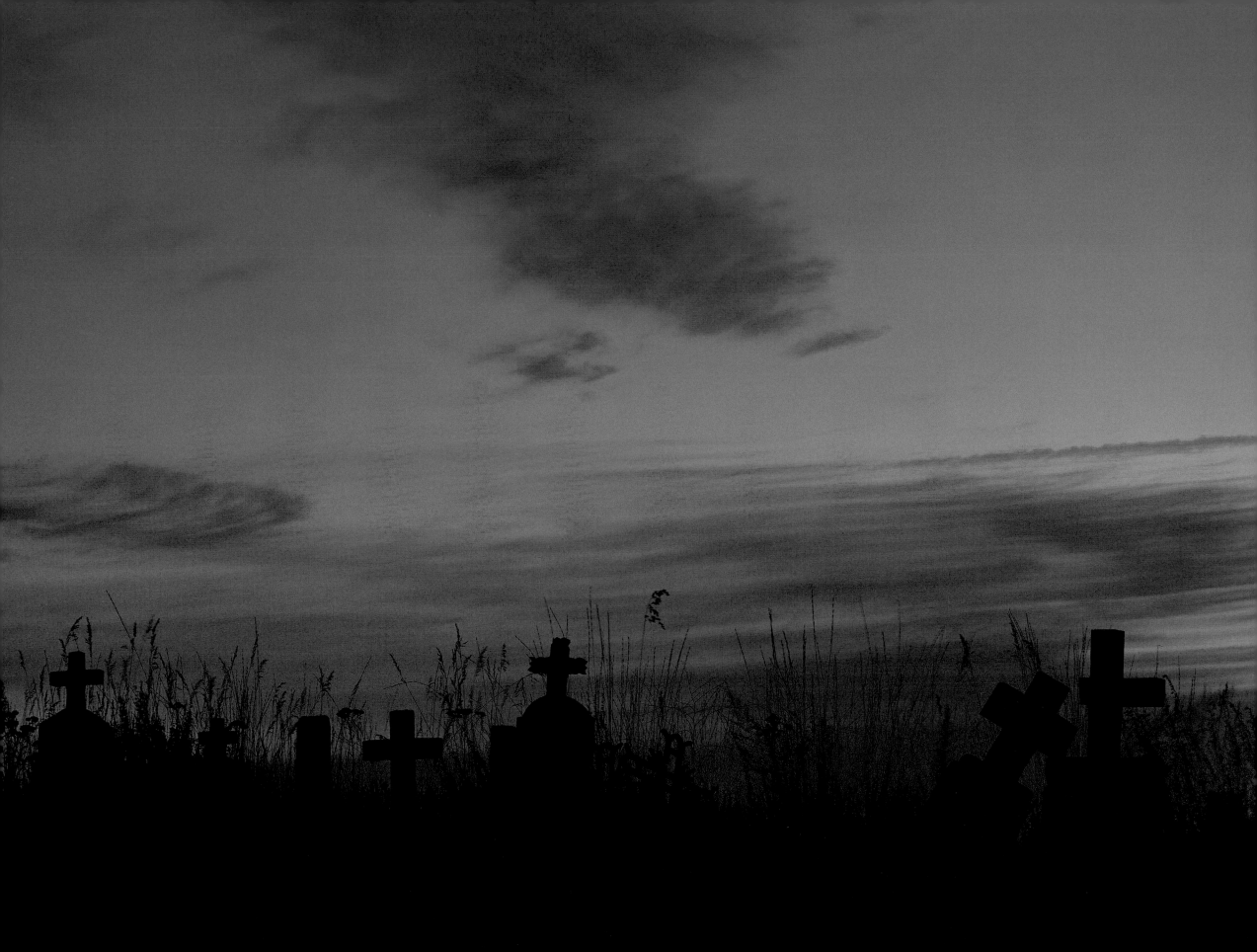

Central & Northern Interior

Cemetery on Douglas Lake Ranch

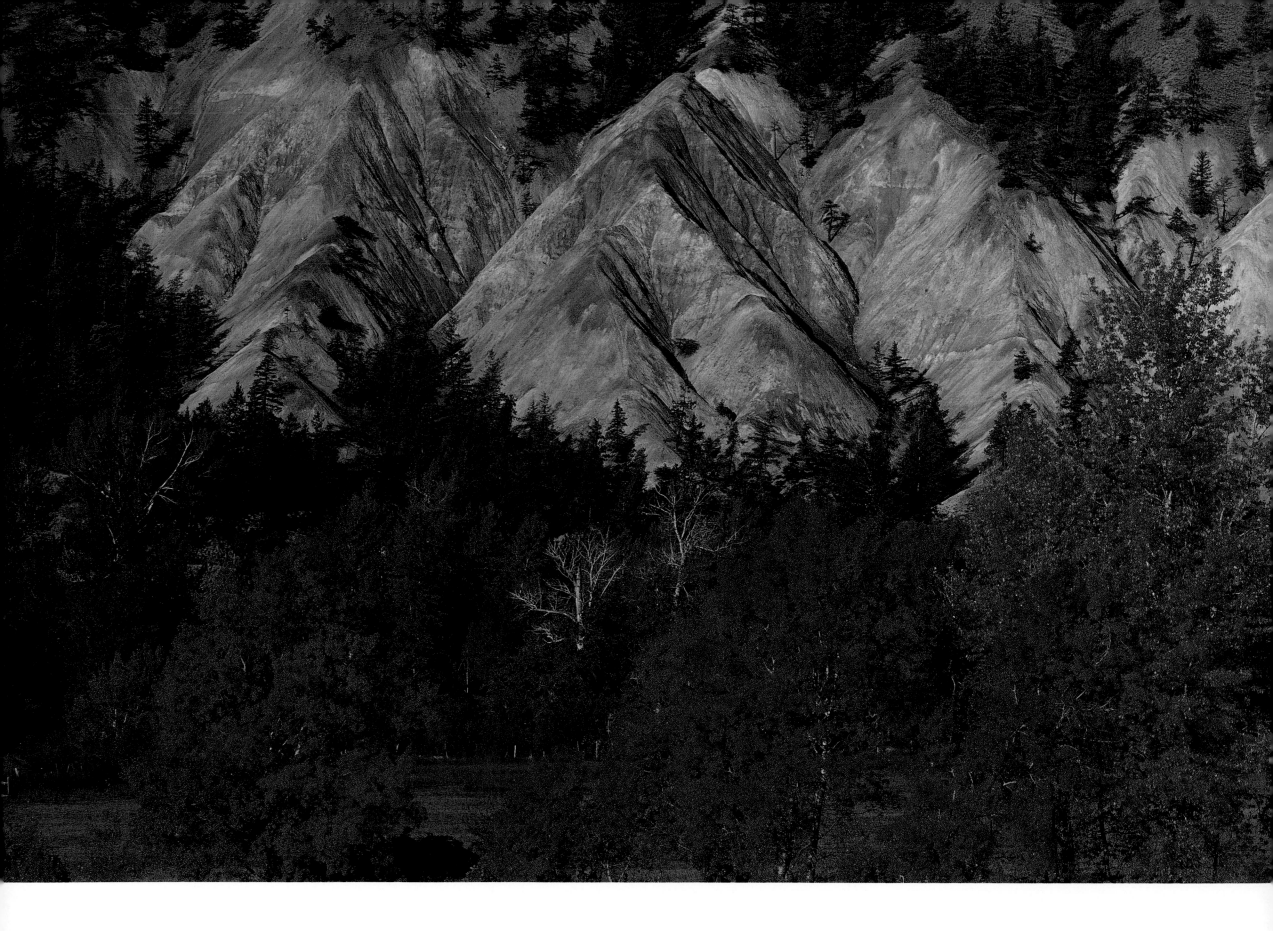

Erosion meets Cache Creek's fall colours

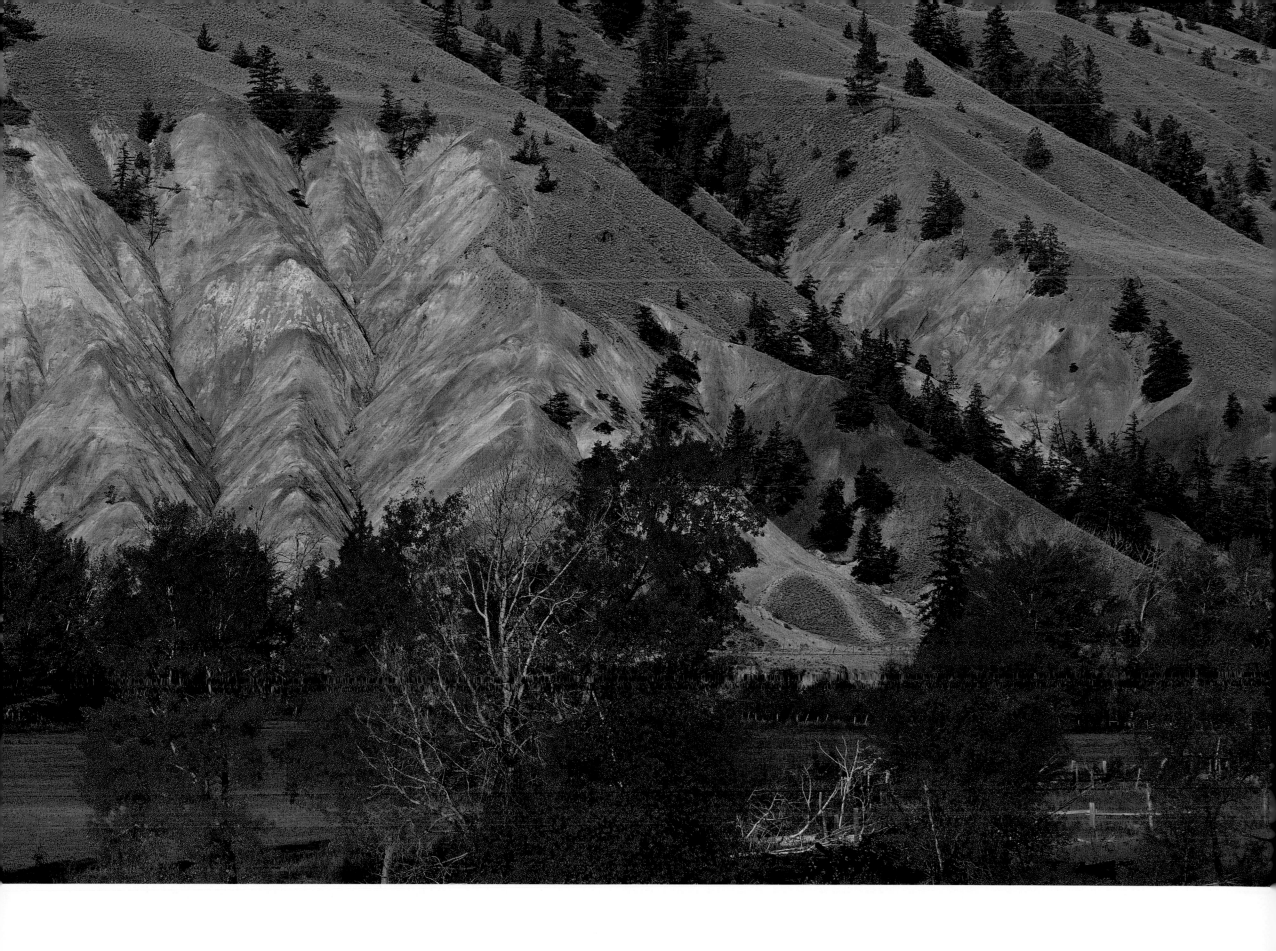

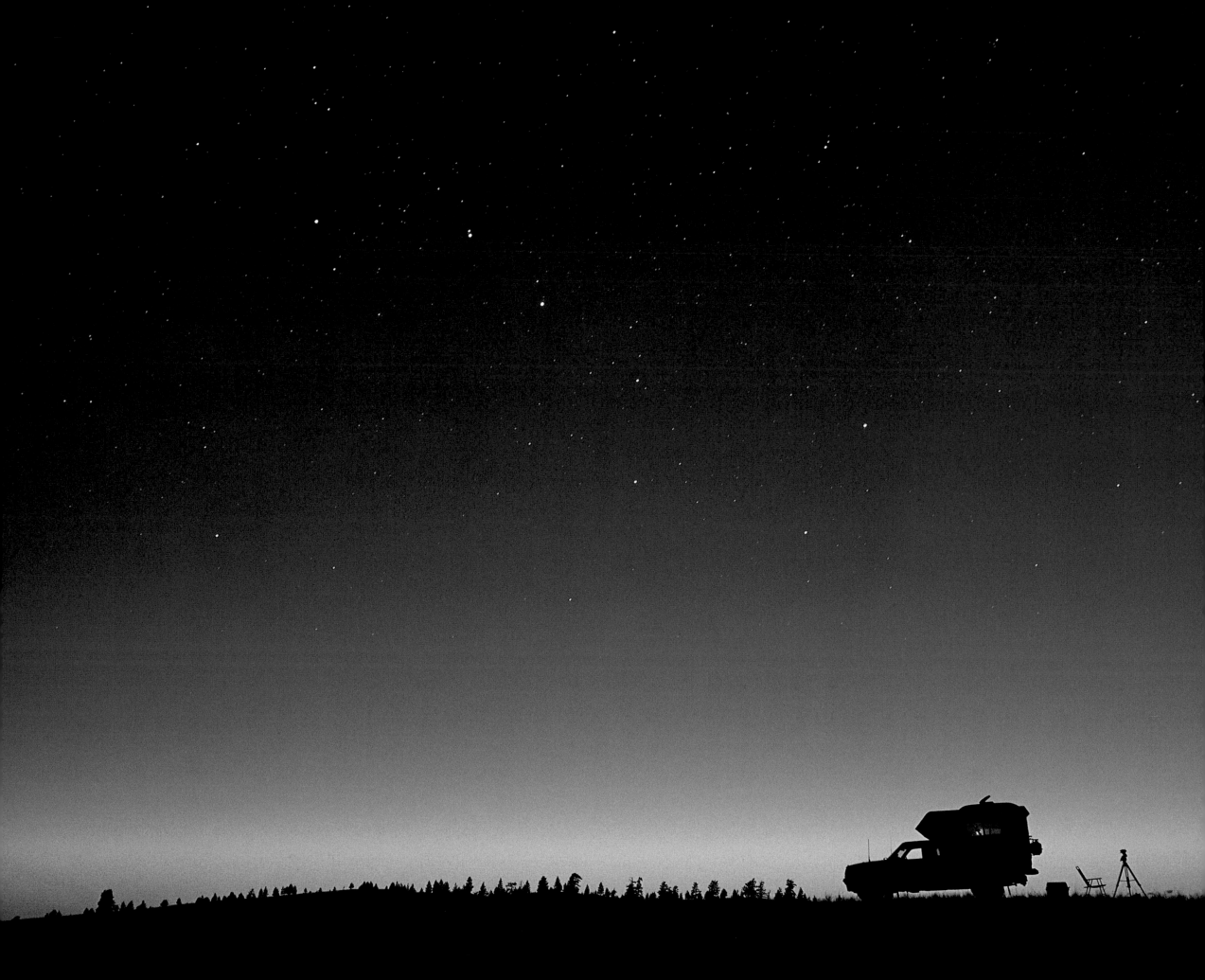

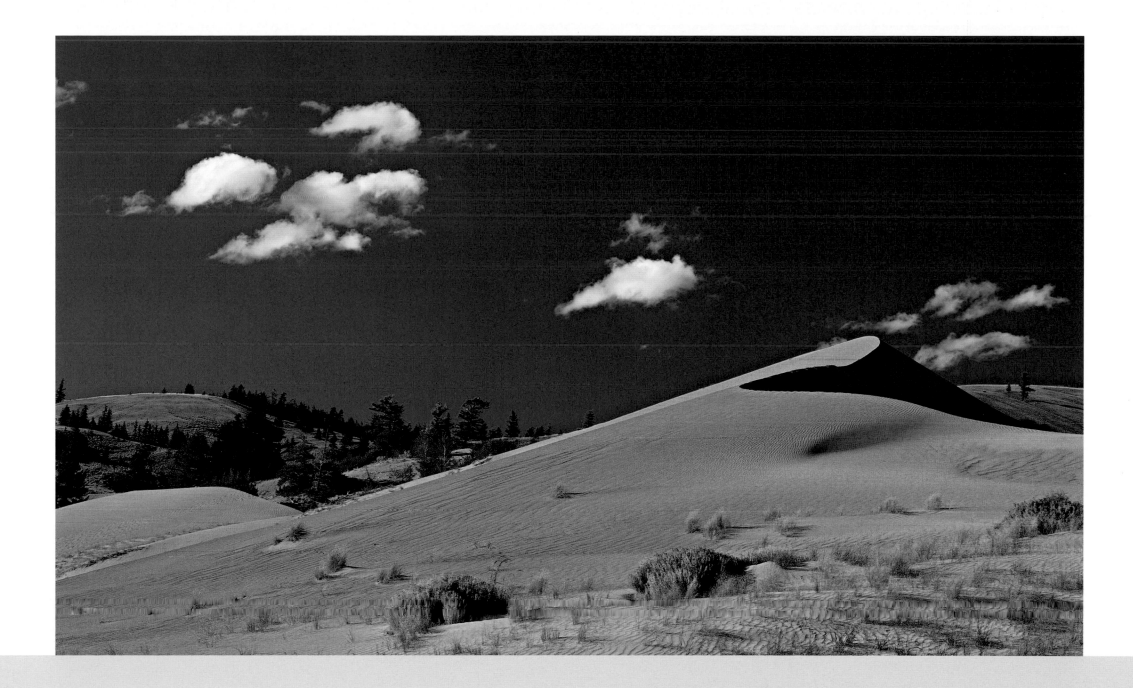

Sand dune, Farwell Canyon

Yes, BC has sand dunes. This one sits on the edge of Farwell Canyon—the result of wind blowing sand from the Chilcotin River shoreline up the cliffs of the canyon and depositing it on the ridge.

Following pages: Churn Creek Provincial Park

I did a double take when I saw this scene rising up from the Fraser River. It gave me flashbacks of Utah and Arizona with topography reminiscent of places along the Colorado River.

Opposite: Camped under a starry sky on Douglas Lake Ranch near Quilchena

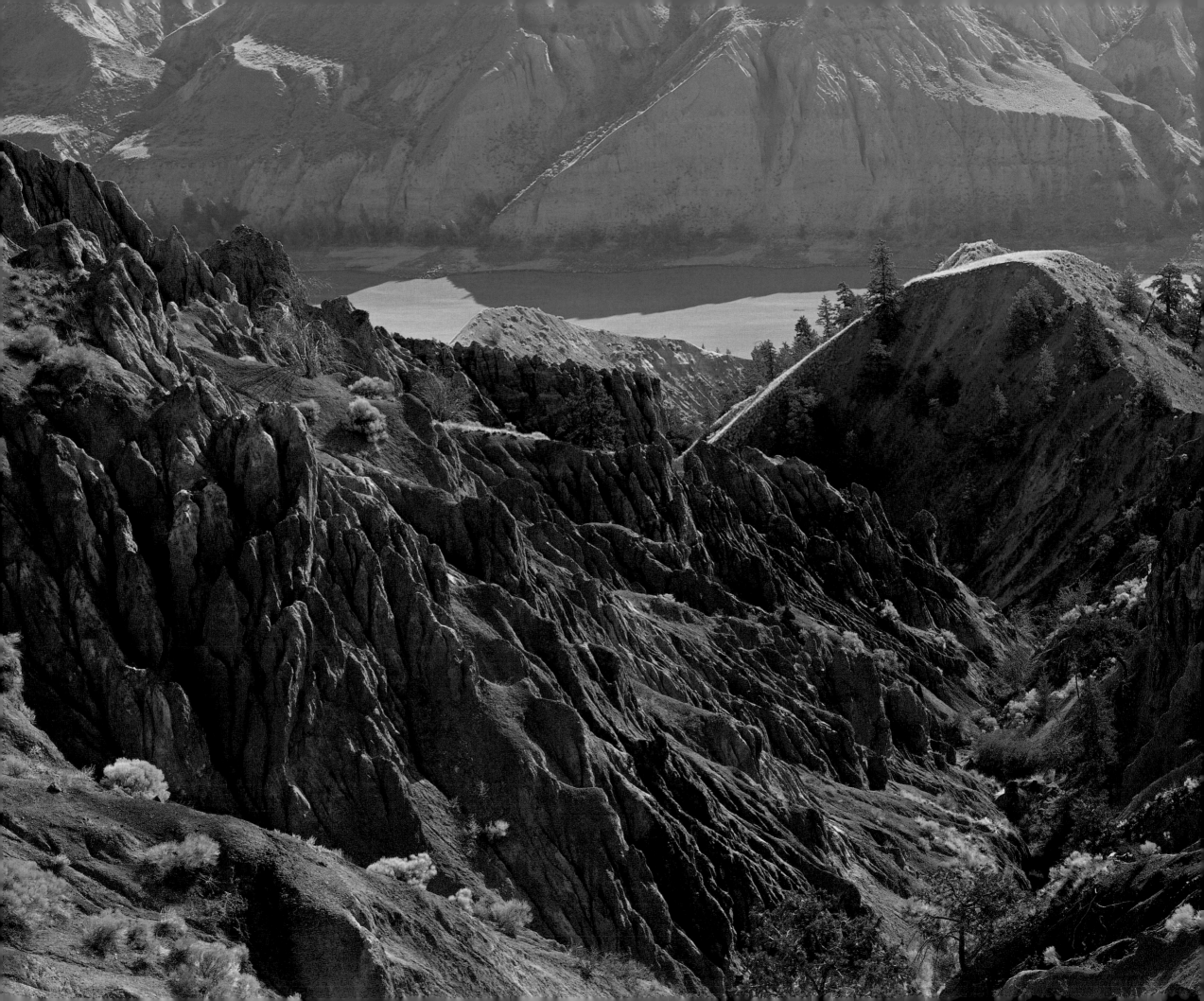

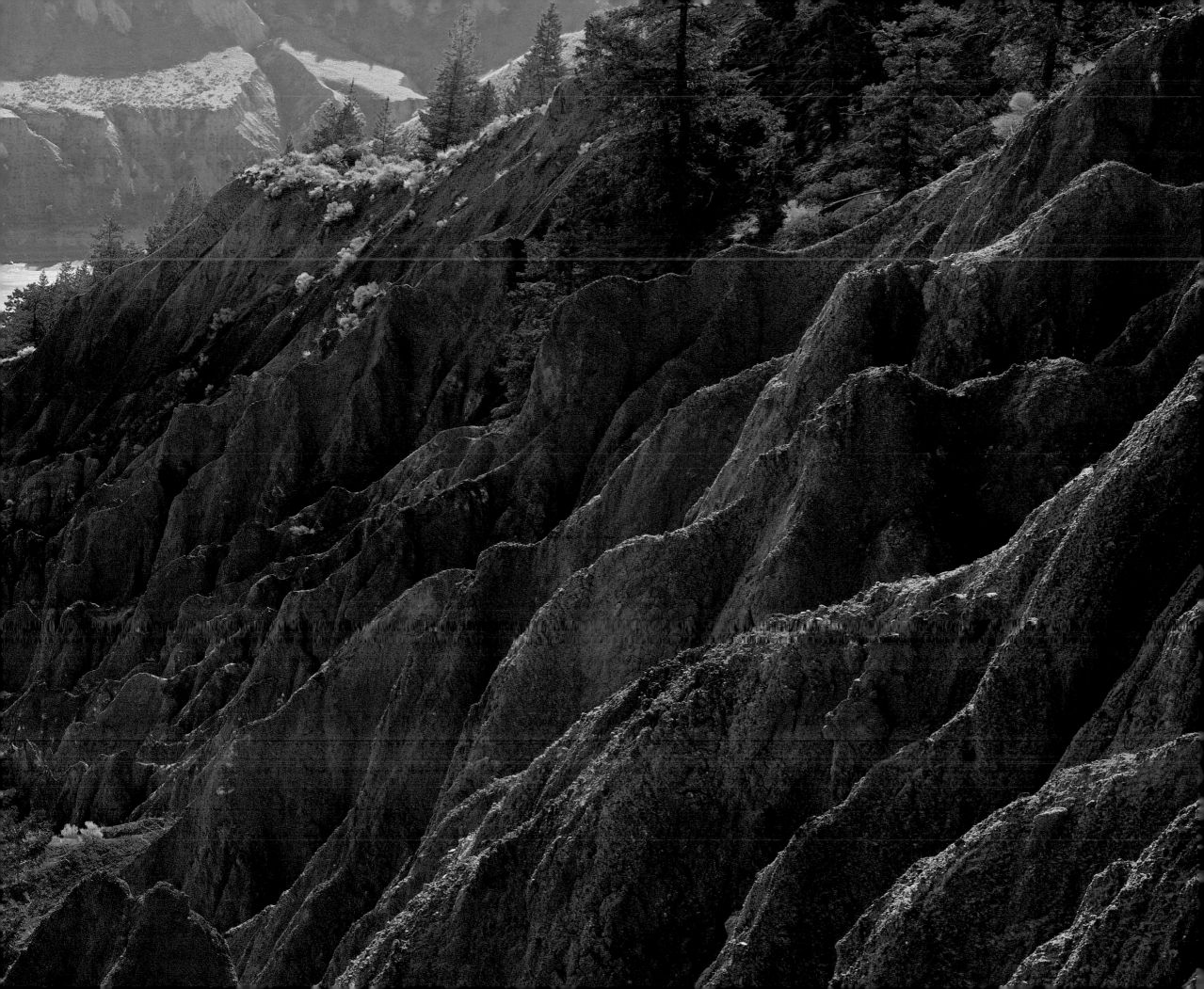

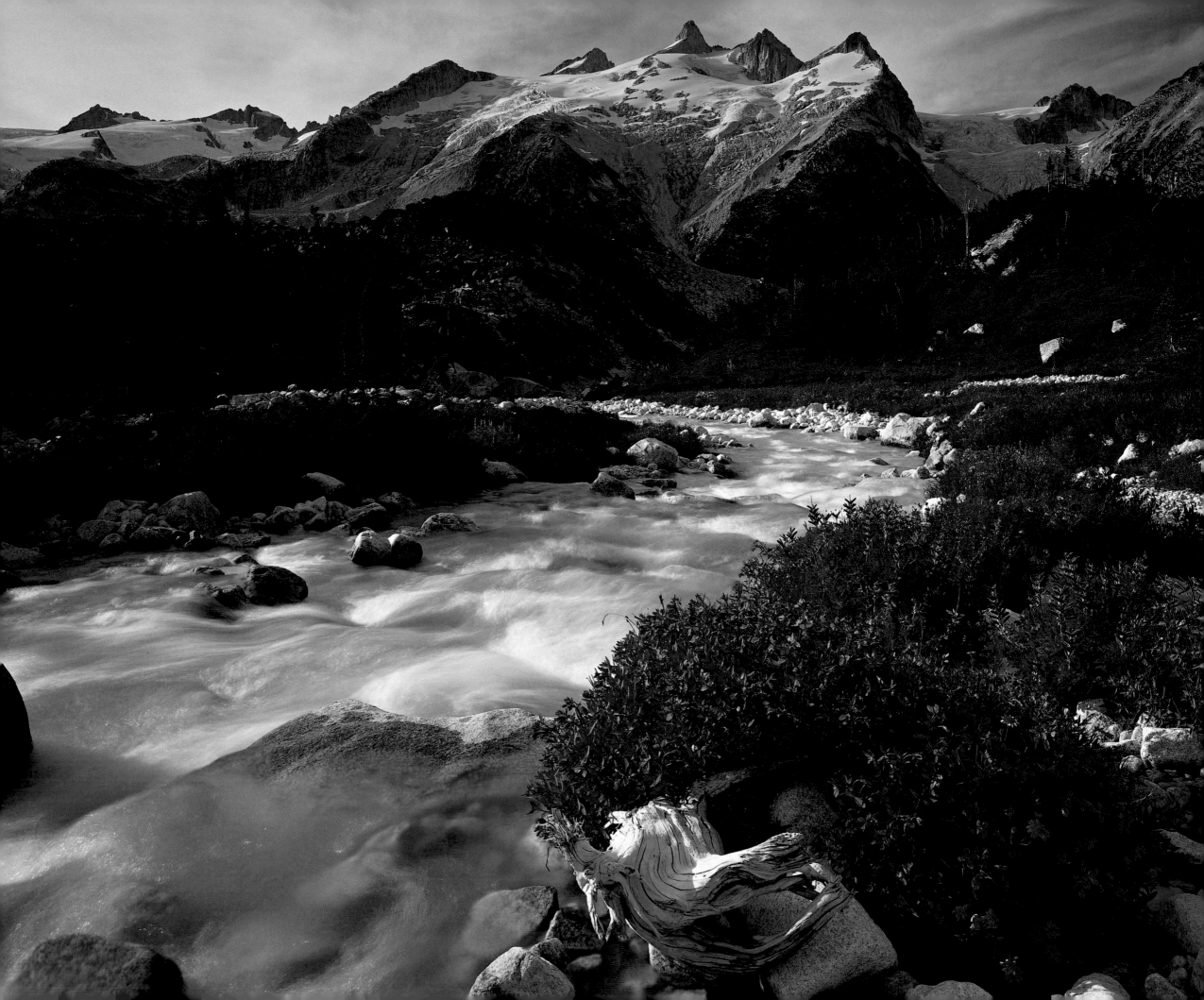

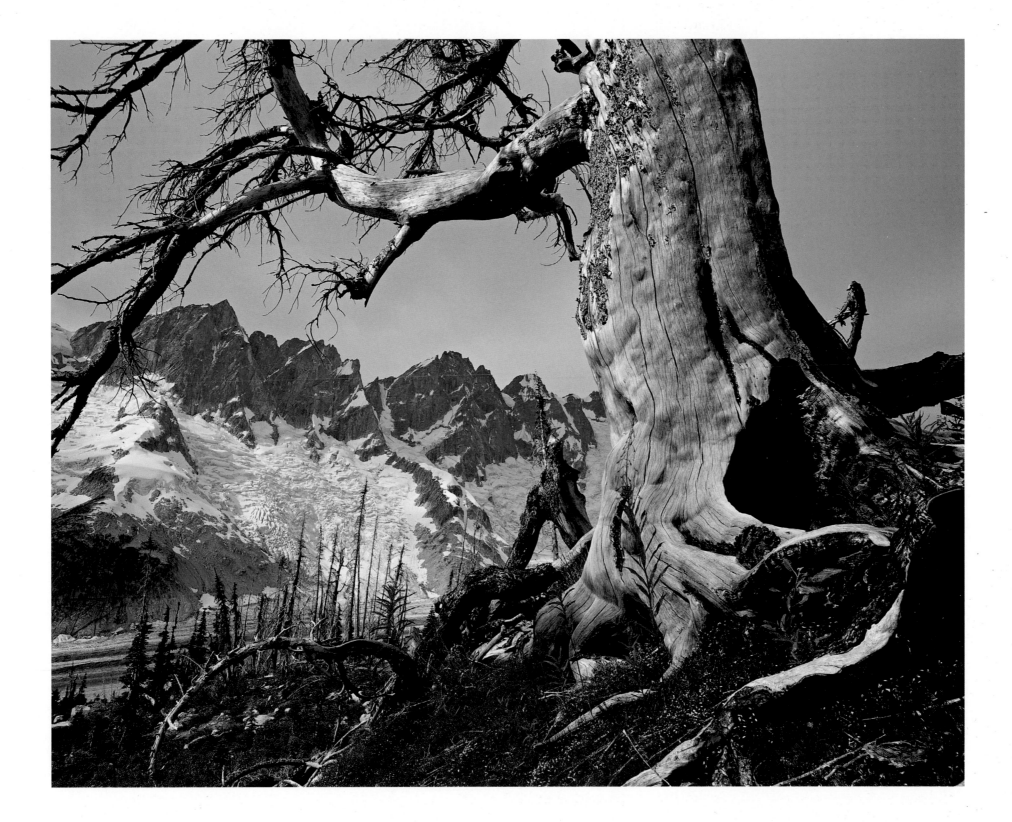

Coast Mountain Range near Mount Waddington

Intrepid fireweed stakes a new beginning beneath a charred spruce.

Opposite: Nabob Pass near Mount Waddington

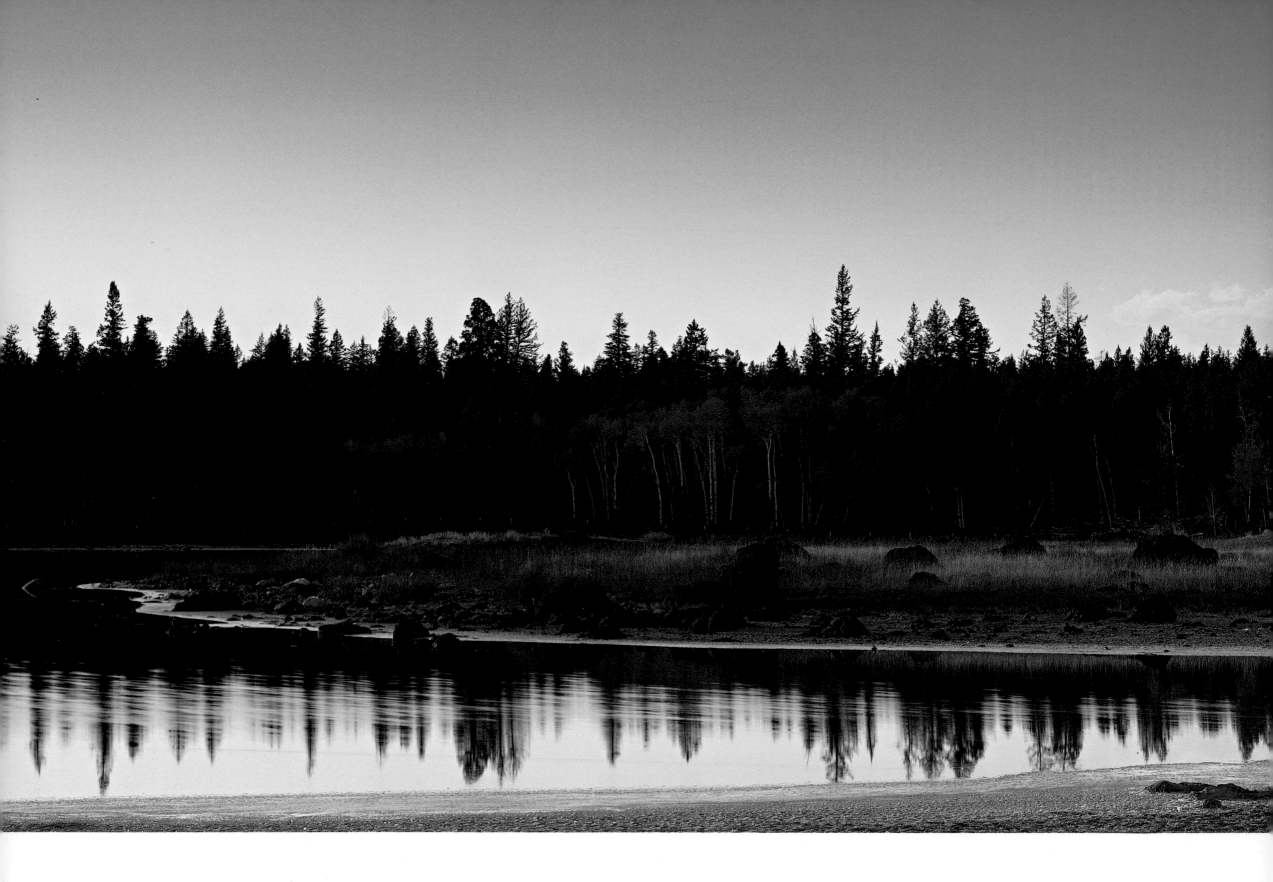

Aspens reflected in a lake near 100 Mile House

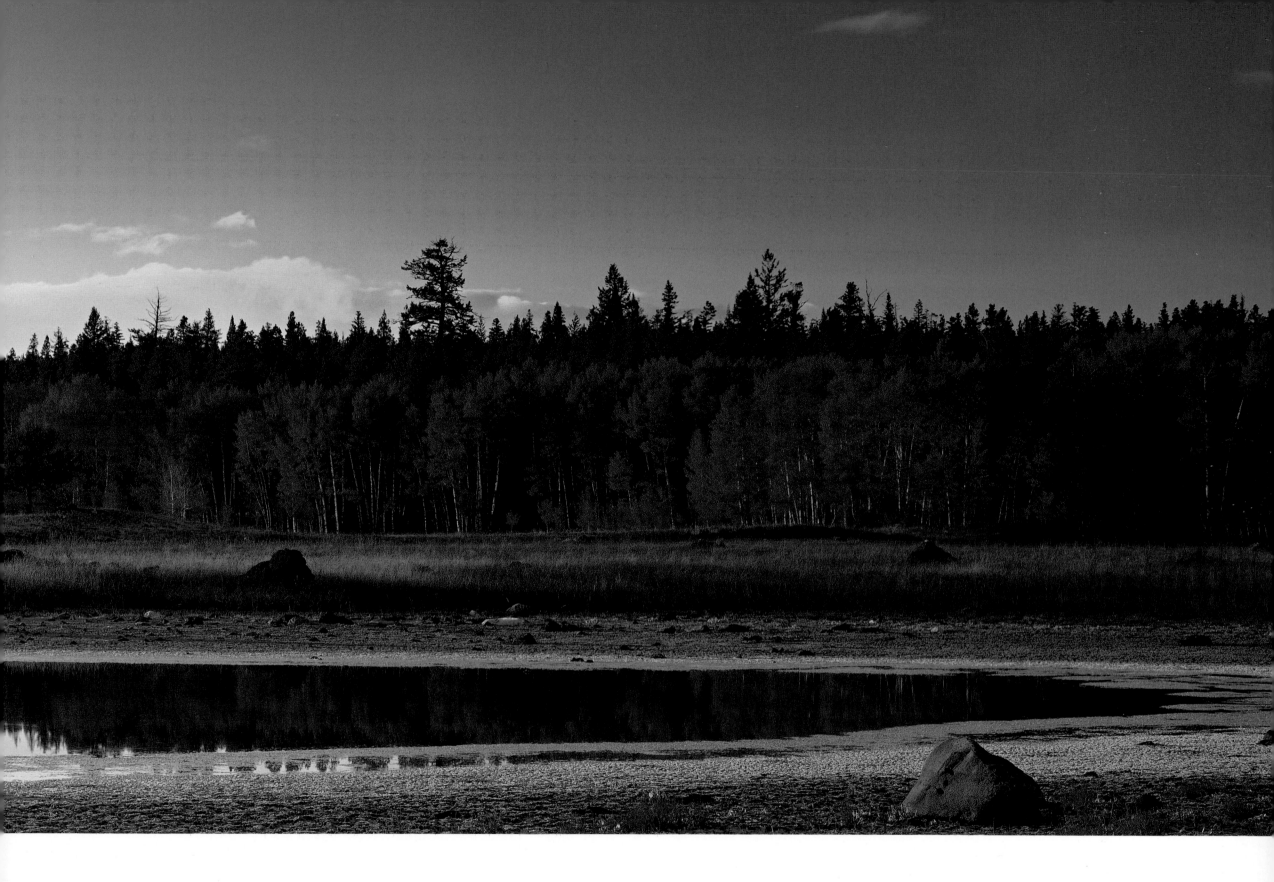

Following pages: Crescent moon over spruce trees

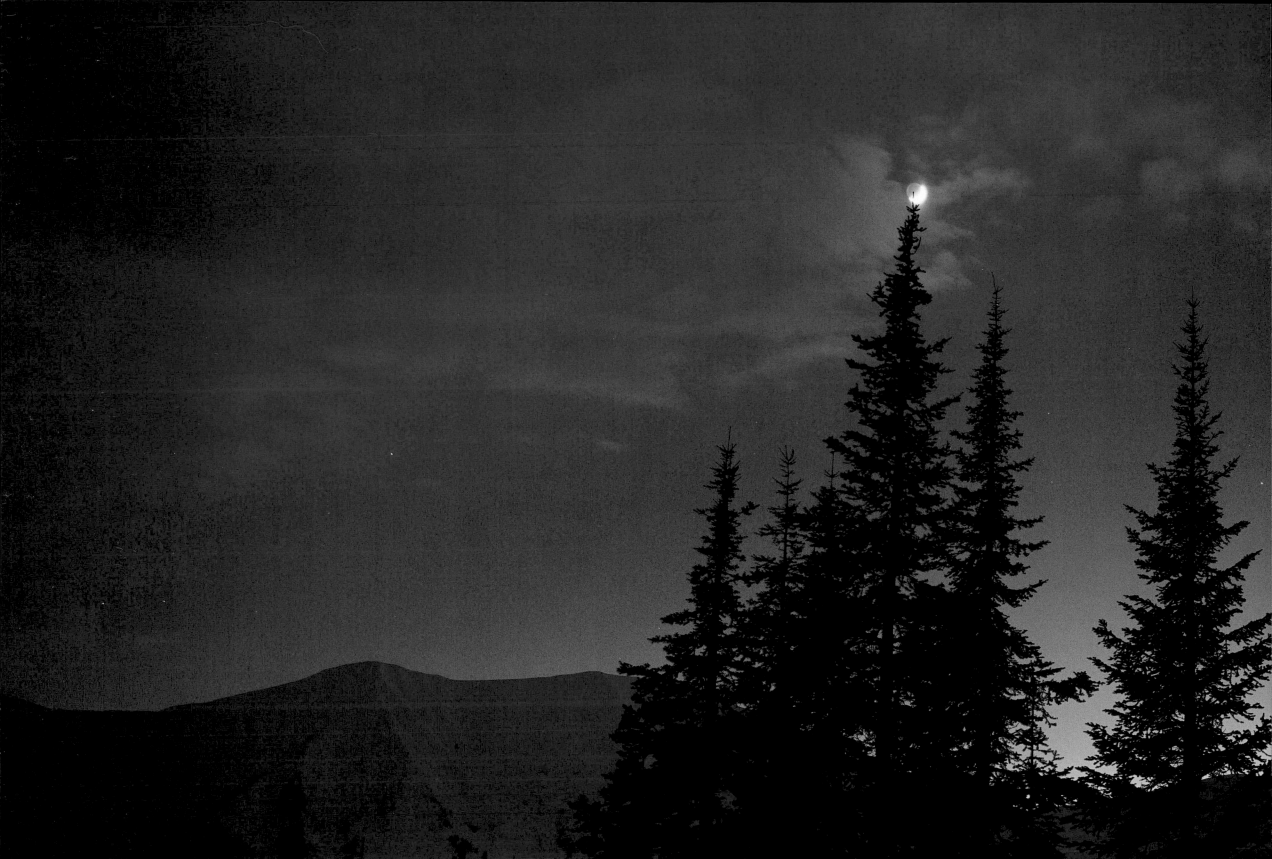

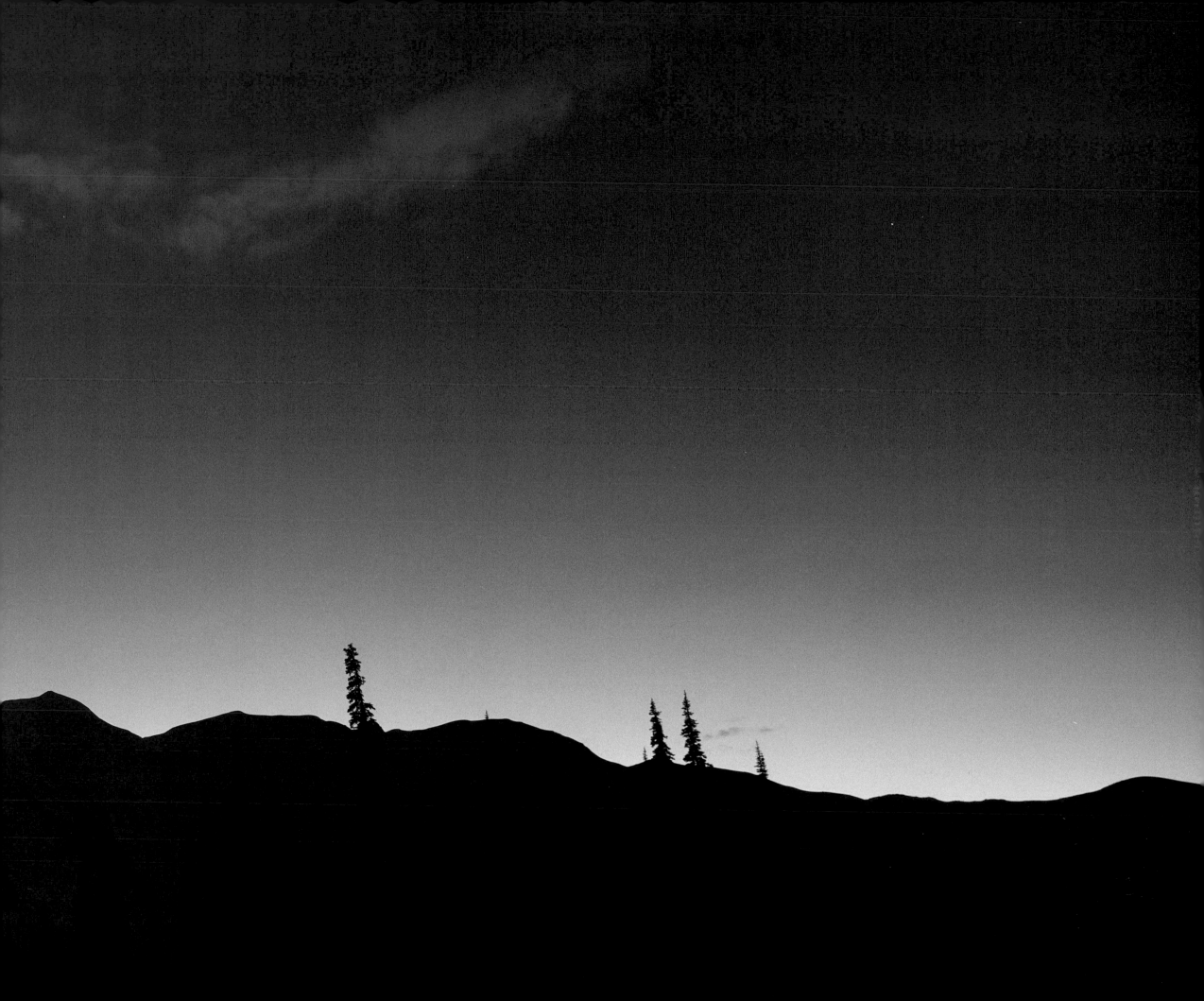

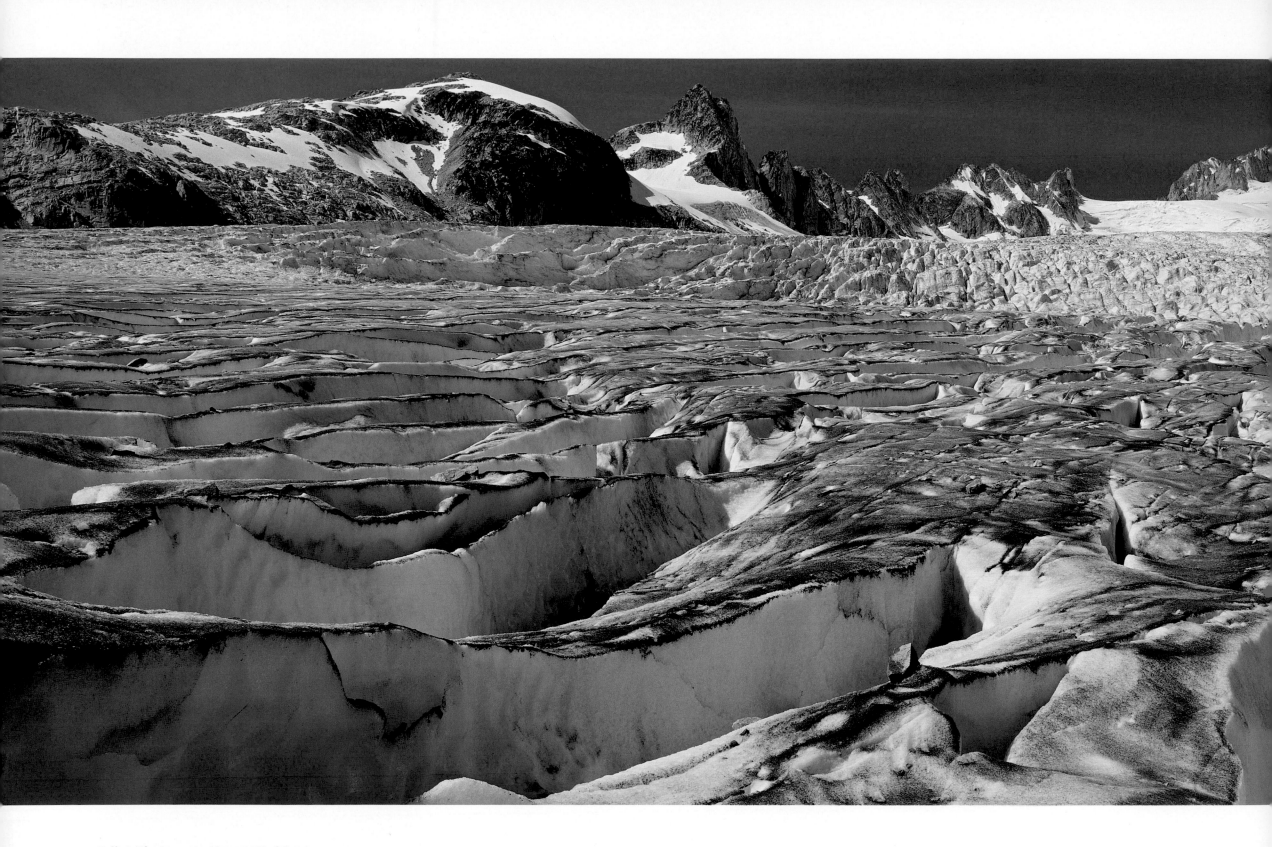

Tellot Glacier near Mount Waddington

I stood at the edge of a crevasse to shoot this photograph.
Walking on the surface of an ice floe is fairly easy, but you
have to be careful as the price of a mistake is very high.

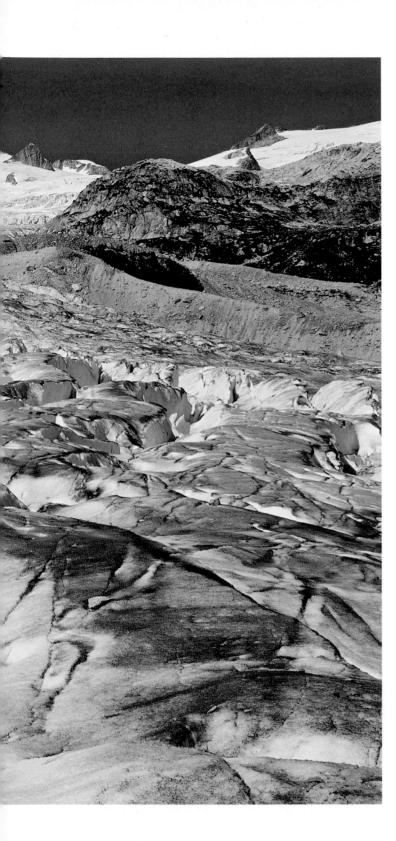

Right: Tent aglow in a night fog

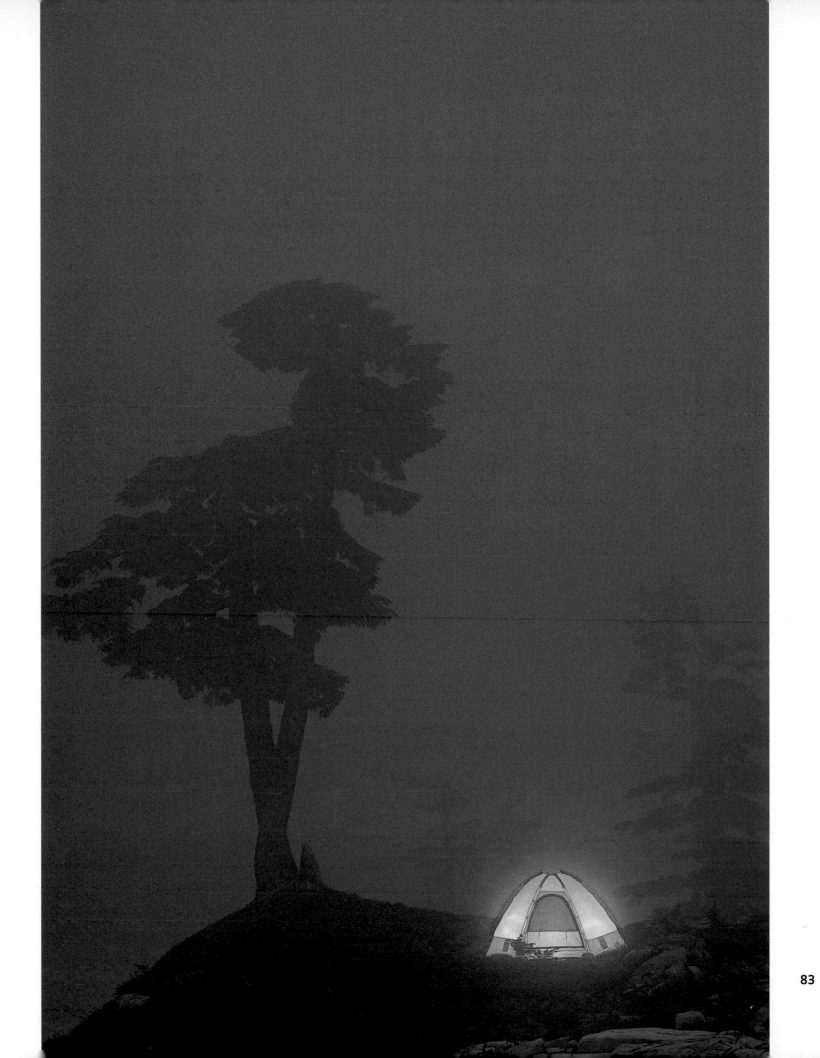

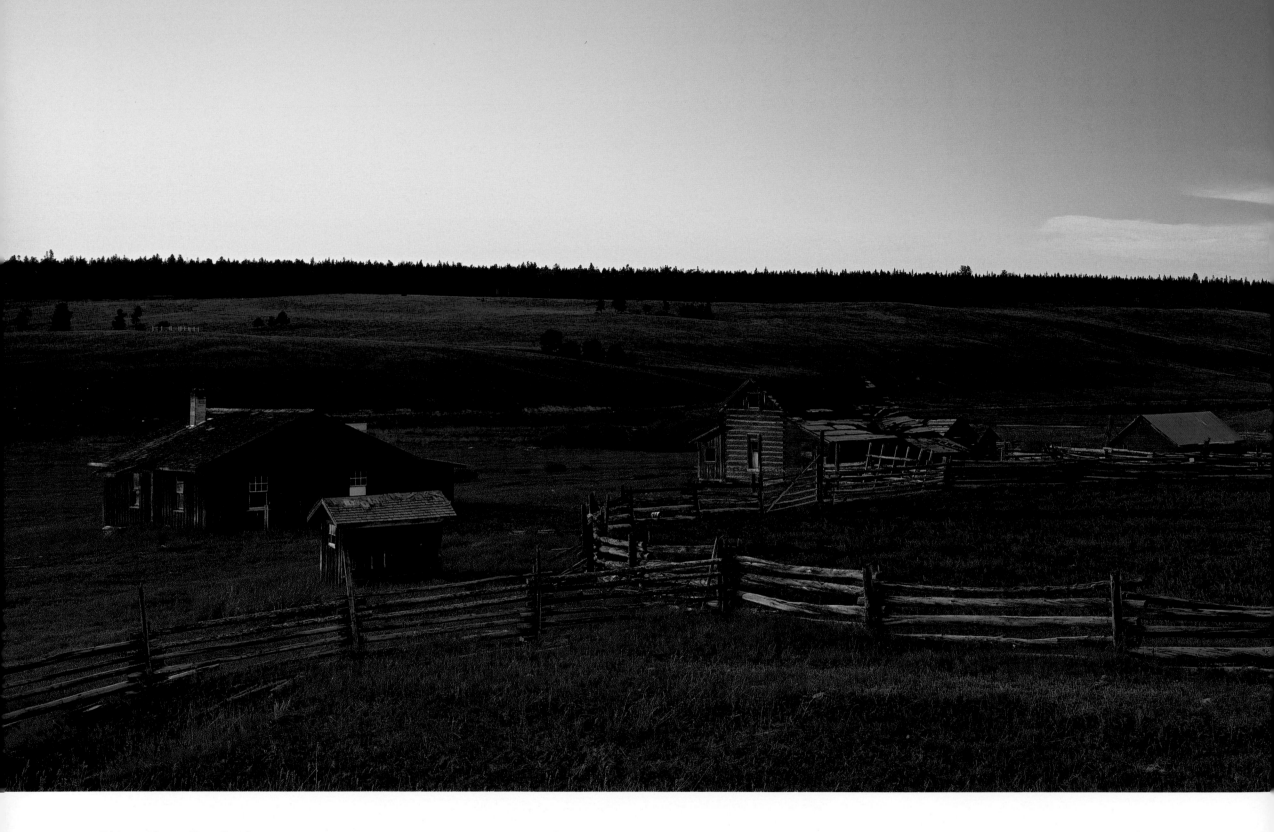

Old corral near Dog Creek

This old corral reminded me of a homestead from an old Western movie until a truck pulled up and a real-life cowboy unloaded two horses and a dog, then rode over and talked to me awhile before heading up into the hills to punch some cows.

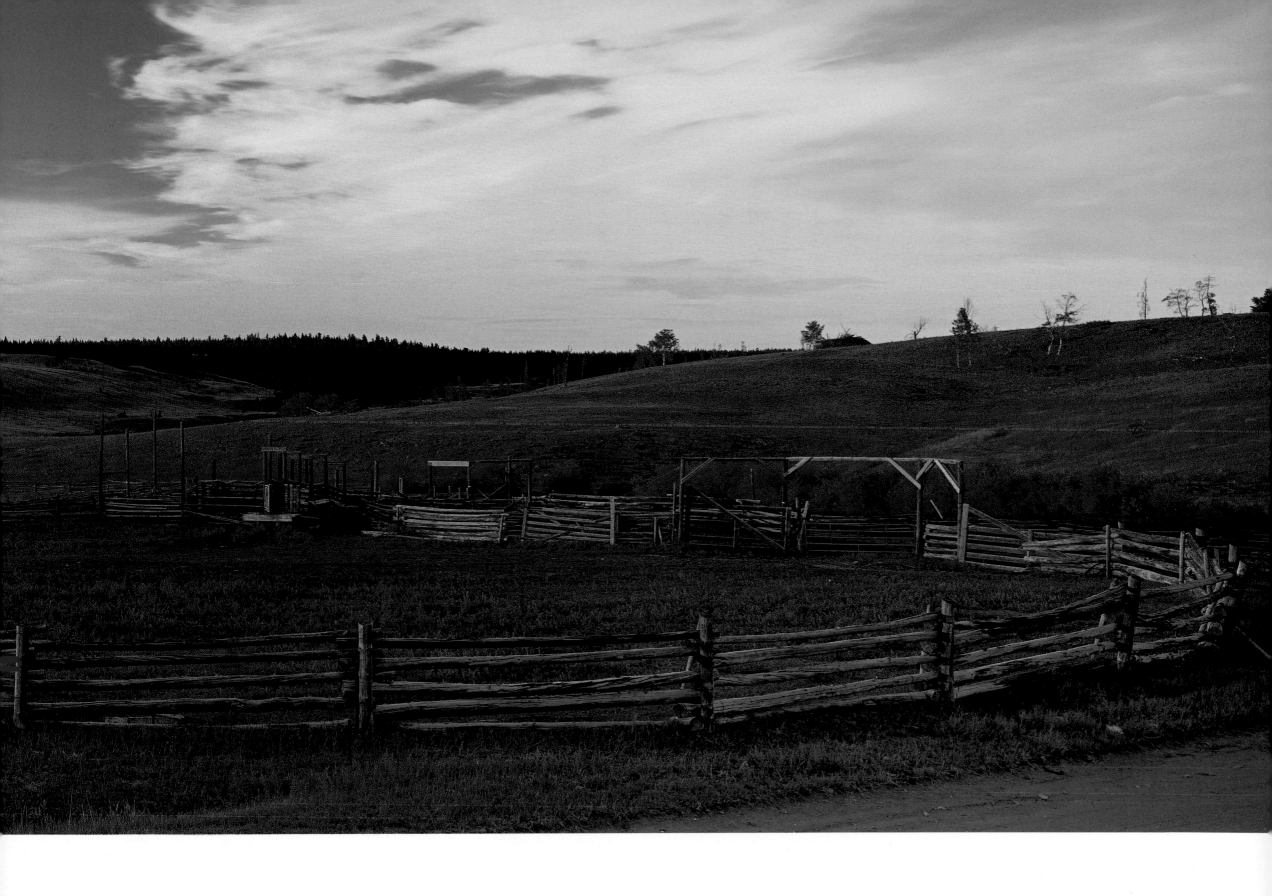

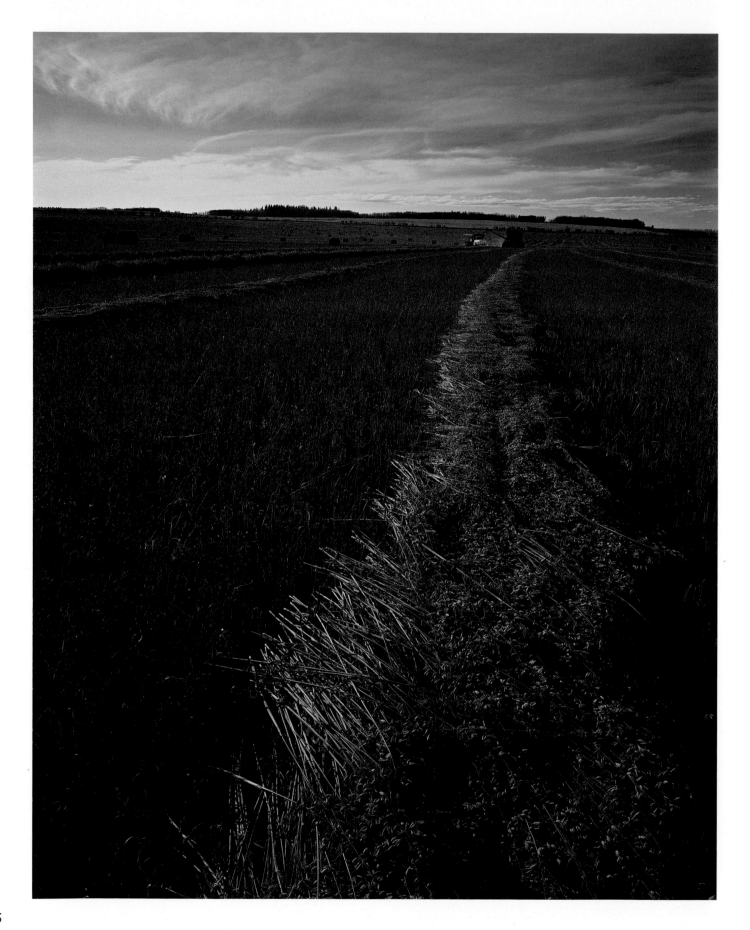

Rows of oats, Peace River

Normally one doesn't associate this sort of scene with British Columbia, but in the Peace River region we do have our own little prairie that produces wheat, oats, canola and good photographs.

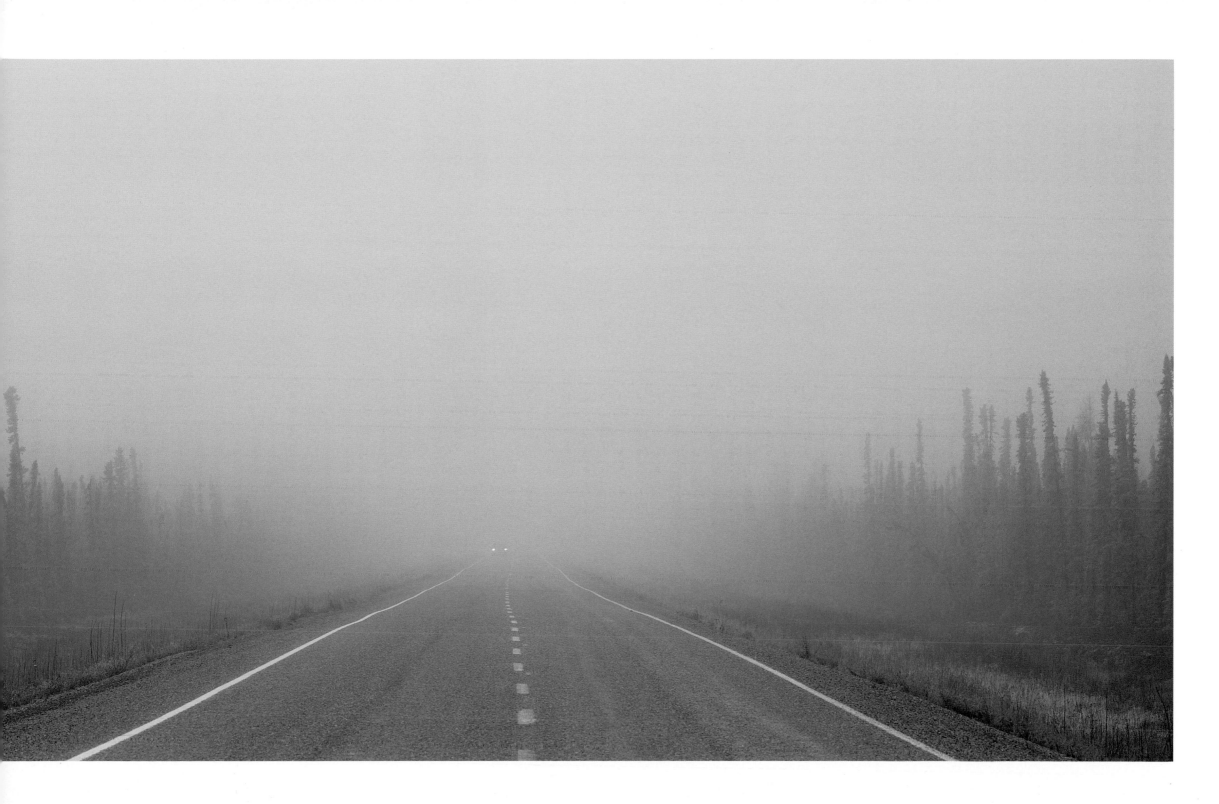

Alaska Highway in fog

Following pages: Aspens near Clearwater

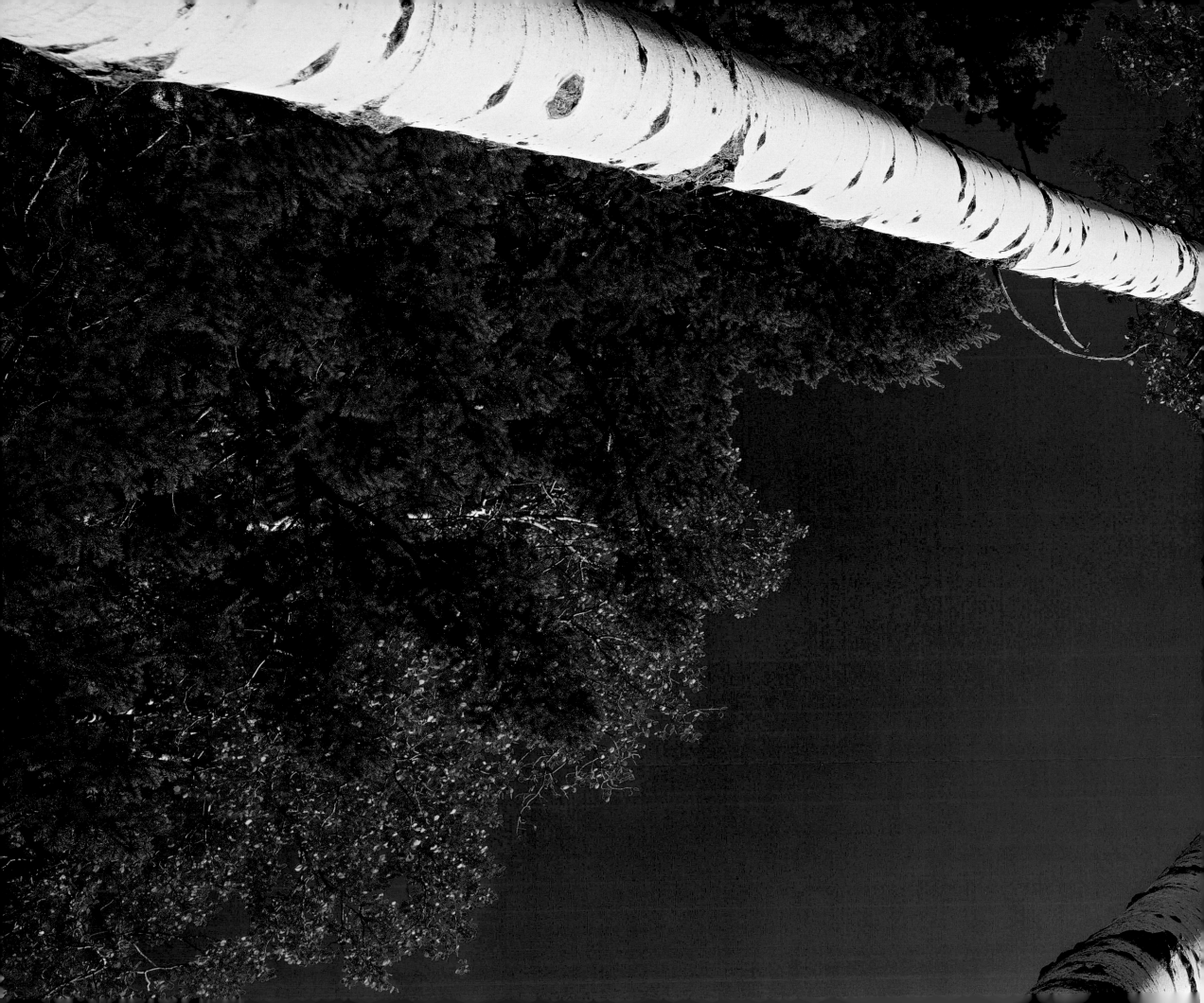

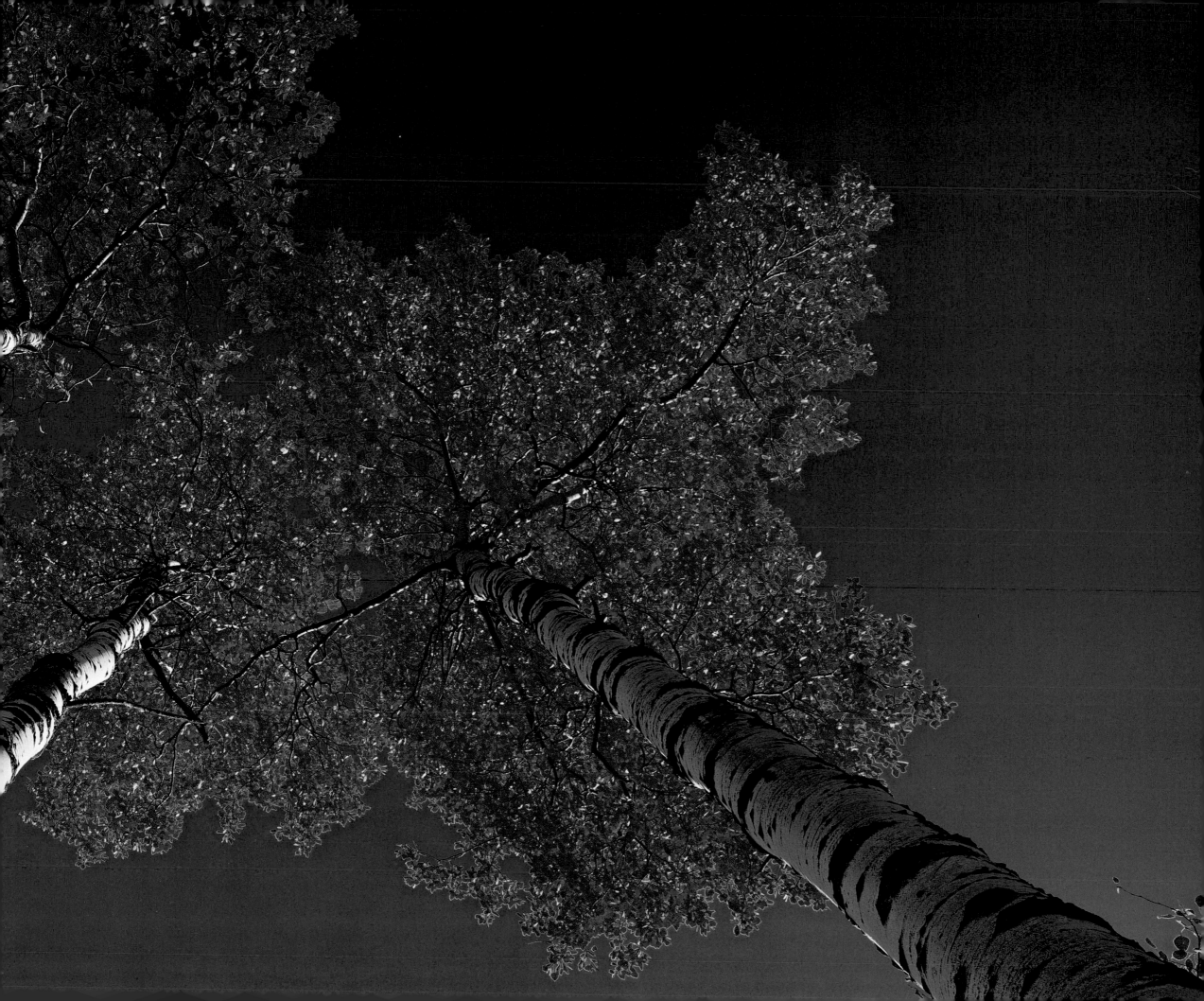

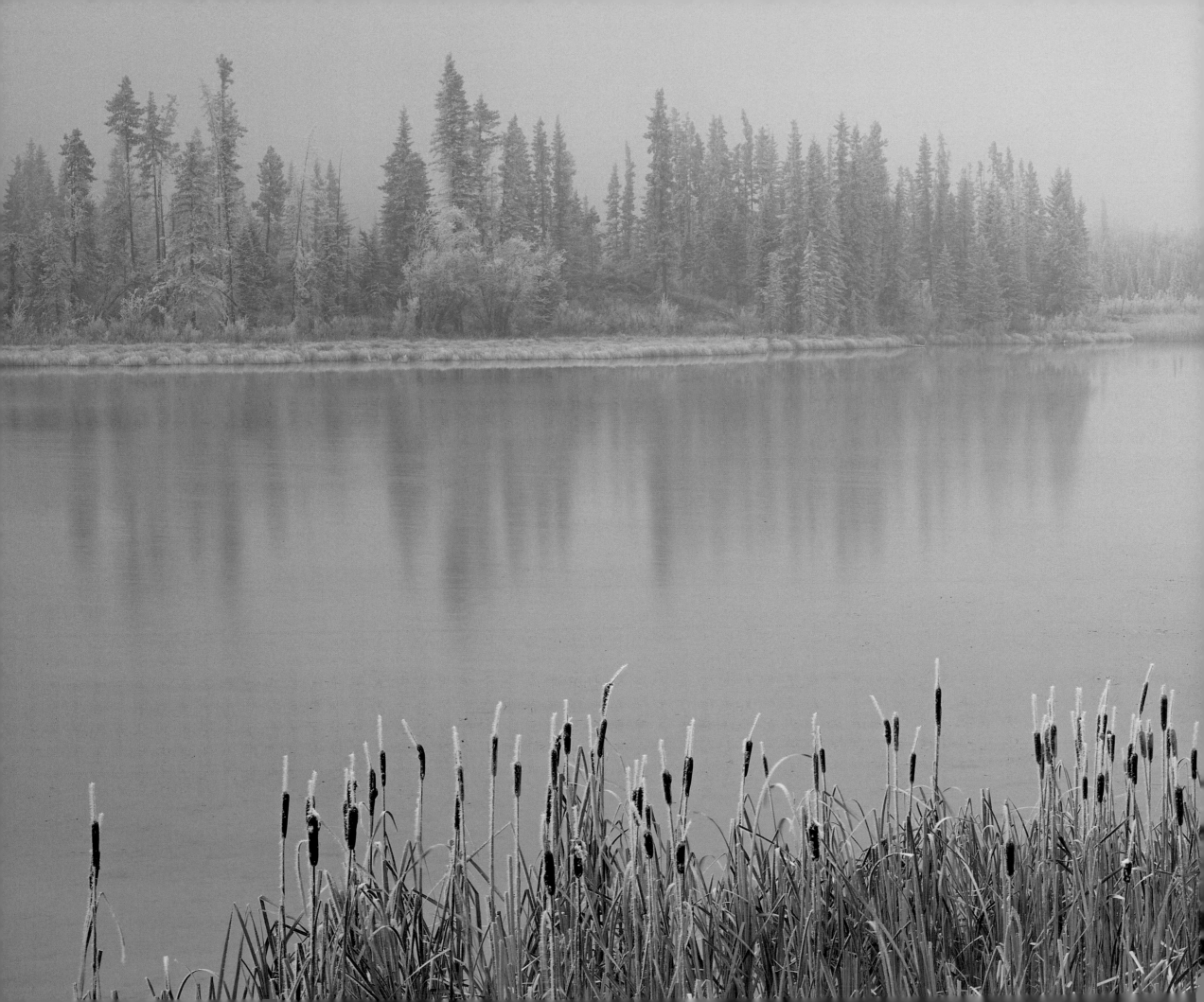

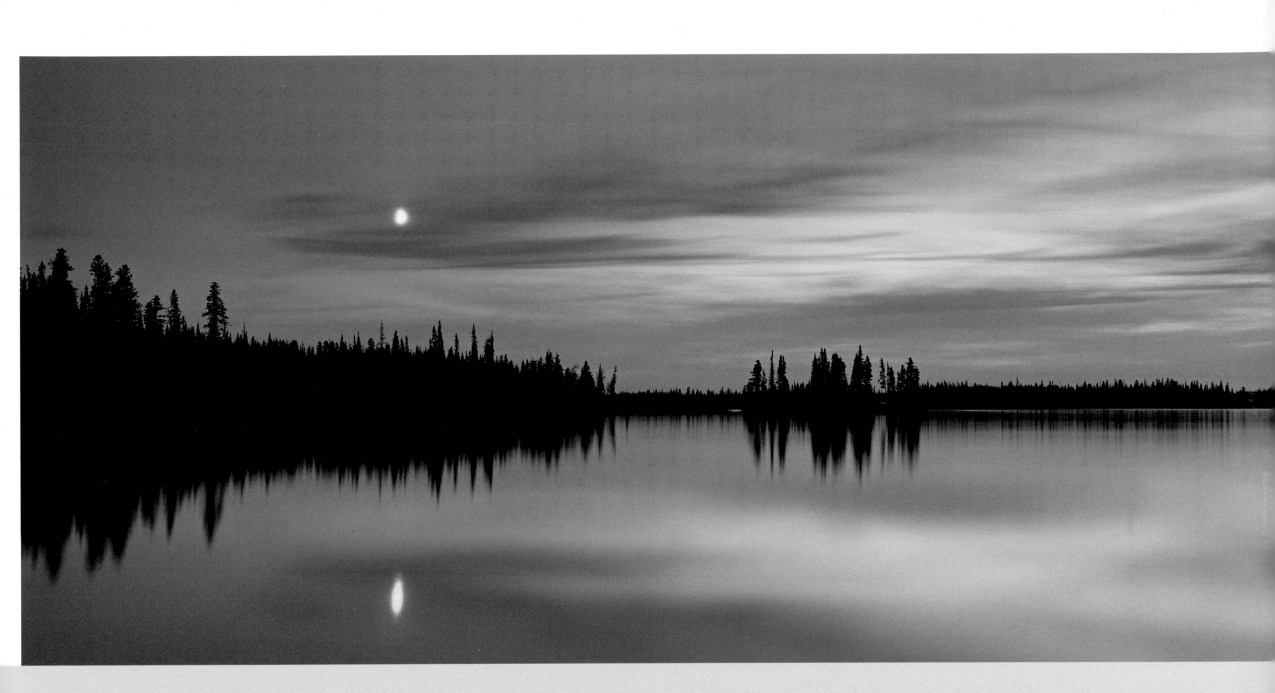

Opposite: Frozen bulrushes near 100 Mile House

Three-quarter moon rising over Summit Lake north of Prince George

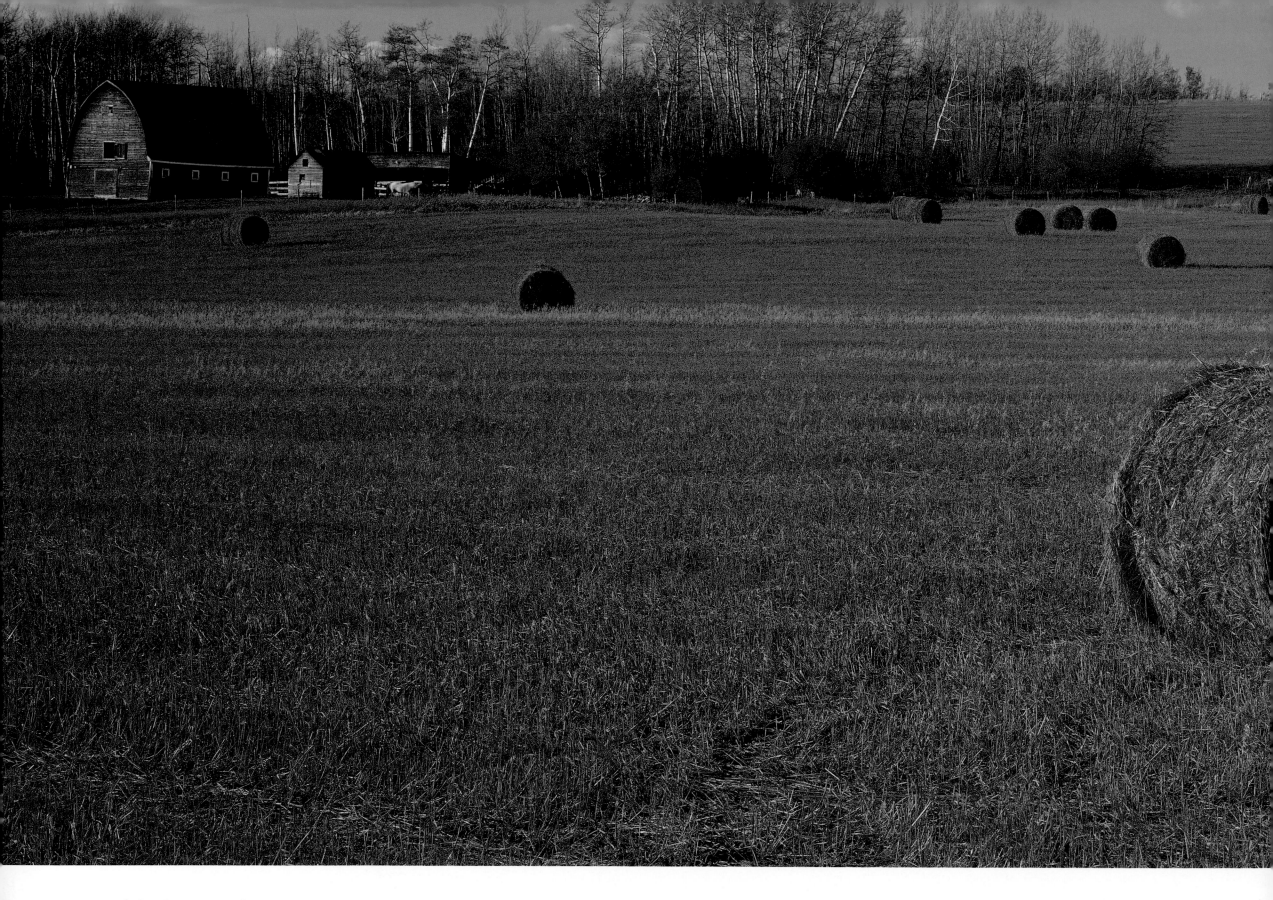

Hay bales, Dawson Creek

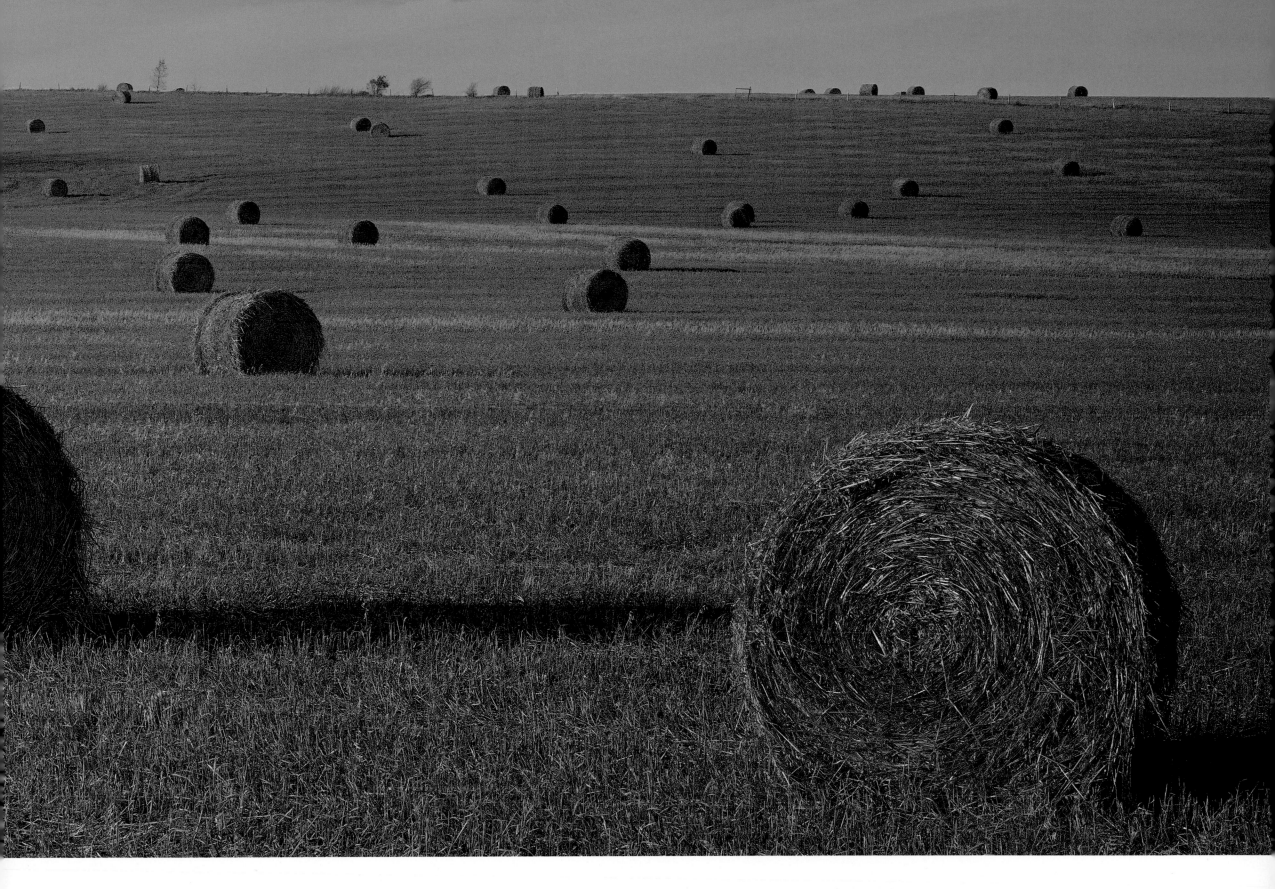

Following pages: Frost-covered trees, Alaska Highway

I shot a lot of film to get this picture. It was a foggy day, and well below freezing, so instead of forming dew when it condensed, the fog formed a coating of ice crystals on everything.

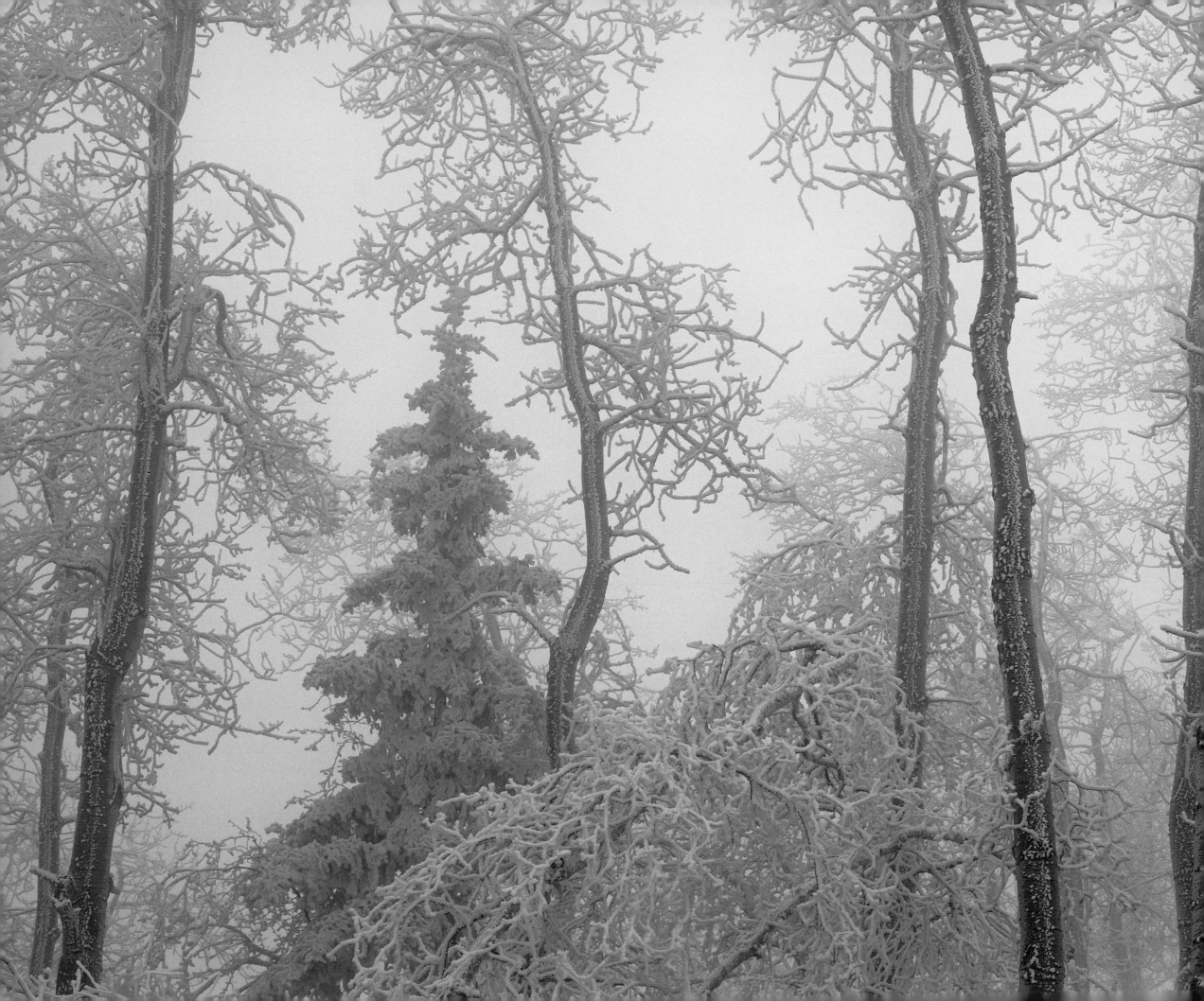

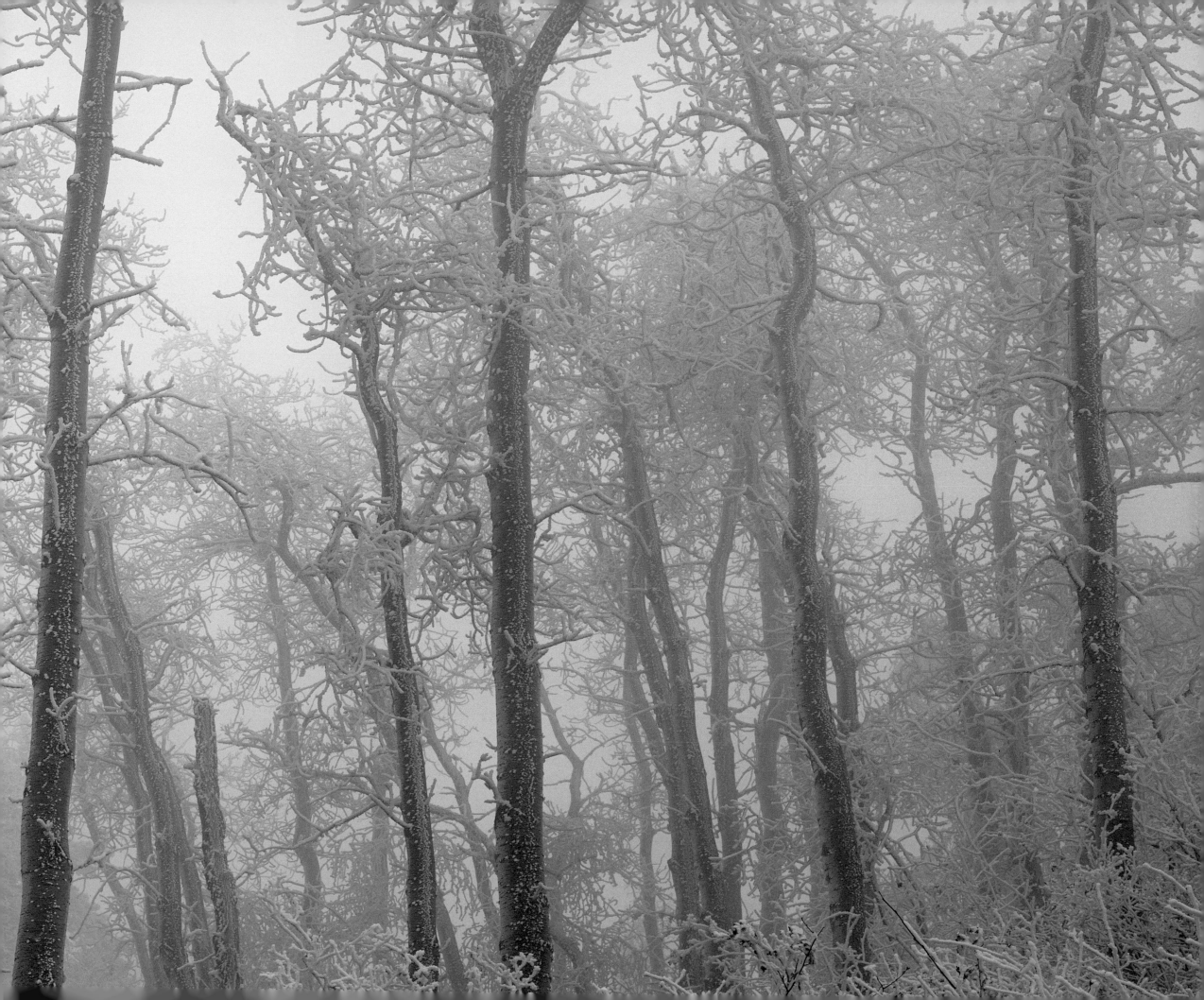

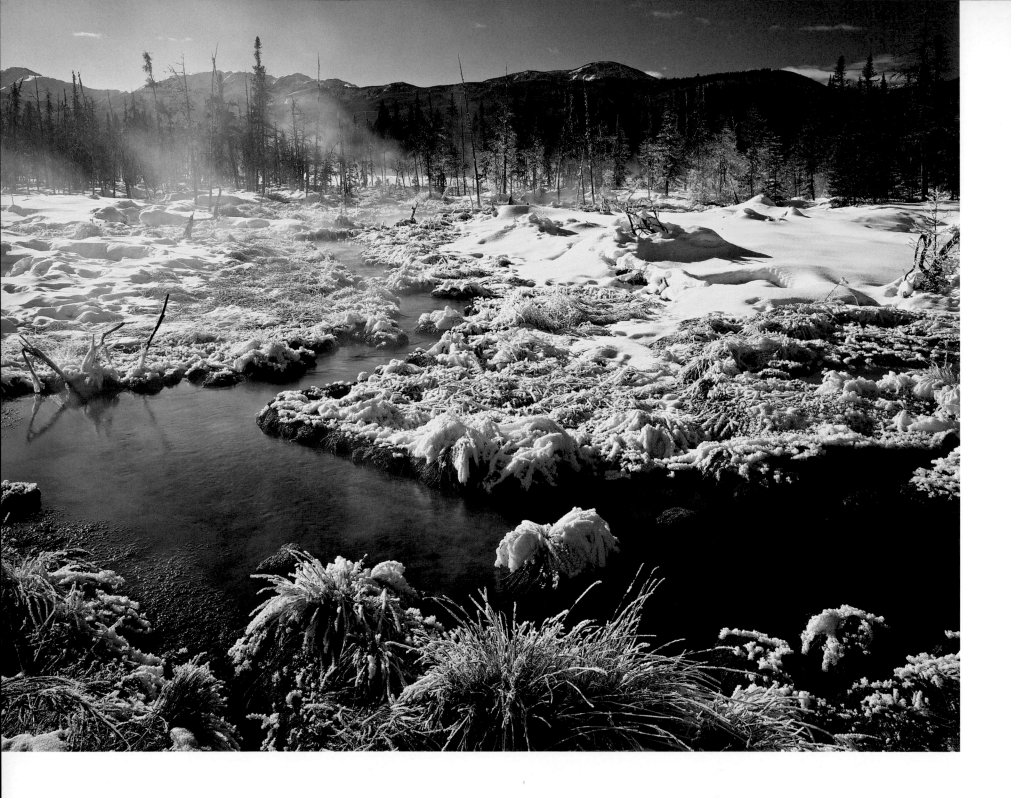

Liard River Hot Springs in January

While outside air temperature dips to minus 30°C, insects, snails and a unique species of fish, adapted to warm water life, bask all winter in the hot spring. Rushes, their roots nestled in the warm mud, are fooled into sending succulent new shoots up into the winter air, where they are promptly frozen off at water level. Summer transforms the place into a temperate jungle.

Right: Northern Lights with moon over Boya Lake

The Inuit believed the aurora were torches leading the dead to the land of souls. Scientists say that northern and southern lights are caused by the solar wind knocking electrons off oxygen and nitrogen molecules in the upper atmosphere. I suspect they are God finger-painting the sky in her spare time.

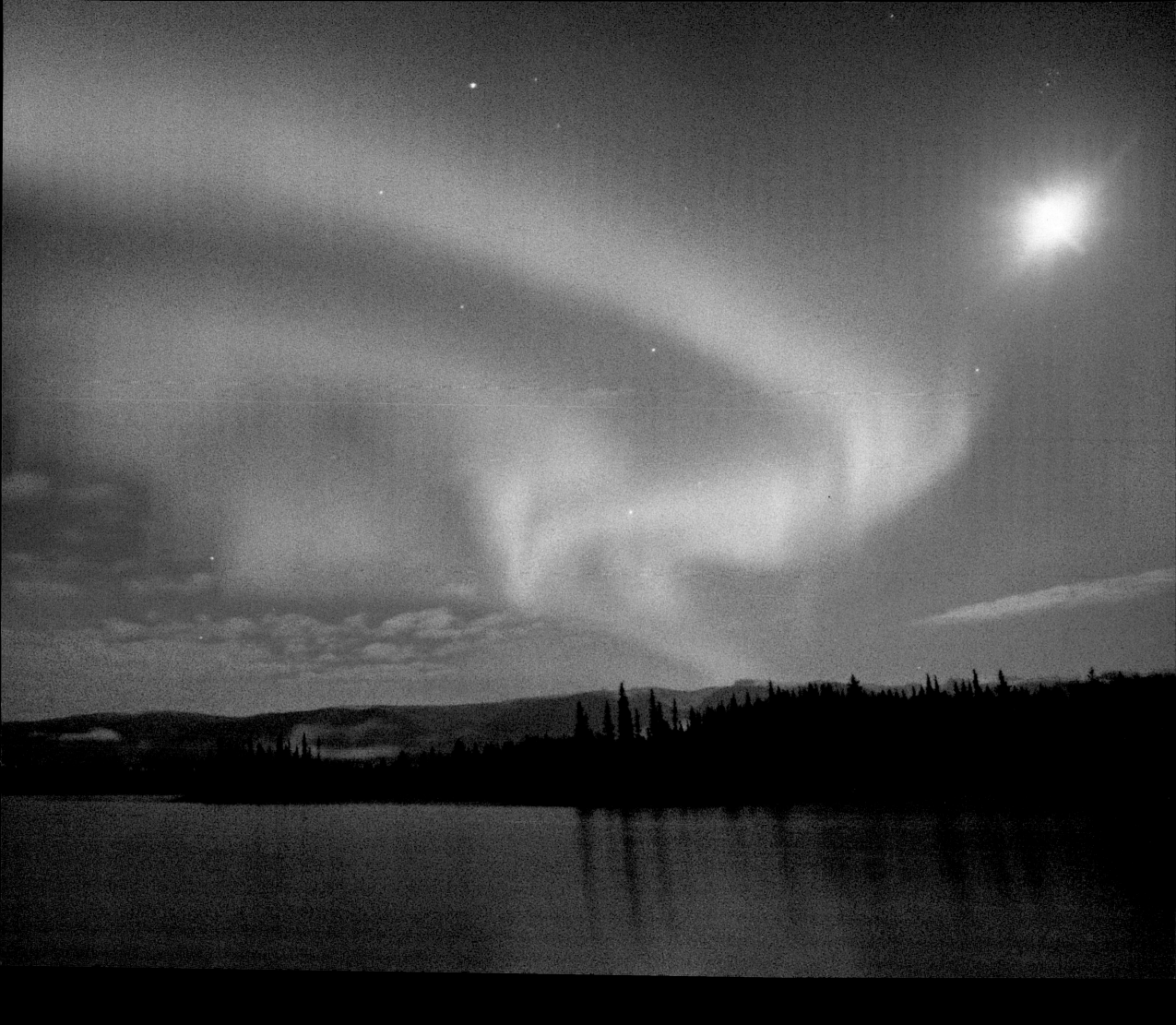

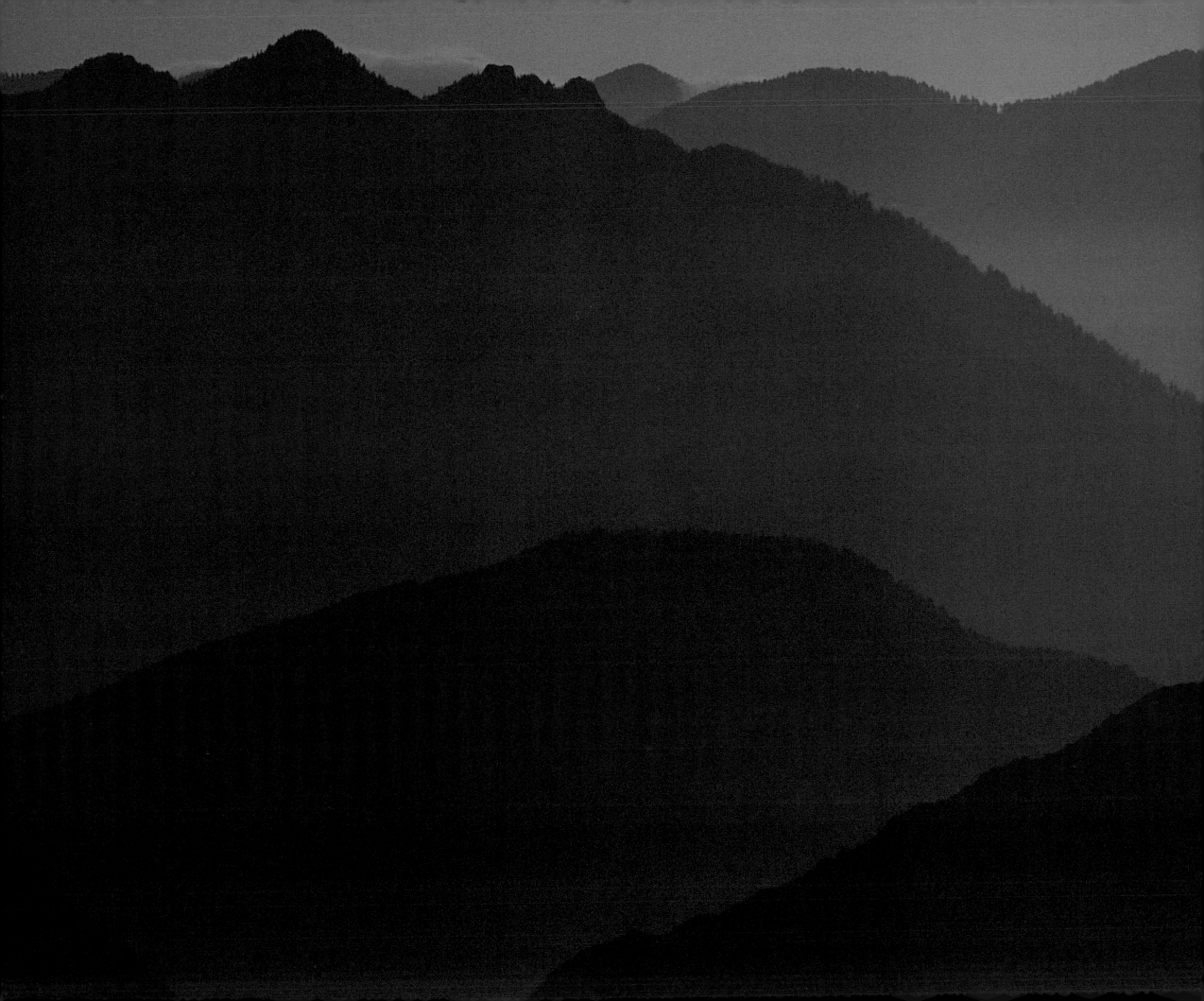

North Coast

Coast Mountains at sunset

When nature gets in a colourful mood all the photographer has to do is capture the performance.

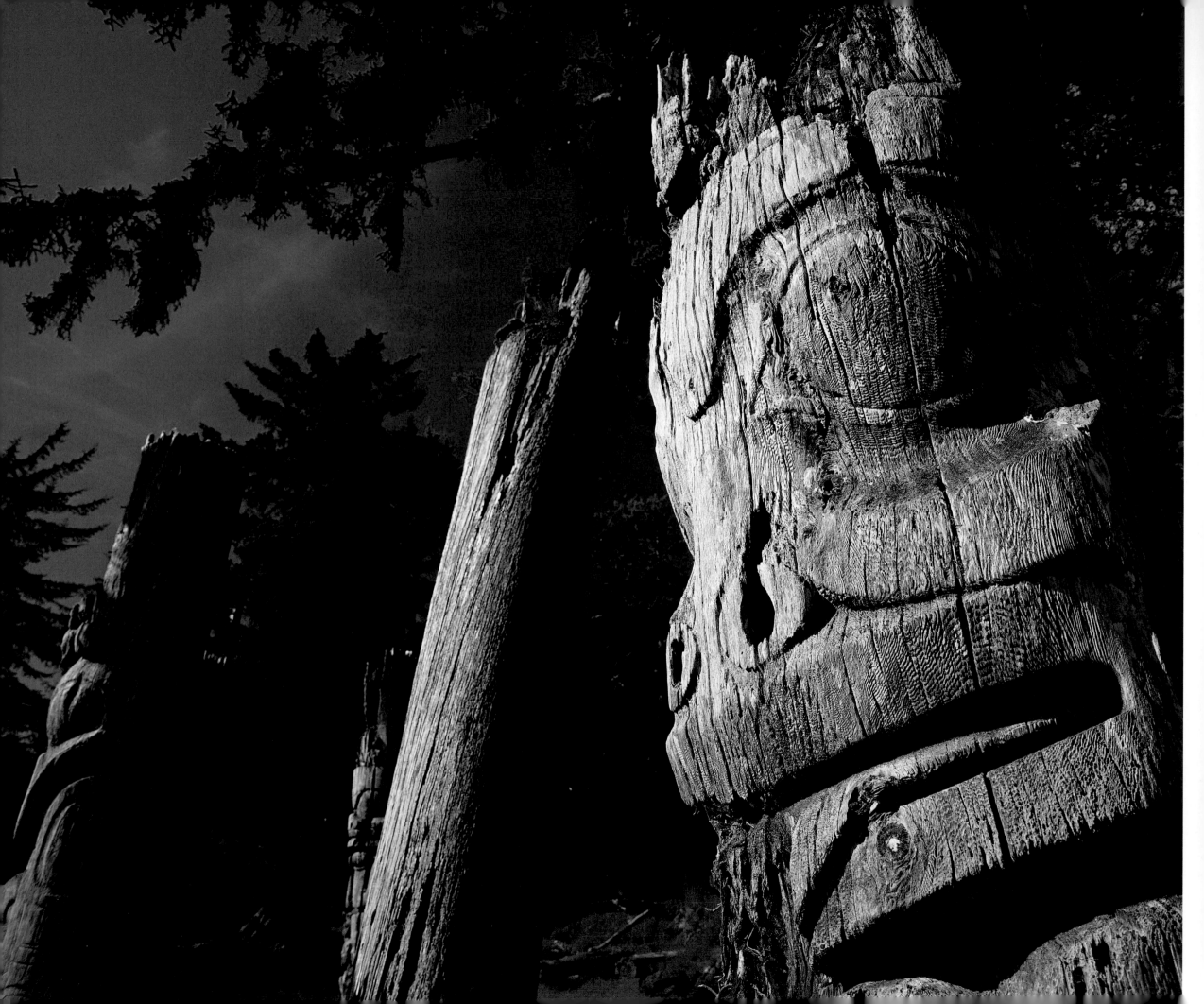

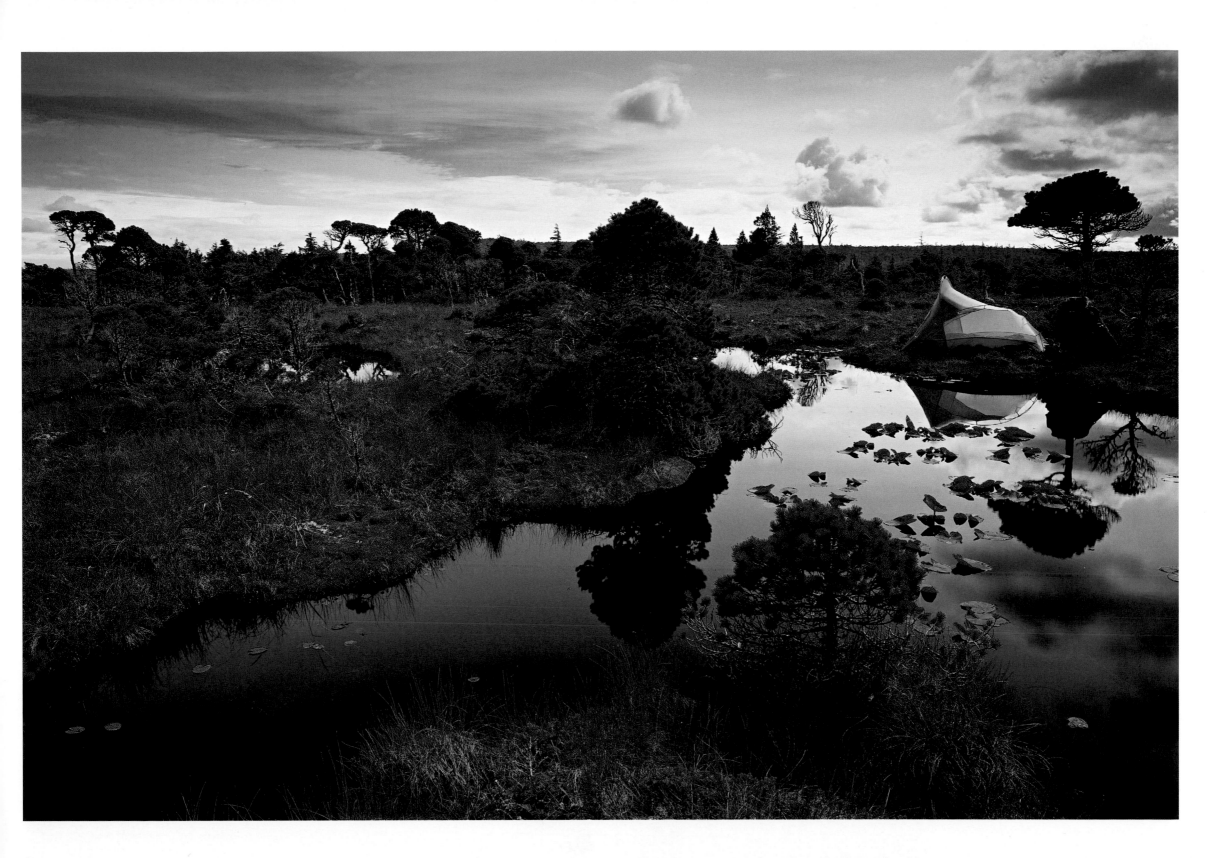

Haida totems

Bear mortuary pole in the ancient Haida village site of Ninstints, declared a World Heritage Site by UNESCO in 1981.

Naikoon Provincial Park, Queen Charlotte Islands

Everyone who's seen this picture says it looks like something out of Africa. That's what I thought too, except that every step you take in this place is on squishy, soaking wet moss.

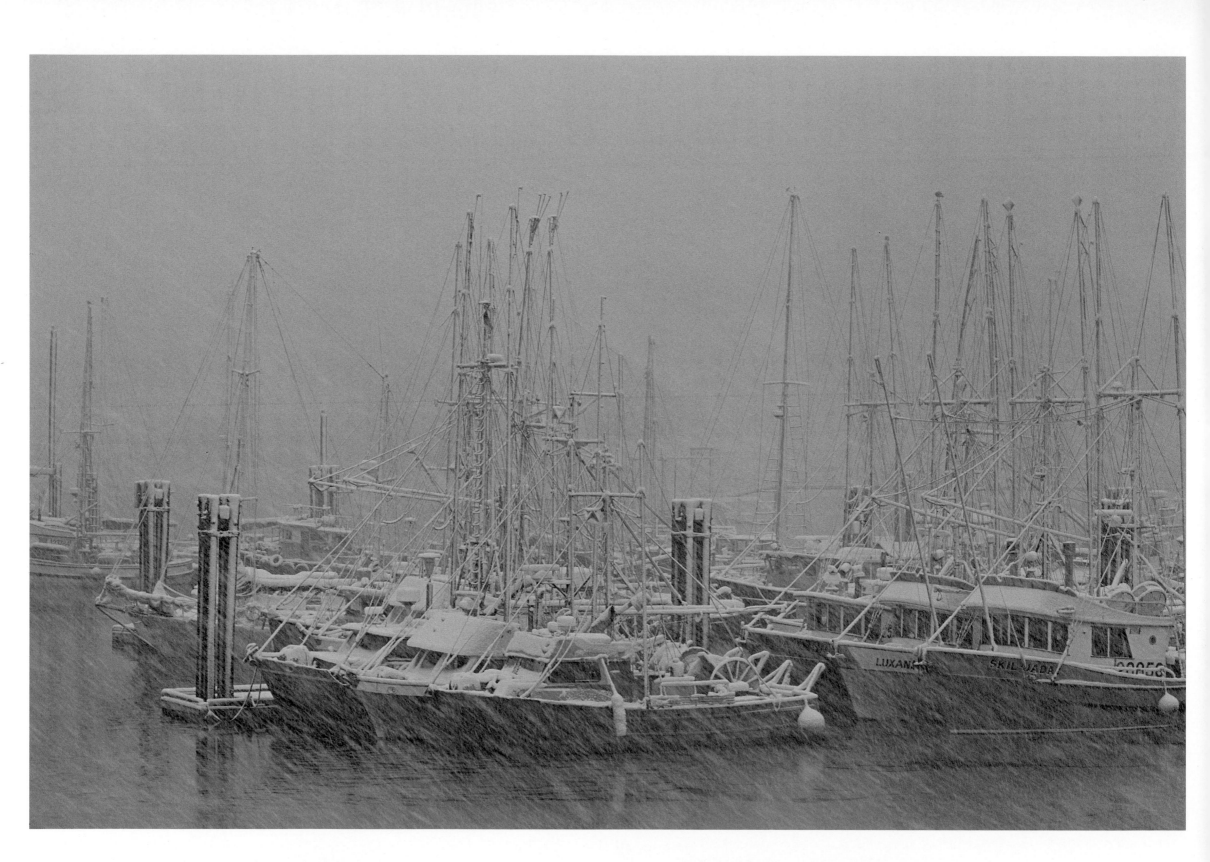

Fishing boats in a March snowstorm, Queen Charlotte Islands

Opposite: Abandoned fishing boats, Masset

Fishing boats from another era—abandoned and quietly rotting on the beach in Masset. The sun had already set on their days at sea.

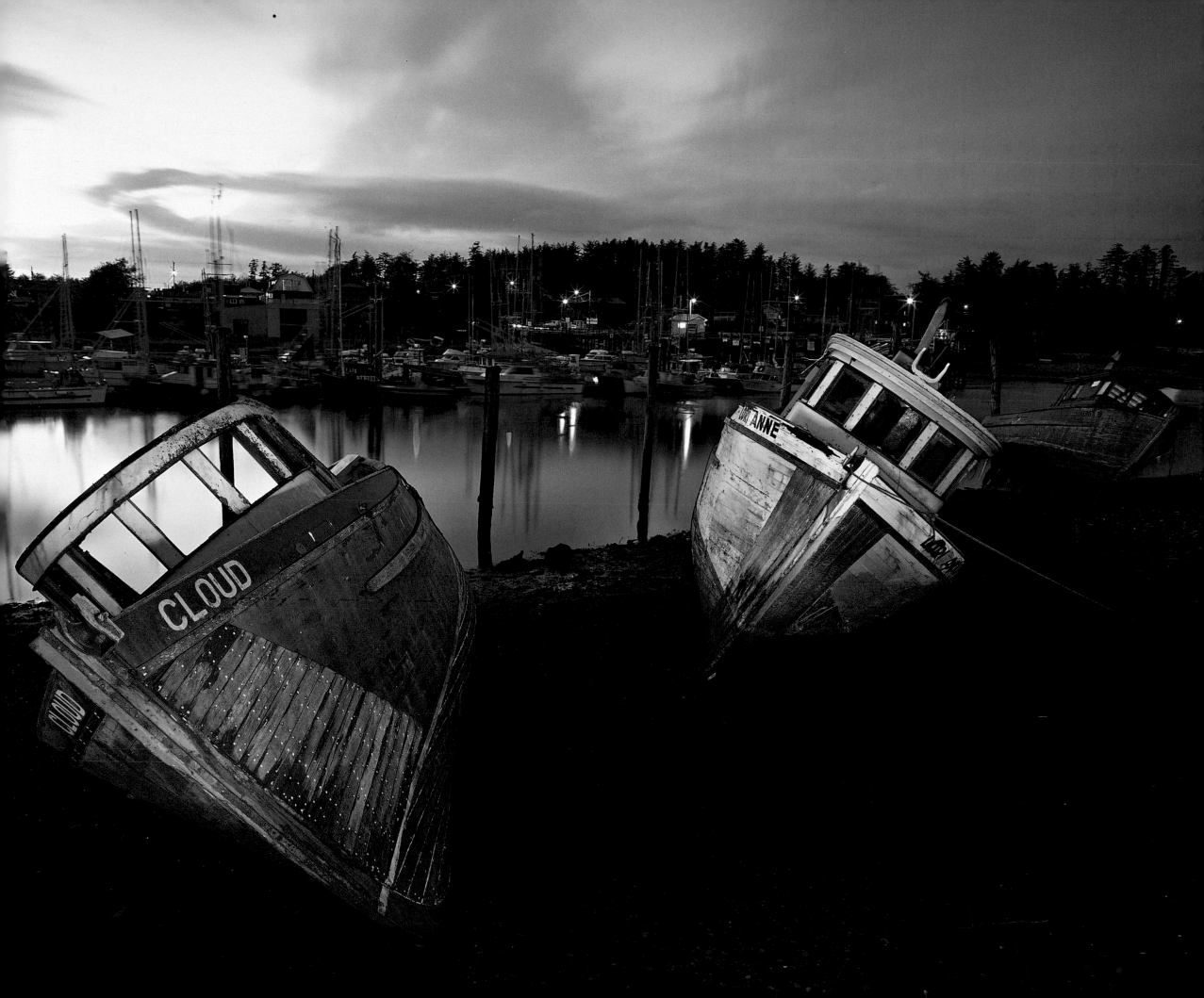

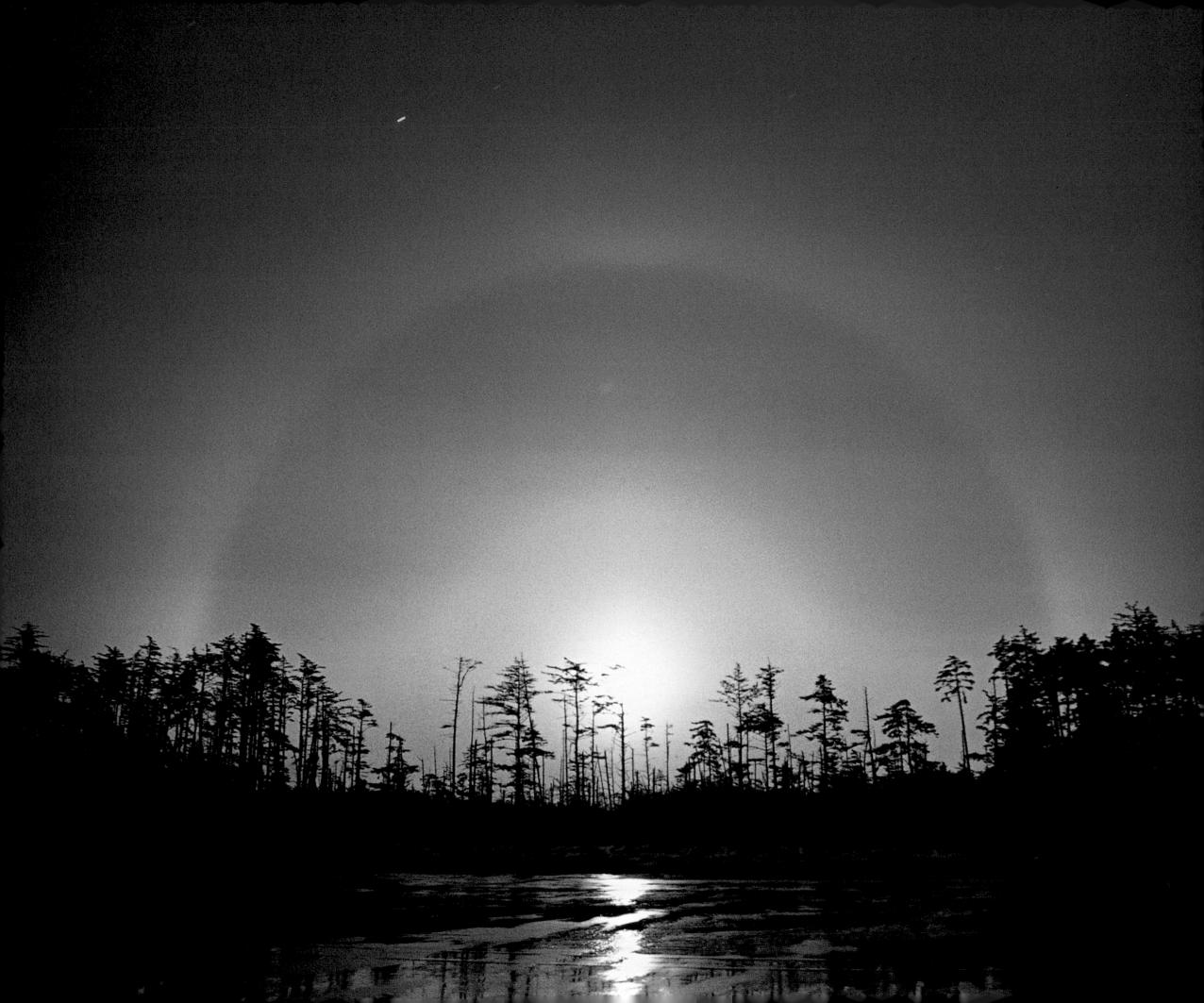

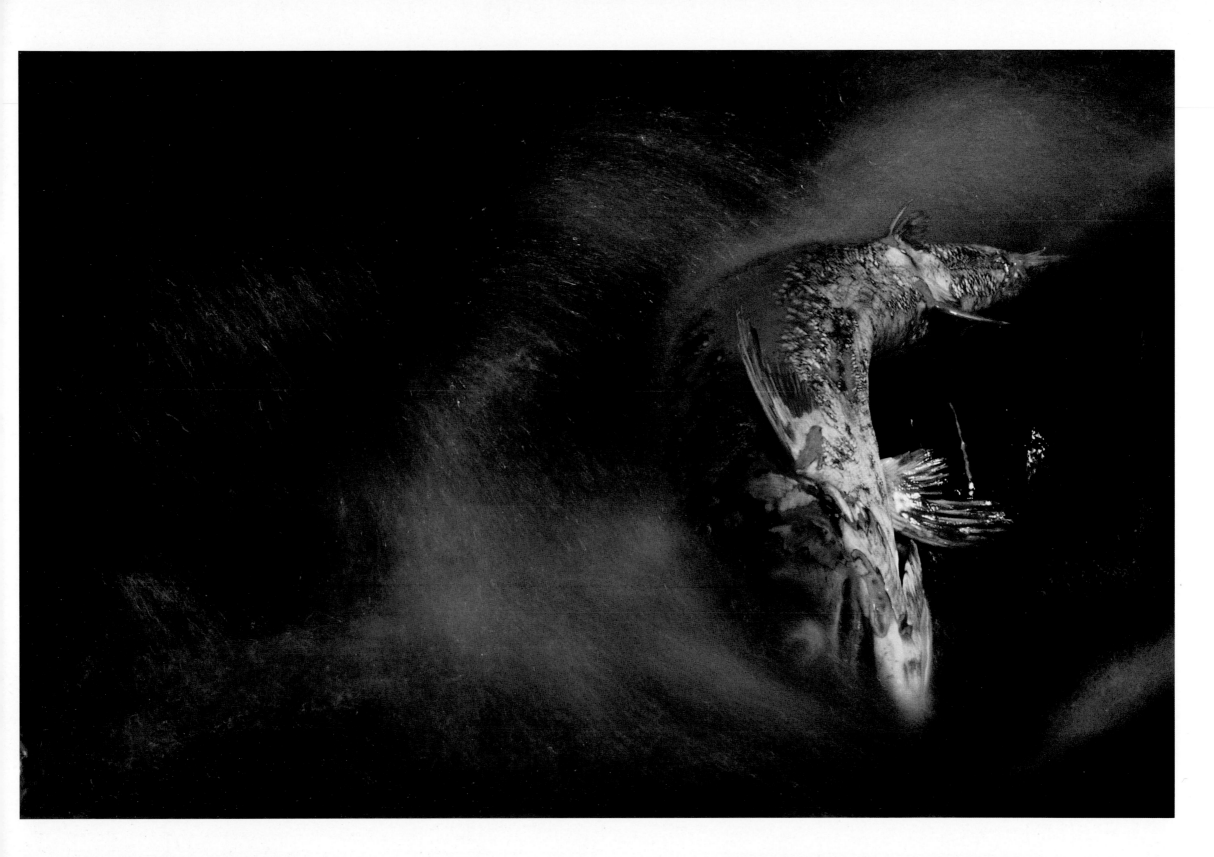

The two lunar halos in this picture are the work of icy particles in the upper atmosphere viewed through a veil of cloud.

Dead spawned Chum salmon, Queen Charlotte Islands

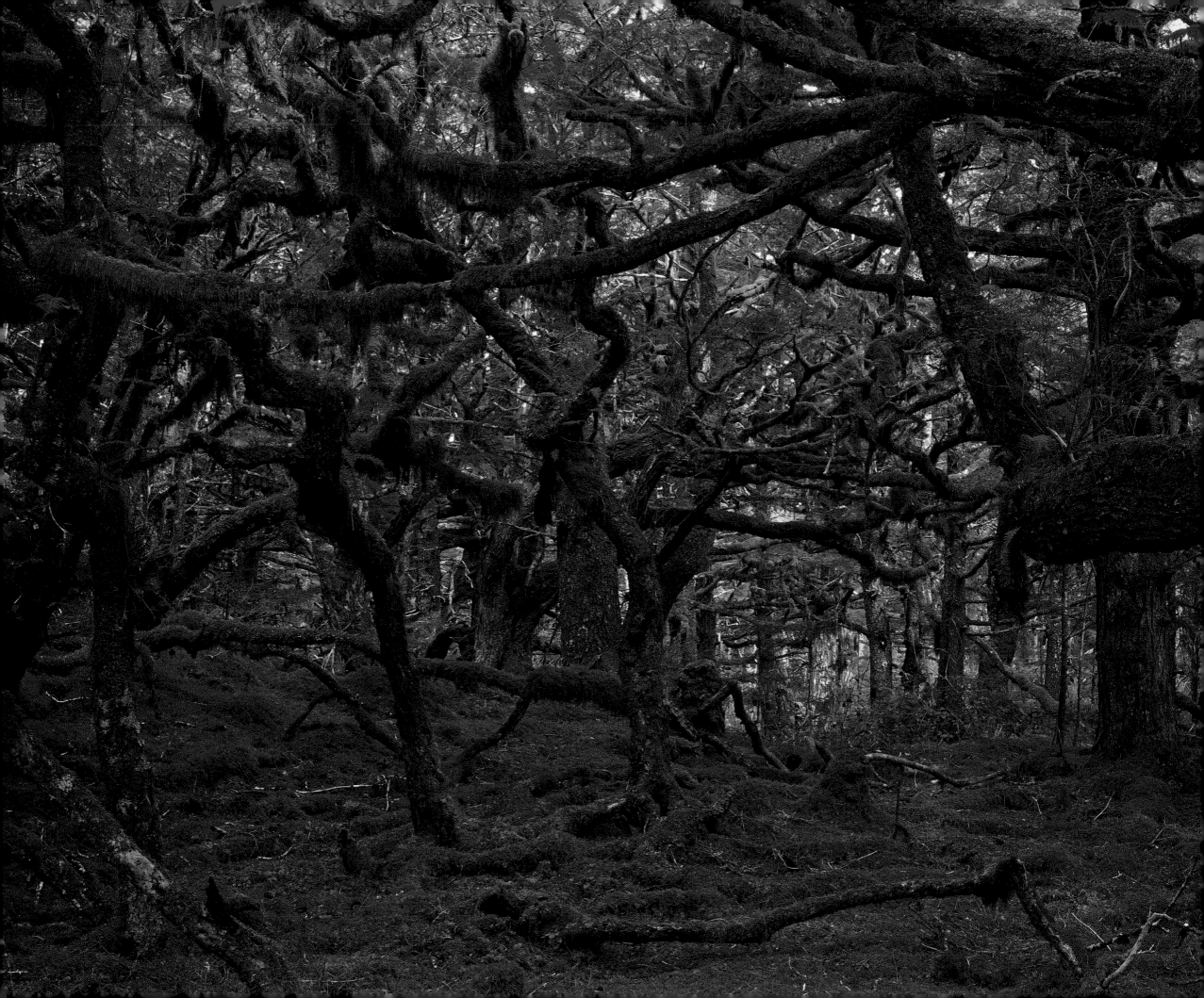

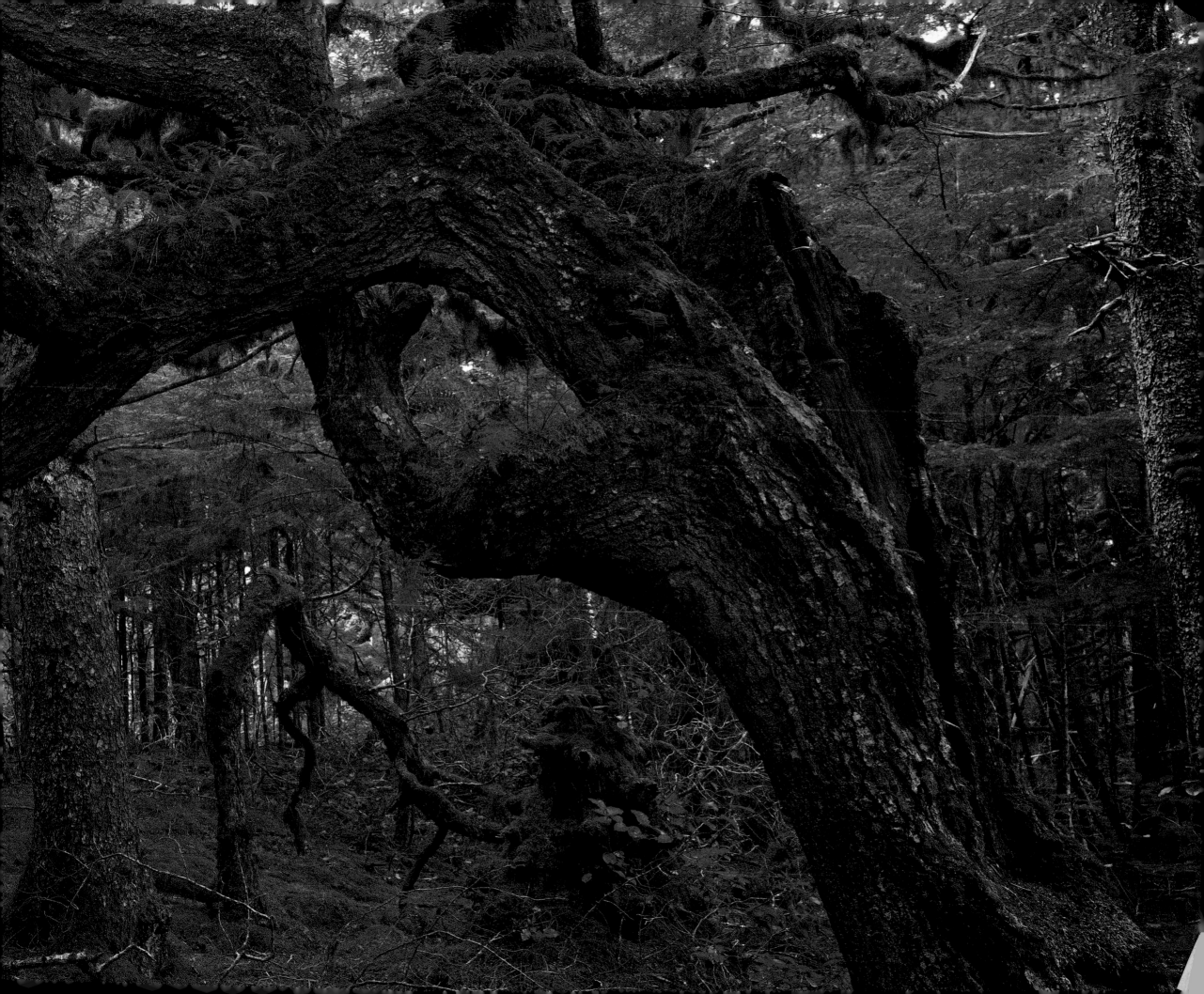

Preceding pages: Naikoon Rainforest

Sitka spruce and hemlock normally have one straight main trunk, but here for some reason they grow in a twisted multi-trunked pattern, giving the forest an eerie unfamiliarity.

Fly agaric, *Amanita muscaria,* Queen Charlotte Islands

The original pesticide, Europeans would chop *Amanita muscaria* and add it to a dish of milk to kill flies.

Opposite: View from the alpine of Takakia Lake, Queen Charlotte Islands (Haida Gwaii)

I had always thought of Haida Gwaii in terms of rainforests and tide pools, but was happily surprised to discover that the place has an alpine dimension as well. The best part is that you don't have to hike uphill six or seven thousand feet to find it. Here at the 54th parallel, alpine starts low, at around the thousand-foot level.

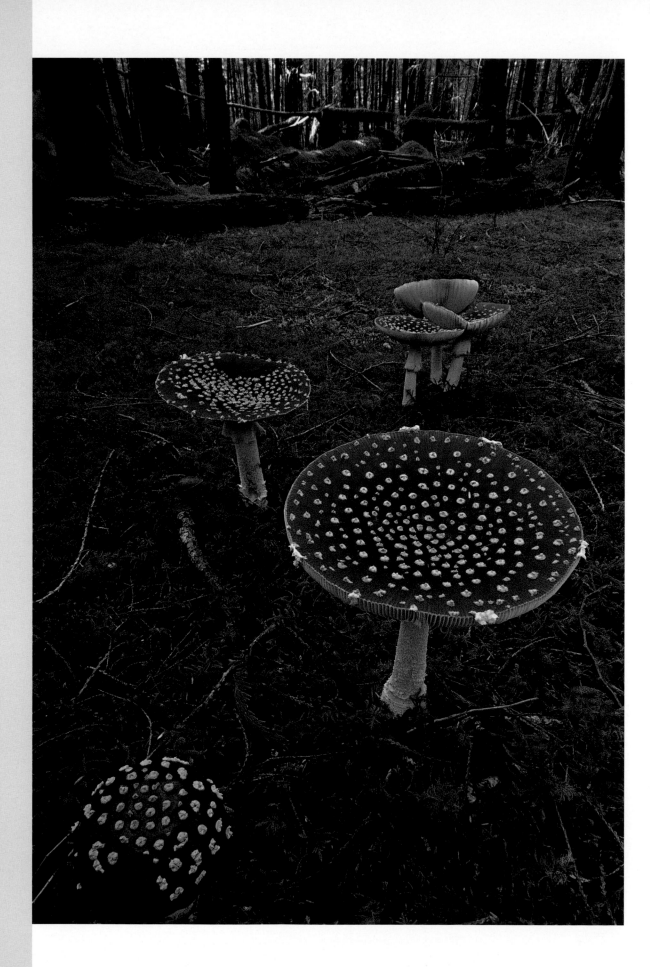

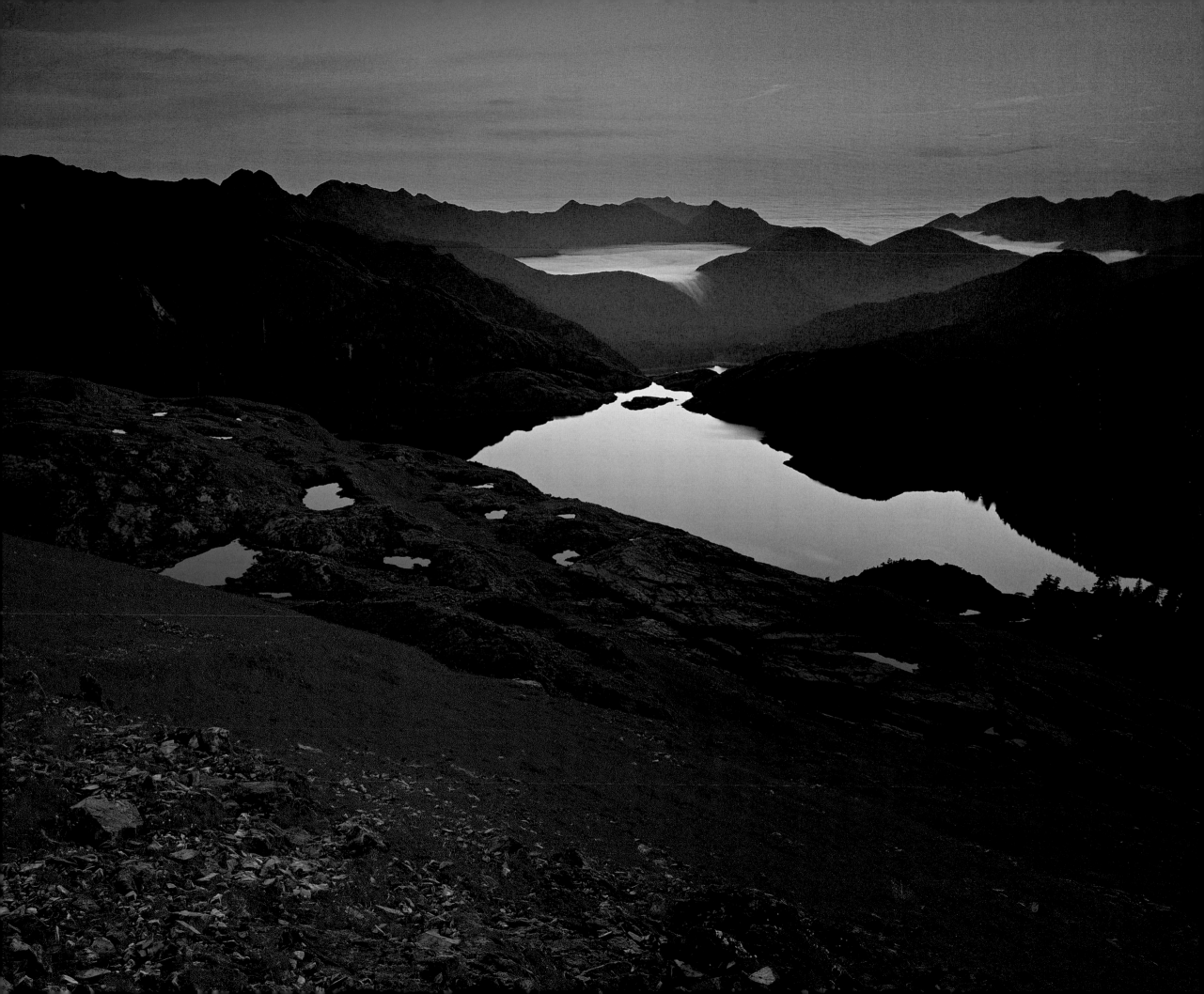

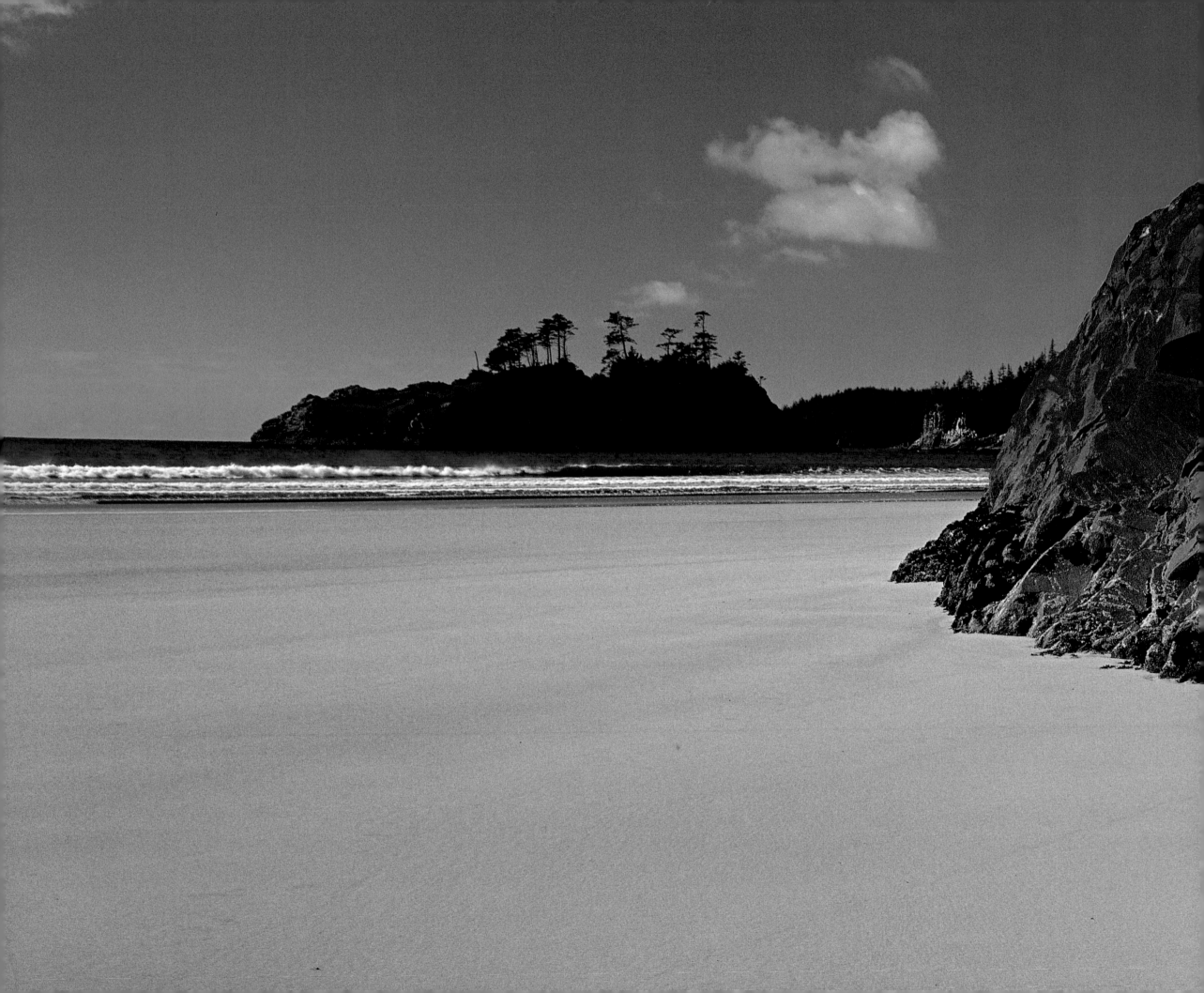

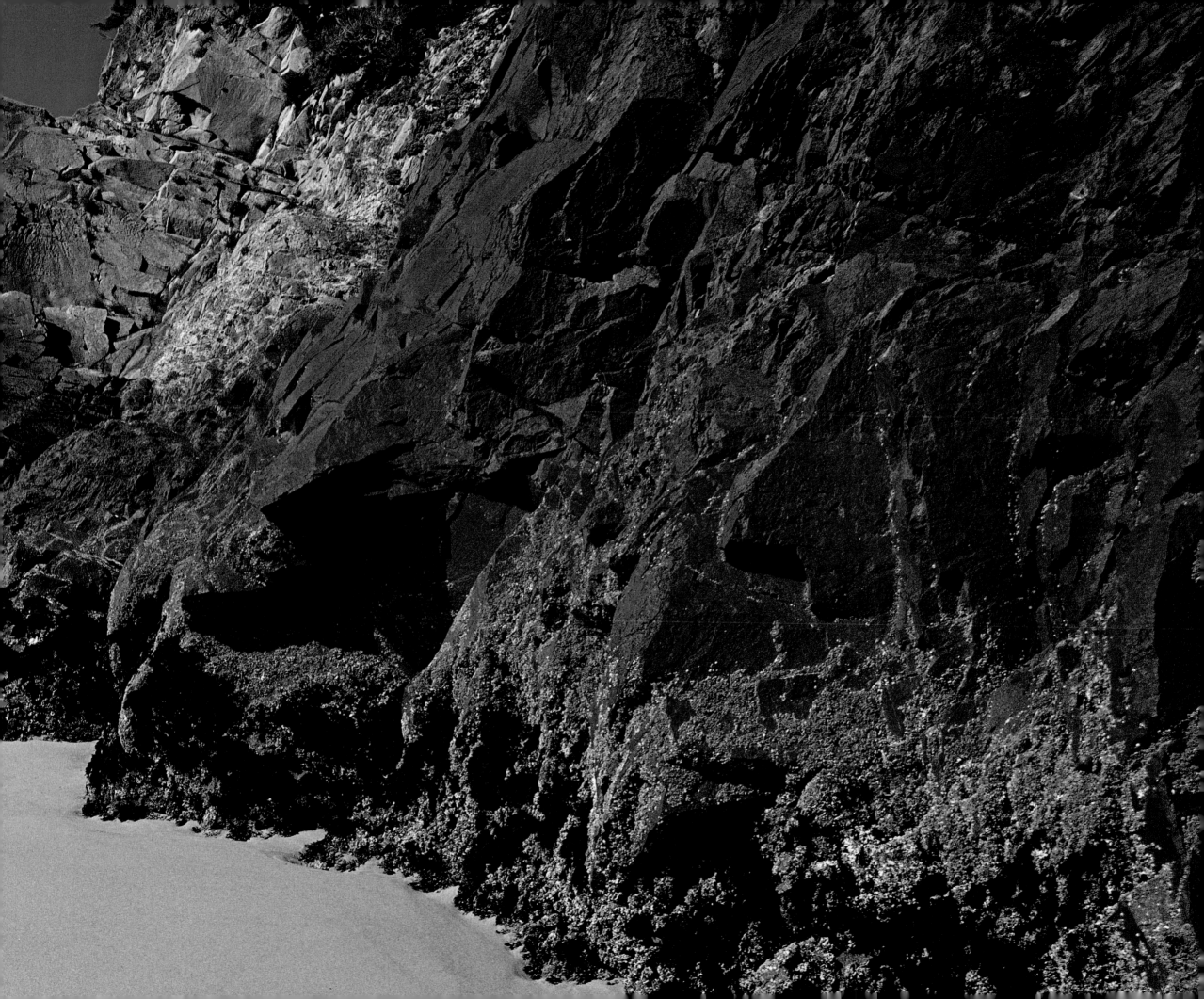

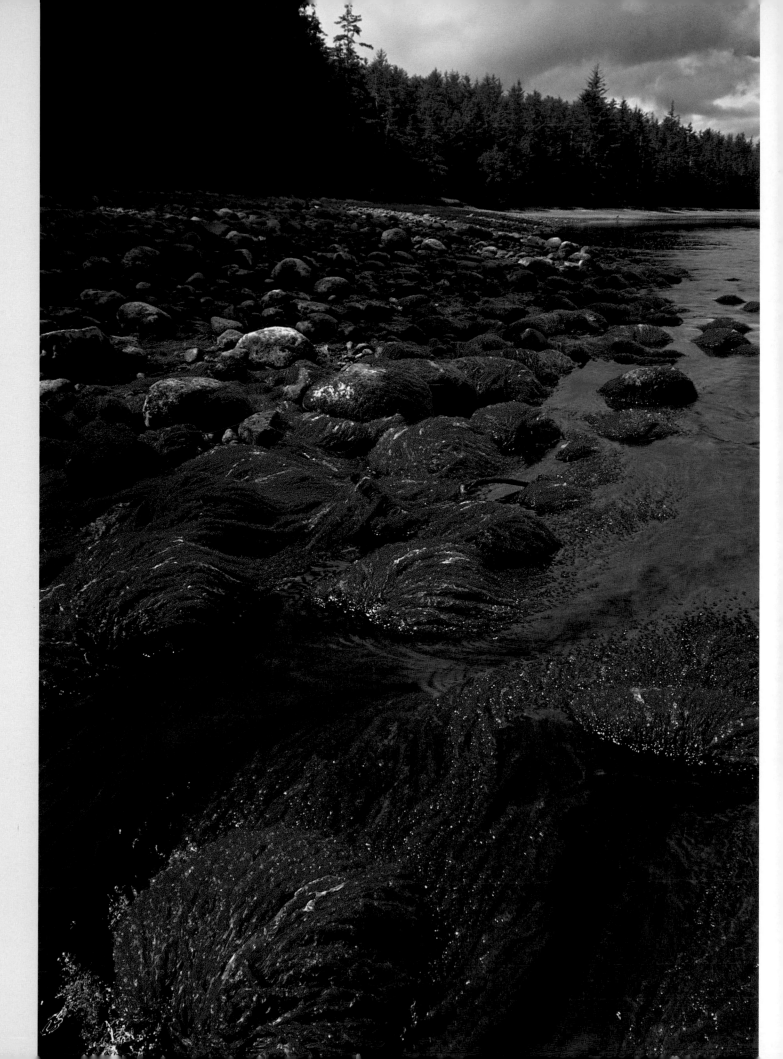

Preceding pages: Lepas Bay, northwest corner of Graham Island, Queen Charlotte Islands

Algae in the tidal zone of the Tlell River

Opposite: Dolomite Narrows, Queen Charlotte Islands
Visiting the narrows at low tide is like scuba diving in gumboots. When the sea recedes for the afternoon, stacks of sea urchins, anemone, moon snails and giant clams sprawl over each other in wait for the ocean's next delivery.

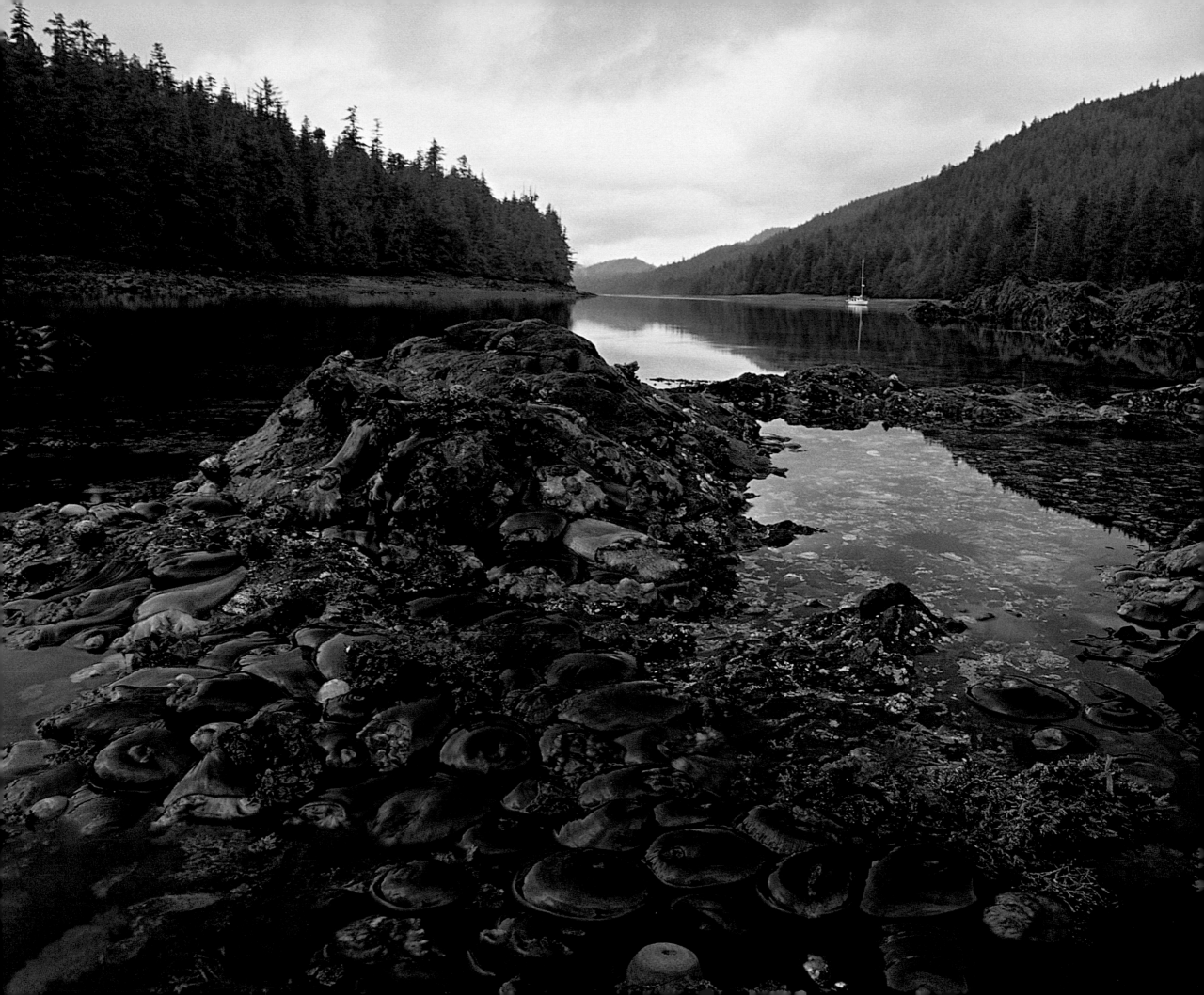

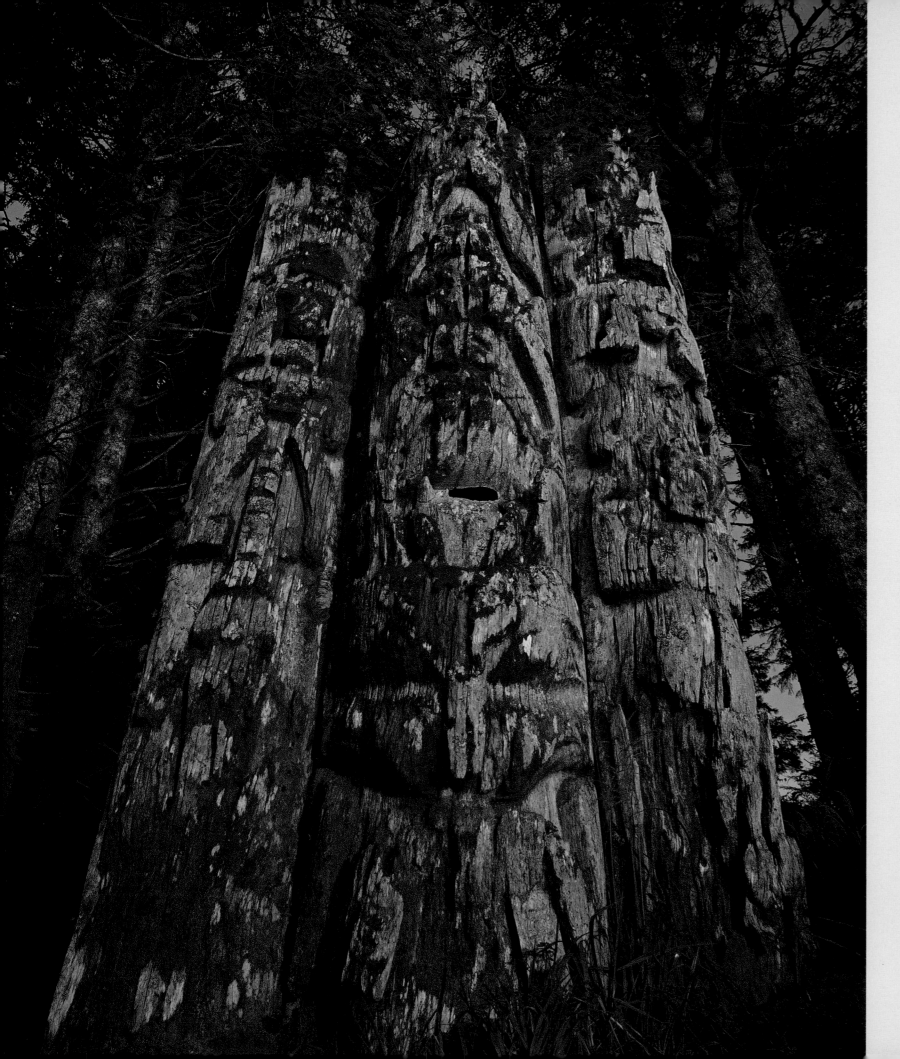

Triple mortuary totems in the abandoned village of Kiusta, northwest tip of Graham Island, Queen Charlotte Islands

Also known as the Edenshaw mortuary pole, it is believed to have been erected between 1830 and 1850, and once bore aloft the remains of Chief A.E. Edenshaw.

Opposite: Road through Naikoon Provincial Park, Queen Charlotte Islands

Sometimes a road is a beautiful feature of the landscape in its own right. With its gnarled old-growth trees and mist that lasts for days, this one makes getting there one of the best parts of Naikoon.

Following page: Wave watching, Rennell Sound

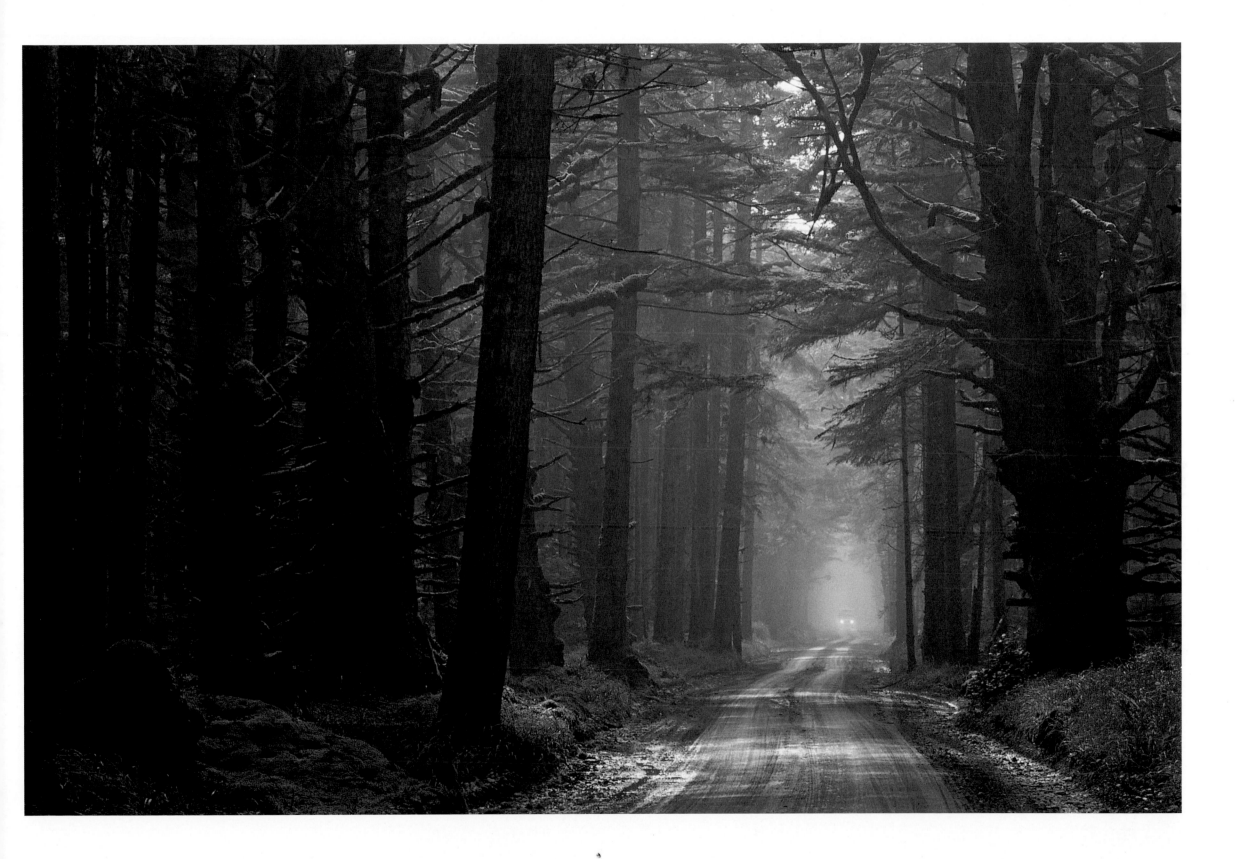

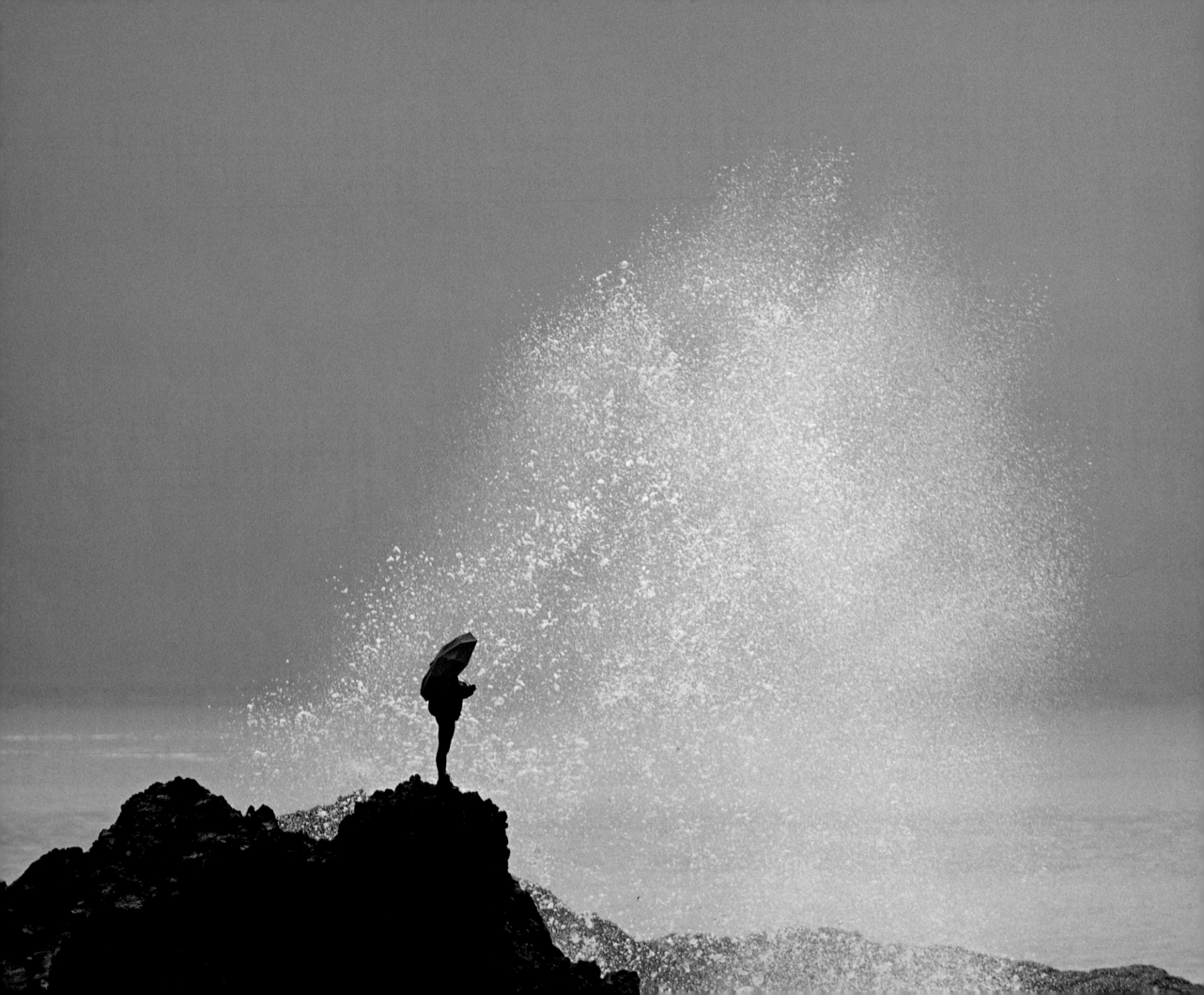

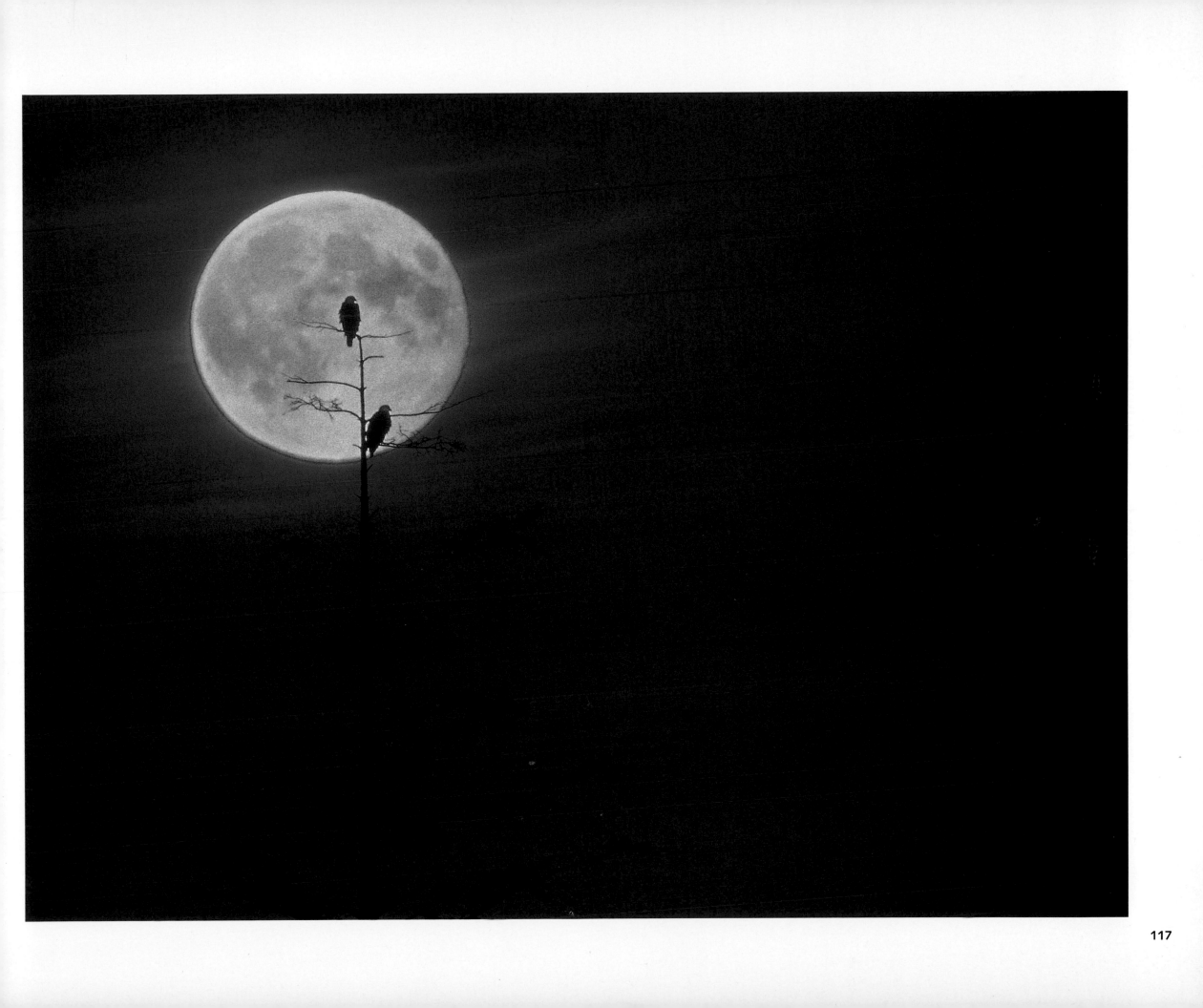

Preceding page: Bald Eagles and full moonrise, Queen Charlotte Islands

One evening on the coast, I noticed the nearly full moon rising over a tree with an eagle perched on it. I realized that at about the same time the next day, the moon would be even lower in the sky and if that eagle was inclined to sit in the same place I could photograph it silhouetted against the full moon. The next day, the eagle returned and brought a friend. The full moon rose behind them on cue and my camera captured the celestial alignment.

Abandoned truck

One man's garbage is another man's photographic treasure.

Opposite: Balance Rock, Queen Charlotte Islands

Known in geological terms as an erratic, Balance Rock was left behind on the shore near Skidegate by a glacier in retreat.

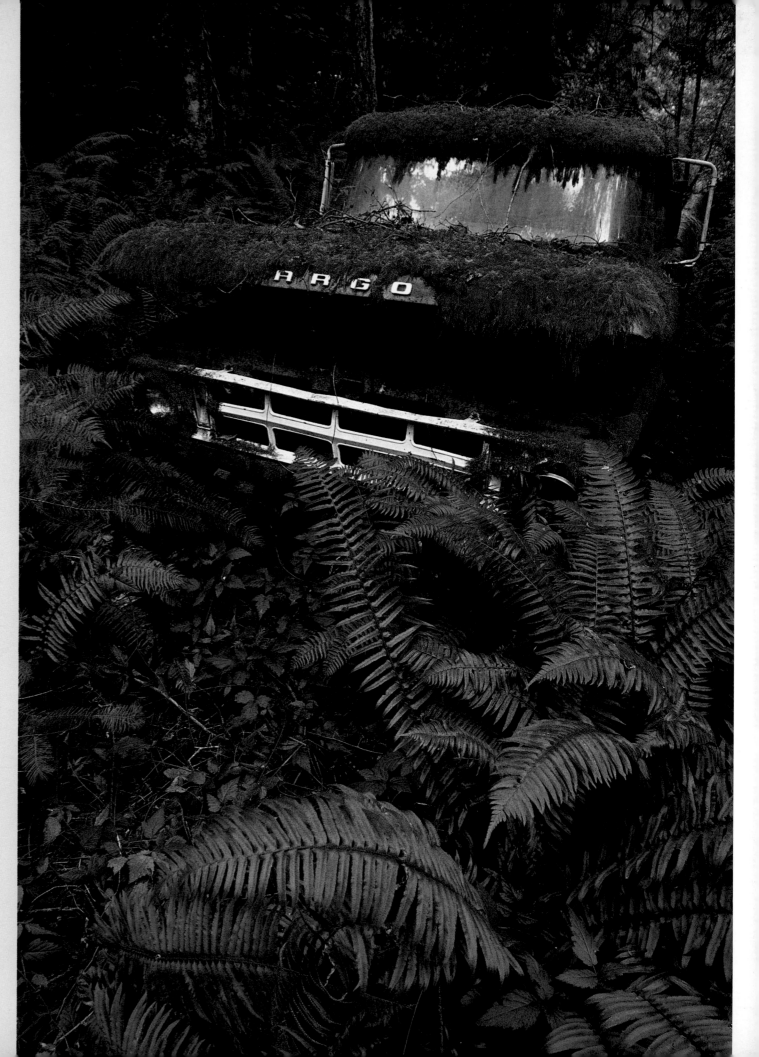

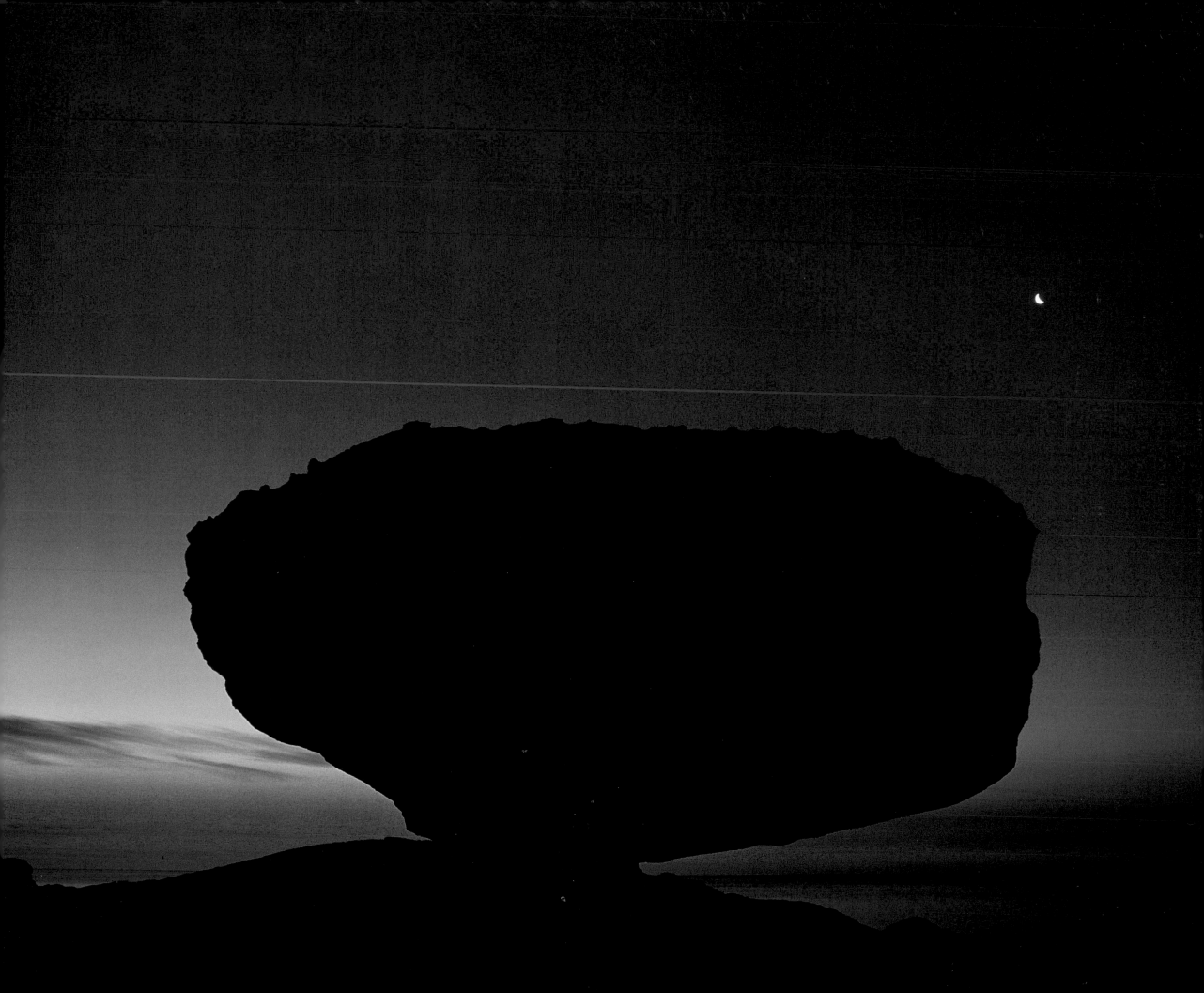

Acknowledgements

British Columbia is full of people who live by the side of the road offering a helping hand to passing photographers. They do it because they want to and not because they expect to see their names in print. At least I hope that's the case because I have lost most of them. Here's a global "thank you" to all you wonderful Samaritans. I hope you can take some satisfaction by looking over this book and knowing you made a difference.

A lot of people have helped in other ways large and small. Dave Cochrane of Canadian Mountain Holidays took care of getting me into the Bugaboos. Ron Watts loaned me his Fuji GX 617 until I was man enough to buy my own. The Etzkorns— Jerry, Janet, Jake and Justine—provided me with a memorable glimpse into the world of a West Coast lightkeeping family. I want to thank Norm Lindley for not kicking me off the Douglas Lake Ranch, where I love to go for night photography, and Mike Parkin for helping hike gear up to Panorama Ridge in Garibaldi Provincial Park. I want to express my appreciation of Blue Mountain Vineyard for having a vineyard design that is a composition unto itself. I want to thank the hardworking gang at Harbour Publishing, particularly Vici Johnstone, for bringing order to a large, disorderly and constantly changing pile of material, and Roger Handling for putting it all together. Lastly, I want to thank Dave Jones for serving as my personal literary tutor, Tom Kitchin and Victoria Hurst for their continuing support and Victoria Miles for her editing skills and more.

Dedication

To my father, John, for giving me the camera that started my scenery hunting.

Published by
Harbour Publishing Co. Ltd., P.O. Box 219, Madeira Park, BC V0N 2H0
www.harbourpublishing.com

Cover and page design by Roger Handling
Photographs by David Nunuk

Printed and bound in China through Colorcraft Ltd., Hong Kong

Harbour Publishing acknowledges financial support from the Government of Canada through the Book Publishing Industry Development Program and the Canada Council for the Arts; and from the Province of British Columbia through the British Columbia Arts Council and the Book Publisher's Tax Credit through the Ministry of Provincial Revenue.

National Library of Canada Cataloguing in Publication Data

Nunuk, David
 Natural light : visions of British Columbia / David Nunuk, photographer.

 ISBN 1-55017-273-5

 1. British Columbia--Pictorial works. I. Title.
FC3812.N86 2003 971.1'04'0222 C2003-911086-9

Technical Notes

Although this book spans most of my career, the bulk of the photographs were taken over a two-year period of travel throughout British Columbia between 2000 and 2002. For the remote and exotic, I used float planes, helicopters or hard work to get myself into the backcountry. For the more accessible sites, I simply hit the road in my camper looking for pretty places.

The equipment used was varied: Nikon 35mm cameras with optics from 20mm to 500mm, a Pentax 6X7 medium format, a Fuji GX 617 panoramic, and a Sinar 4X5.

Filters used were graduated neutral density and polarizing only. No colour filters or colour-enhancing filters and no digital manipulation of any kind were used to help create any of the pictures in this book, although I did occasionally use auxiliary lighting.

Film stock was Fujichrome 50, except page 97 which is Fujichrome 400.

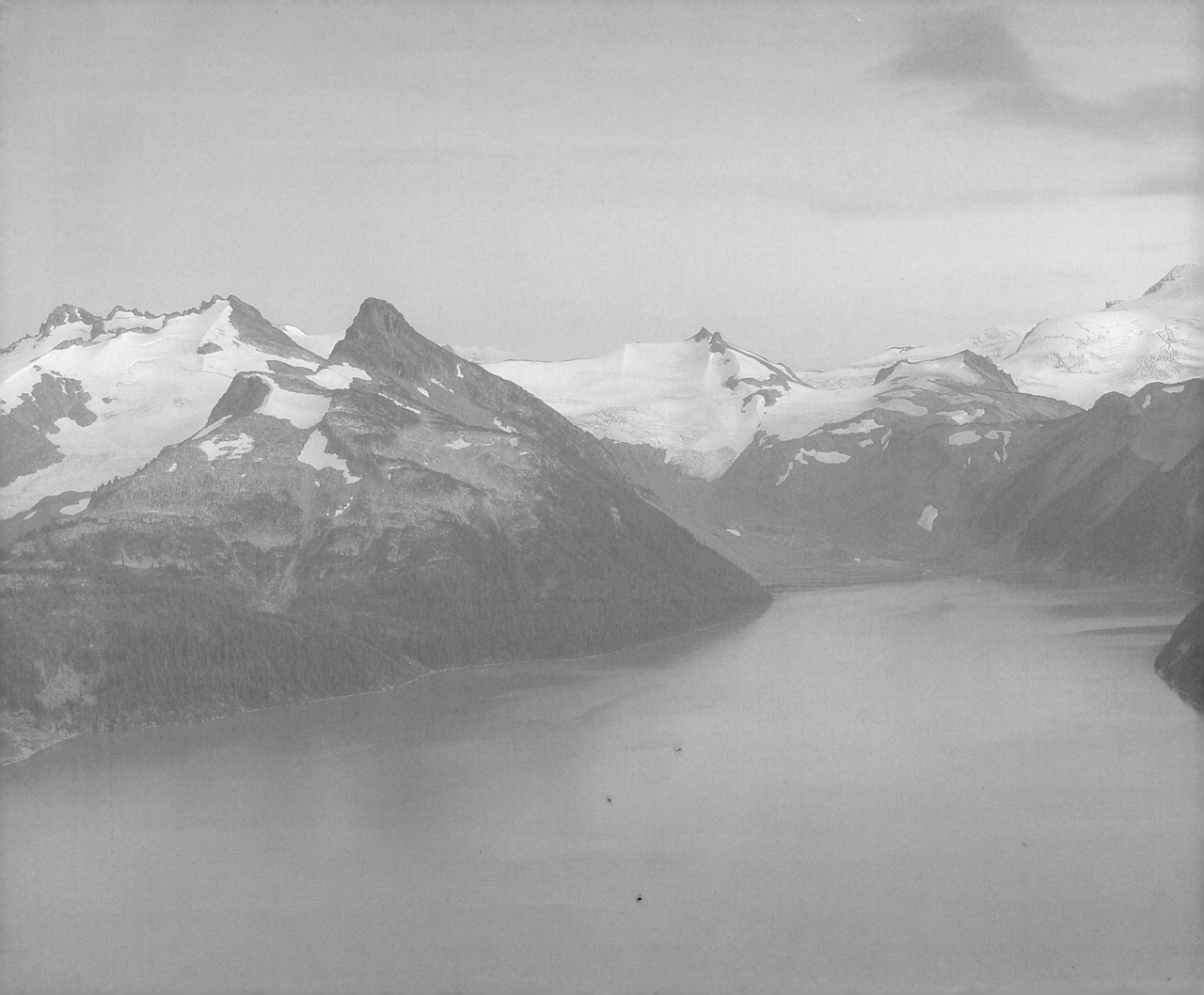